The Portrait Now

Sandy Nairne
Sarah Howgate

Yale University Press

The Portrait Now

Sandy Nairne
Sarah Howgate

Yale University Press

Published in Great Britain
by National Portrait Gallery
Publications, National Portrait
Gallery, St. Martin's Place,
London WC2H 0HE
www.npg.org.uk

Published in North America
by Yale University Press
P.O. Box 209040
302 Temple Street
New Haven, CT 06520-9040
www.yalebooks.com

ISBN 0-300-11524-5

Library of Congress Control
Number: 2005936061

Publishing Manager: Celia Joicey
Senior Editor: Anjali Bulley
Editor: Caroline Brooke Johnson
Captions and Biographies:
Charlotte Bonham-Carter
and Zoe Morris
Research: Jes Fernie
and Kate Phillimore
Copy Editor: Claire Fletcher
Production: Ruth Müller-Wirth

Cover Illustration:
Gillian Wearing
Self Portrait, 2000
C-print
2135 x 2135mm
(84$\frac{1}{8}$ x 84$\frac{1}{8}$")
Courtesy Maureen Paley,
London

Contents

**Portrait of a Portrait of Claude
Shannon, 2000–01
Custom electronics, LEDs,
treated plexiglass
305 x 381 x 76.2mm
(12 x 15 x 3")**

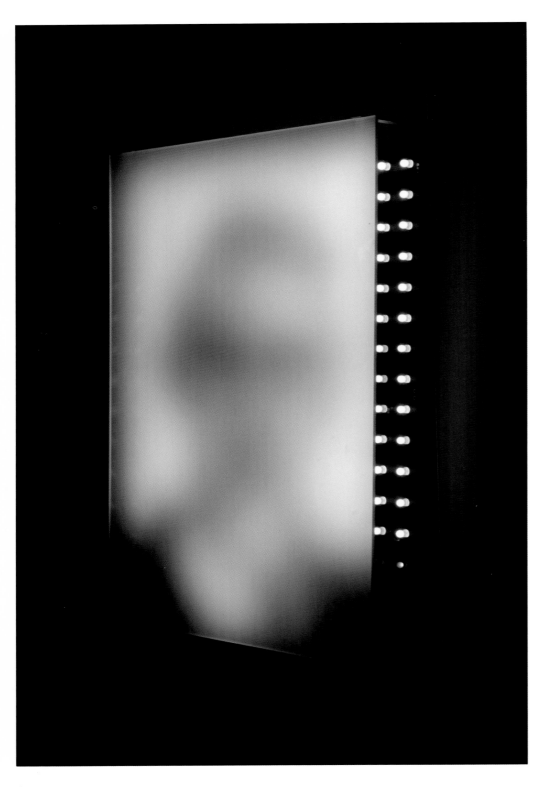

In 1993 the National Portrait Gallery in London presented an exhibition titled *The Portrait Now*. Selected by the then Twentieth Century Curator, Robin Gibson, it surveyed a decade of portraiture from around the world and focused on painting and sculpture, setting portraits in the context of a changing art world. This was a period in which the return to figuration – represented by *A New Spirit in Painting* of 1981[1] – had overcome the simplistic but previously dominant view that abstract art, whether expressionist or minimalist in style, was the most valid contemporary form. The new eclecticism of the 1980s and early 1990s was well represented in *The Portrait Now*, although video pieces (such as that by Marty St James and Anne Wilson) were included while photographic portraits were not.

In the period since 1980 the National Portrait Gallery has developed a programme for commissioning new portraits. Against a background of 500 years of British history presented through the portraits of individuals, why and how, in the twenty-first century, portraits continue to be important are frequently asked questions. The six or seven portraits commissioned each year by the Gallery are always of those 'contributing to British history and culture'. Some will be famous, some less so, but in all cases there will be reasons to celebrate the sitter, and the artist is set the challenge of conveying something of the subject's signal achievement to a wider public.

After more than a decade, and with the commissioning programme twenty-five years old, it is an appropriate time to examine and reflect on contemporary portraiture again, focusing on a selection of works made since the beginning of the new millennium. For this book we have given a certain position to the traditions of portraiture – particularly the commissioning of honorific images. But we have also looked more widely, acknowledging important stylistic developments within portraiture as a genre, and recognizing the influence of more domestic traditions, for instance the place of private photographic keepsakes or snapshots, continuing a contemporary version of the miniature as an embodiment of personal memory and affection.

In thinking about the range of work to represent, it was important to include works in all media, whether paintings, sculptures, digital works or photographs. While making an international selection, there were distinct limits as to how many portraits could be included. Some more complex works, such as installations or videos, do not easily translate into still images reproduced in a book. But far from acting against traditional ideas of portraiture, the new media have extended them, and we wished to include more conceptual and experimental works. The overall selection is not intended to be a detailed survey, but rather a view of the current state of portraiture through a choice of portraits that interested us, not as generic human images, but as particular individuals.

We also want to demonstrate that the portrayal of others (and of the self) remains central in contemporary art. This is a hugely engaging – and creatively successful – area for many artists who have earned critical attention through other work. The idea of the portrait connects to themes of identity, representation, power and nationality, providing artists with fertile ground for reinvigorating the depiction of what are arguably the most intriguing of all subjects: ourselves and others.

Sandy Nairne
Director

Sarah Howgate
Contemporary Curator

Braco Dimitrijevic
**The Casual Passer-By I Met at
3.41pm, New York, 1988
Photographic paper
mounted on canvas
5 x 4m (16ft 4^{8}/$_{10}$ x 13ft 1^{5}/$_{10}$")**

Robert Crumb
Jacket cover, taken from
The R. Crumb Handbook

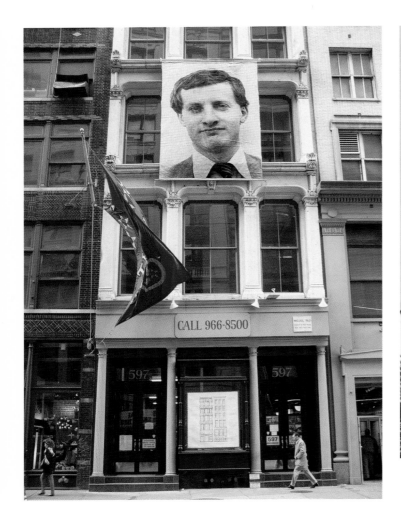

The Condition for Portraits

Catastrophic events of recent years have been accompanied by insistent media commentaries and images circulated almost simultaneously around the world. This aspect of globalisation is characterized by an almost instantaneous effect in which new photographs of conflict and calamity, such as 9/11, the Madrid bombs of April 2004 and the Asian tsunami of December 2004, are burned as visual images across the collective consciousness. The focus of much of the first communication of these events is perhaps inevitably the image of particular human beings, whether as witnesses, victims, heroes, survivors or perpetrators.

Despite this worldwide and continuous exchange of images, the condition for portraits – the conscious depiction of particular individuals – relates to a fundamental social need rather than simply to a matter of artistic style. At one level portraits endure against the backdrop of such an instantaneous culture. They are part of the response to a changing and challenging world. At another level the symbolism and resonance of representations of specific individuals remain powerful within the media. The toppling of the sculpture of Saddam Hussein in central Baghdad in April 2003 – mirroring the earlier removal of heroic portrait sculptures of Stalin and Lenin so prevalent after the end of the totalitarian period of the Eastern bloc – was widely regarded as a symbol of the overthrow of both dictator and regime. And the poignant posting of images in public places or on the web, either of survivors or of those feared lost in disasters, tells all too clearly of how a collective emotive power is invoked by the evocation of single individuals amidst collective suffering of unbearable proportions. That power lies in the link from portrait to subject whether as a world leader or seemingly unknown but loved individual.

The circulation of images of film actors, models and sports stars – the culture of celebrity – has been driven forward through the same global networks of magazines, television and the Internet. An obsessive and often prurient interest in the private lives of the rich and famous, regarded as if they were public property, centres greatly on their representations. In the late 1970s Cindy Sherman's self-portraits, styled as 'Untitled Film Stills' were of imaginary B-movie set ups, in which she is variously disguised (p.8). Every face is her own, but readable only through the genre of movie stills, brilliantly exploring the ideas of portrayal and identity. Making a new portrait in the midst of the intensive celebrity world can involve negotiating multiple received images. When Sam Taylor-Wood made a commissioned portrait for the National Portrait Gallery (2003–4) of footballer David Beckham, she made an hour-long video portrait (with a nod to Andy Warhol), not of Beckham on the pitch or posing glamorously, but asleep (p.9). Touching in its intimacy, this portrait is effective precisely

because of its intrusion into an arena of personal space, giving the viewer a sense of an unguarded almost defenceless presence. We share something of the space and the experience. It is a riposte to the world of *Hello* magazine.

The fascination with the anonymity of the crowd, one of the metaphors for the impersonalization of modern life,[2] creates an intriguing genre of the unknown but very particular individual. Previously rendered poignant in early modern works such as Walker Evans's famous subway portraits of 1938, or made heroic in Braco Dimitrijevic's billboard-scale photographs of passers-by of the 1970s and 1980s, which mocked the large-scale pictures of political leaders, the idea of capturing anonymous portraits emblematic of contemporary life remains prevalent. Anonymity has a particularly powerful effect in the work of Christian Boltanski. His works such as *The Reserve of the Dead Swiss*[3], an installation of photographs taken from newspaper obituaries of Swiss subjects unknown to the artist, exhibited with miniature spotlights, call up the photographs of those lost in the earlier horrors of the concentration camps, or the everyday image processing of a Western world dominated by security and surveillance. Something of this nervous anonymous territory is explored by Willie Doherty who uses the complex and violent history of Northern Ireland as the background to his chosen male subject (pp.110–11). We are given insufficient information to interpret the depiction, but the work stands for the many areas of violence around the world.

The politics of portrait images are also writ large in the overlapping fields of caricature and cartoon. Both remain vital, and great figures remain active, whether Gerald Scarfe in the UK or Robert Crumb in the USA, using exaggeration and distortion to brilliant effect.

The Purpose of Portraiture

An essential question for any portrait is whether it simply records the outer, visible surface of a person – as in John Singer Sargent's view of a portrait being 'a painting of someone where something has gone a little wrong around the mouth' – or whether it provides insight to their character, some essence of their being. The early modern portrait, in the work of Édouard Manet or Edgar Degas, or even looking back further to Diego Velázquez or Francisco de Goya, was able to lay claim to such insight. The supposition both then and now is that the portrait should transcend the occasion or circumstance for which it was created. The portrait should allow something of someone's personal interior life to be made available in public, and this purpose – to bring out hidden information – should be important to both artist and the eventual viewing public.

Chuck Close has provided a systematic basis to the processing of images: creating large-scale paintings of heads that are as much

Sam Taylor-Wood
**David, 2003–4
Digital film displayed on
plasma screen
Commissioned by the
National Portrait Gallery,
London**

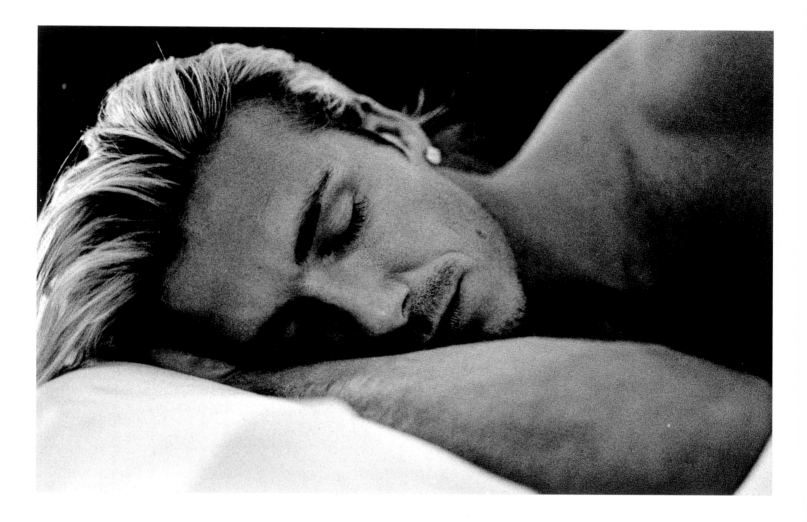

Susan Hiller
Midnight Waterloo, 1987
C-print
762 x 520mm (30 x 20")

Paula Rego
Germaine Greer, 1995
Pastel on paper laid on
aluminium
1200 x 1111mm
(47¼ x 43¾")
Commissioned by the
National Portrait Gallery,
London

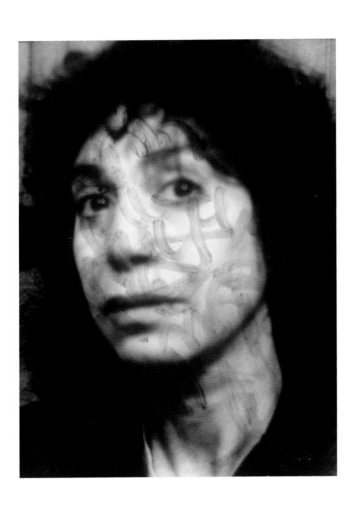

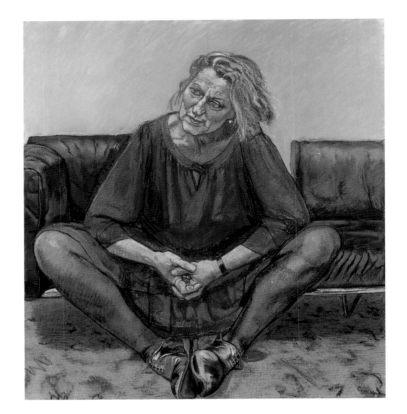

about how to make a painting, as they are about the subject. In recent years he has moved in two rather opposing directions, painting near-abstract shapes, which only form a portrait composition when viewed at a considerable distance, and making daguerreotypes, an exquisite and almost miniaturised process of fixing a portrait image onto a small metal plate. Close's works may seem to challenge the idea of portraiture as the investigation of the interior world of an individual subject, yet even he has admitted that '… people's faces are roadmaps of their life …'.[4]

Lucian Freud produces a more consciously emotive effect, continuing to render both person and body in highly charged translations between the paint on the canvas and the skin, hair or cloth depicted. *The Brigadier* is a large-scale painting of such power that the languorous and literally unbuttoned form of the sitter allows the character to seep out through the oil paint (p.136). If in other paintings the skin can itself be considered as a kind of costume, here the uniform has become a ragged skin. Part of the strength comes from how Freud paints the subject in relaxed, introspective guise: as he has said 'I like the idea of working from people who are able to be themselves – not posing, just being'.[5]

Sam Taylor-Wood created a project in 2004 to photograph men crying: Ed Harris is pictured bent over and apparently sobbing, his head falling forward in a stoop of despair (p.45). The portraits in the series of these celebrated male actors offer a conundrum between real and invented emotion. They disturb our presumptions about the male public image and something private made public in this way produces a portrait of masculinity that is curious and unexpected. By comparison Jiří David's 'No Compassion' series offers the opportunity to test the degree of our empathy with individual world leaders (p.44). These mostly male figures are expected to conform to an image of stern, objective statesmanship or seigniorial control.

Mario Testino is now almost as famous as some of his sitters, and particularly renowned for creating photographic portraits both sympathetic and telling. With *The Prince of Wales with his sons Prince William and Prince Harry* (p.80), there may seem to be much at stake – particularly in the wake of the tragic loss of Diana, the princes' mother. Public curiosity and media intrusion have made their lives even more complex, and a positive look on their posed faces may be demanded as a kind of public testimony. Their portrait wins considerable sympathy.

The Terms of Portraiture

With the emergence of the new figurative painting and urban-related sculpture of the 1980s, the art world was jolted in the

1990s by the brash new conceptualism taking centre-stage in Britain following the success of the *Freeze*[6] exhibition (1998) and the rise of the yBa (young British artist) generation of, among others, Tracey Emin, Damien Hirst, Gary Hume, Sarah Lucas, Marc Quinn, Sam Taylor-Wood and Gillian Wearing. Much of this work centred on ideas of selfhood and contemporary experience, alongside the more formal concerns of making and facture. Equally important in the wake of the political and cultural upheavals of the 1960s and 1970s was the emergence of women artists, such as Susan Hiller, Ana Mendieta or Adrian Piper, and also those in Britain from Asian or Afro-Caribbean cultural backgrounds, such as Anish Kapoor, Sonia Boyce and Chris Ofili (who was twice selected for the BP Portrait Award exhibition in 1990 and 1991). Such artists, for most of whom images of self or others have been central, did much to challenge the basis on which art had always been enjoyed – both in terms of simple pictorial pleasure and its political and critical understanding.

There was growing concern in the 1990s that art colleges were failing to offer advanced training in life drawing, anatomy or perspective for those who might pursue figurative work or portraiture in particular. But while conventionally painted portraiture might have seemed less relevant to some art critics, the BP Portrait Award at the National Portrait Gallery has attracted more entries and more visitors year-on-year since its inception in 1990. While on one level artists have extended the terms of portraiture with new media, at another, the more historically grounded forms of painting and drawing have offered a platform for some outstanding traditional portraits.

Since the 1980s the work of Lucian Freud has been appreciated ever more widely, with exhibitions on both sides of the Atlantic, both retrospective and of new work. It was indicative that a single new self-portrait put on display in London in the spring of 2005 drew considerable press and public attention. The expressive portraiture of Frank Auerbach and Leon Kossoff, in whose paintings a face may emerge out of swirls and the density of the paint, has had an increasingly strong impact on critics and audiences. There is also a growing appreciation of the portrait work of David Hockney, an artist who cannot stop examining how to look at the world around him through paintings, drawings, photographs or watercolours. Important artists, such as Tom Phillips or Humphrey Ocean, who would not regard themselves essentially as portraitists, have also produced commissioned works of great distinction.

Leon Golub and Marlene Dumas, who have worked figuratively in watercolours and oil paintings, have both been widely influential and helped to extend the category of portraiture – blurring the edges between figurative, narrative, symbolic and portrait paintings. The commissioned portrait by a figurative painter not

Marlene Dumas
Helena nr.3, 2001
Oil on canvas
2000 x 1200mm (78 x 47")

Ishbel Myerscough
Dame Helen Mirren, 1997
Oil on board
351 x 348mm (13¾ x 13⅝")
Commissioned by the
National Portrait Gallery,
London

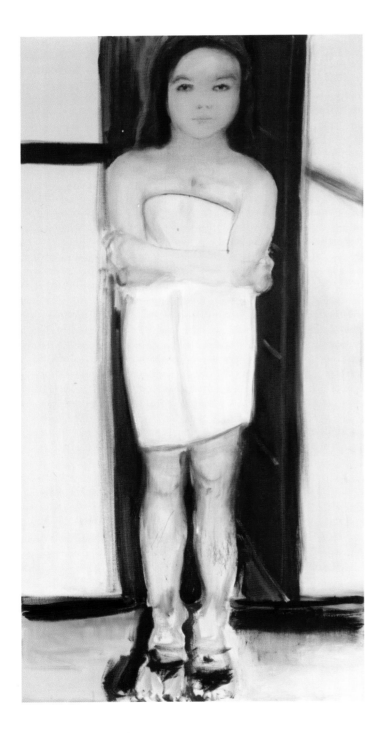

usually drawn into the realm of portrait commissioning, such as *Germaine Greer* by Paula Rego, has attracted considerable notice and public attention. As the writer Peter Campbell referred to her work recently: 'Her pictures invite, demand even, that you attend to what they are about as well as how they look'.[7] Such senior artists have much to offer to the field of portrait painting, and have opened up areas which younger artists have been able to explore.

Within commissioned portraiture in Britain experienced practitioners, such as John Wonnacott, Daphne Todd and Andrew Festing amongst others, have also continued to create fine painted portraits whether for private or public commissions. Indeed, Andrew Festing's series of group portraits of the staff of the Earl of Leicester's estate can be counted as an exceptional project, eventually to be made up of seven large-scale group paintings: a reinterpretation of the idea of the 'servant portrait'. A number of very striking portraits that joined the National Portrait Gallery's collection in this period have gone on to become 'classics' in the public's mind, such as that of Salman Rushdie by Bhupen Khakhar, 1995, and *Mo Mowlam* by John Keane, 2001. A younger and energetic generation of portrait painters has also emerged in Britain – including James Lloyd, Ishbel Myerscough, and Stuart Pearson Wright[8] – concerned with recreating a precise and highly observed form of painted portraiture in which symbolic content has a place.

Stuart Pearson Wright's commissioned portrait of J.K. Rowling allows a few of the myths about the author to be incorporated into the image (p.98). Here the writer of children's fiction sits as if posed in the Edinburgh café in which she first wrote the famous Harry Potter stories. The artist has produced a lasting graphic rendering of Rowling's features, as part of a *trompe-l'œil* ensemble, creating a delightful depiction of this elusive and famously camera-shy writer. In another commissioned work for the National Portrait Gallery, Philip Hale successfully collaborated with composer Thomas Adès, to produce a strangely extended and rather Egon Schiele-like pose (p.32). The composer is presented as an elongated figure but with much tension in the stretching of his fingers (which happened to need exercise after a minor accident).

The cross-over between the world of art and that of pure photography, whether studio or documentary work, has been productive in terms of critical and wider debate about portraiture. The development of a deadpan aesthetic by European photographers such as Thomas Struth or Thomas Ruff emerged in sharp contrast to the provocative portrait photographs by American Robert Mapplethorpe of naked men, or Andres Serrano's studies of the Klu Klux Klan members. The latter were amongst the most controversial images in America of the 1980s. Equally telling were Jeff Wall's dramatic, constructed scenes, and the focused documentary work of Martin Parr and Paul Graham.

And some of the most powerful images in the exhibition *Cruel and Tender* (Tate Modern, 2003),[9] were portraits such as those by Philip-Lorca diCorcia, Boris Mikhailov and Fazal Sheikh, the whole project demonstrating a further shift in the thinking of art institutions towards the inclusion of photographic practices, including portraiture, as a part of the world of fine art.

Identity in Portraits

The issue of identity, the characteristics of class, race or gender that form each of us, can be tellingly exposed in portraits through the devices of disguise or reflection, as well as through the immediacy of documentary photography. Identity and the symbolic – whether in clothing, gesture, pose or narrative – are closely connected, and a specific portrait can also stand for more generic categories and groups. Following in the wake of Cindy Sherman, the Japanese artist Yasumasa Morimura has for many years created works in which he elaborately imitates the female subjects of great paintings. In *An Inner Dialogue with Frida Kahlo, 'Hand-shaped earring'* he almost absurdly inhabits the persona of the great Mexican artist Frida Kahlo, stepping across the boundaries of culture and history (p.48). If the homage produces a certain frisson it is because of bridging in symbolic form the vast gulf between Kahlo's identity and what we know to be Morimura's own culture and context.

Gillian Wearing creates another disguising effect with *Self Portrait at Three Years Old*, 2004, in which she 'adopts' in mask-like form her own face as a child (p.49). The result is a strange displacement by which the essence or identity of 'Gillian Wearing' – as we might imagine her now – is shown as a composite, the culmination of several earlier images (and selves).

The symbolic 'jungle' representation of Queen Elizabeth II by British artist Hew Locke, reorders the monarch's portrait through a tangle of plastic flowers and toys (p.128). Somewhere a more sinister association emerges, perhaps about colonial power and the collective consciousness. But nevertheless the image is suffused with a colourful, perhaps populist association with cheap high-street goods.

The American painter John Currin became prominent in the art world with his paintings of exaggerated pneumatic female subjects, small-town girls replayed in retro-pin-up style. From these stereotypes he has moved to create a 'Thanksgiving' family scene in a conscious Old Master style (p.30). Currin's wife Rachel appears, offering an uneasy mix between reality and doll-like depiction. The painted portrait conveys something that is clearly not quite real, while intriguing us with a sense of more universal domestic ceremony.

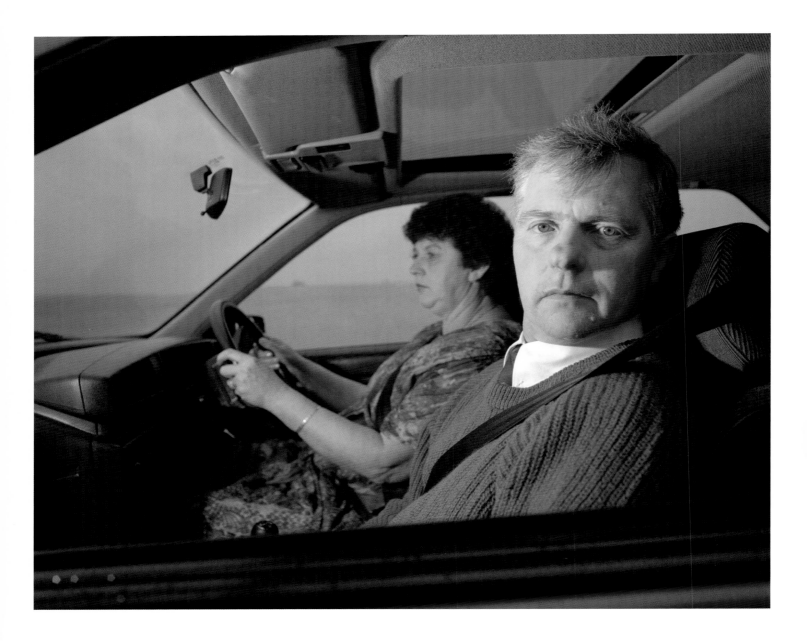

Self-portraits exploring the artist's own identity offer the viewer the enticing chance to stand between the artist and the mirror: in the act of contemplation of their own self. With Celia Paul, the self is viewed consistently and repeatedly, a spotlight applied through the mirror (p.134). The self-portrait image is reduced to essentials, to the marks that will convey the lines of emotion and intelligence. While a direct view of motherhood is apparently proffered by Catherine Opie, frequently the self-image is fragmented or disrupted (p.20). Lucy Jones sets out evident tensions in her body (p.72), while Daphne Todd gives only a tantalising segment of herself (p.133), and Francisco Toledo weaves an image of himself that suggests something of the intricacies of Mexican stories and culture (p.95).

In documentary photographic portraits taken outside the studio the artist-photographer creates an opportunity from what they discover: what they expose. But a framework may be added by the artist. Rineke Dijkstra, has followed many of her subjects over time, photographing them sequentially through a structured institutional environment (p.34). The vivid presence of each subject is reinforced through knowing that she has captured them at different stages of their lives, their identity defined through their profession – costume playing a powerful role. Similar costumed drama in the domestic context is tracked in Tina Barney's 'The Europeans' series (p.78).

By contrast Zwelethu Mthethwa creates a vivid sense of the immediacy of the situation: a pause in hard physical work, the quick glance towards the camera before labour is resumed in the hot fields (p.112). For photographer Malick Sidibé from Mali, conventional studio practice is pursued through a mix of the symbolic and the everyday. Each subject is portrayed with their back to the camera. Their clothing, with its bold fabric design, is dominant, and the photographer has chosen to elect this as the most significant way of conveying their individual persona (p.58). In these and other portrait photographs from around the world, issues of cultural identity are thrown up. Who has the right or position to define another? And what kinds of cultural stereotypes will be countered or reinforced? In 'Goftare Nik/Good Words', Shirana Shahbazi's photographs of daily life in Tehran, the images cut across what might be presumed to be a more 'exotic' cultural location (p.101). And in *E.T. and Others*, Atul Dodiya's portraits are painted on shutters from India; the street culture is absorbed back into the work (p.114). In recent years, many exhibitions, such as those that formed part of the Africa 05 festival in Britain, have tried to span work from varying cultural backgrounds in ways that will give more opportunity to understand different cultural contexts, including those for portraiture – which remains universal in interest, even where attitudes to images and representation are wide-ranging.

The Future for Portraits

Commentators on the future development of portraiture have looked to scientific research to find clues – some of which was rehearsed in a London exhibition entitled *Future Face*[10] that explored at the overlap between scientific, medical and surveillance technologies, mapping or changing the face for different purposes. In a future presumed by many thinkers to involve digital enhancement, electronic recording and constant surveillance, the technology of recognition (attributed to increased security pressures) promises to make the science of the face an arena for further work and development. In this context those digital portraits that already tread the line between stereotype and actual likeness feel particularly prescient.

Equally, the improvements in plastic surgery and the wider spread of its use in the West may change assumptions about character and personality. Surgery or genetic modification may close up on cosmetics, with a person's look being even more a matter of choice. Soon many more people may move on from Botox to try and improve on the combination of chance and genetic disposition. This may be part of the mix of a personal and environmental dystopia, and the very idea of seeking, through a portrait, to find the personality below the surface may be rendered irrelevant. In such a world there could be even greater force to the portrait made of an associated object, whether a piece of discarded clothing or the chair most often sat on.

Such a prognosis, although relevant to the study of portraiture, does not illuminate the central essence of the subject. Because a true portrait still reaches towards an understanding of its sitter. This emphasizes its central role as an arbiter of identity and presentation. Against a digital world of surveillance and distortion, people will continue to desire representations that are made for their own private purposes, and with the creative input of the artist or photographer acknowledged as an evident part of the result. The portrait remains central to artistic practice as an essential way of exploring the world through representations of the people in it.

[1] *A New Spirit in Painting*, selected by Christos Joachimedes, Norman Rosenthal and Nicholas Serota, Royal Academy of Arts, London, January–March 1981

[2] See *The Face in the Crowd*, selected by Iwona Blazwick and Carolyn Christov-Bakargiev, Whitechapel Art Gallery, London, December 2004–February 2005

[3] Tate collection, 1990

[4] Barbaralee Diamonstein, *Inside New York's Art World* (Rizzoli, New York, 1979), p.79

[5] Quoted by Richard Cork, 'The Master and his Muse', *The Times Magazine*, 28 May 2005, pp.40–47

[6] *Freeze*, curated by Damien Hirst, PLA Building, London, 1988

[7] Peter Campbell, 'At Tate Britain', *London Review of Books*, 2 December 2004, p.29

[8] See *Being Present*, Jerwood Space, London, 2004, including work by James Lloyd, Ishbel Myerscough, Stuart Pearson Wright, Jennifer McRae, Philip Hale, Joe Schneider, Brendan Kelly, and Carl Randall

[9] *Cruel and Tender*, subtitled as 'The Real in the Twentieth-Century Photograph', curated by Emma Dexter and Thomas Weski, Tate Modern, London, June–September 2003

[10] *Future Face: Image, Identity, Innovation*, selected by Sandra Kemp of the Royal College of Art for the Science Museum, London, 2004–5, associated book published by Profile Books, London, 2004

Catherine Opie
Self-Portrait/Nursing, 2004

C-print
1018 x 813 mm (40 x 32")

Self-described as a 'twisted social documentary photographer' Catherine Opie's work could be described as 'cultural portraiture'. Opie investigates different, and often marginalised, American communities, particularly the gay community. Though her subject matter is sometimes transgressive, her portraits are classically composed. In capturing her subject, or in this case, herself, in a formal pose against a lavish studio background, Opie's portrait doesn't lend itself to a voyeuristic reading. Instead, the portrait becomes a tender representation of love and domesticity. The image differs from our 'idealised' vision of maternity, but it is no less strong in its effects.

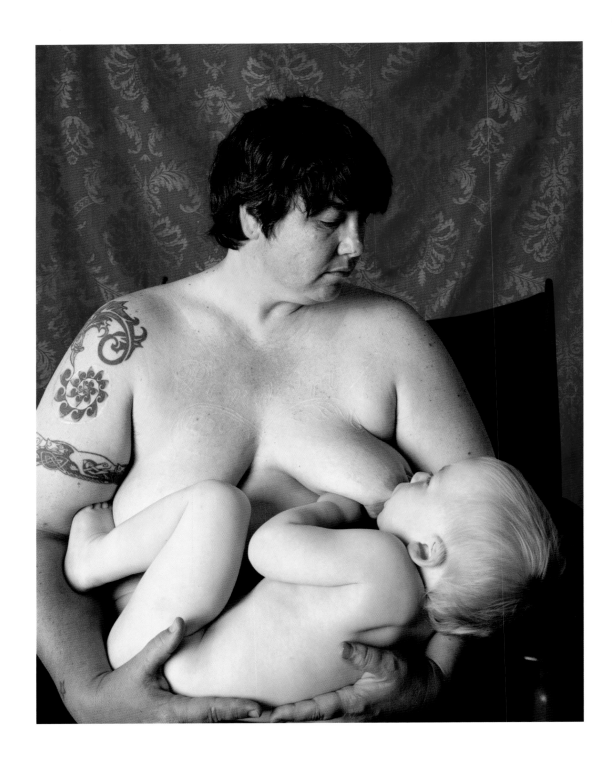

Marc Quinn
Lucas, 2001

Human placenta and umbilical cord, stainless steel, perspex, refrigeration equipment
2045 x 640 x 640mm
(80 x 25³/₁₆ x 25³/₁₆")

To make *Lucas*, Marc Quinn liquidized the placenta and the umbilical cord of his son Lucas. He then froze the liquid into the shape of his son's head. The piece echoes Quinn's iconic sculpture from 1991, *Self*, which was made from nine pints of the artist's own blood.

However, *Lucas* represents a shift in interest for the artist, extending a preoccupation with his own body and fragility to those around him. Interestingly, the piece will not survive if the freezer breaks, perhaps reflecting the fragility of life itself. The work is emblematic of Quinn's proclivity for direct, and often unsettling, subject matter.

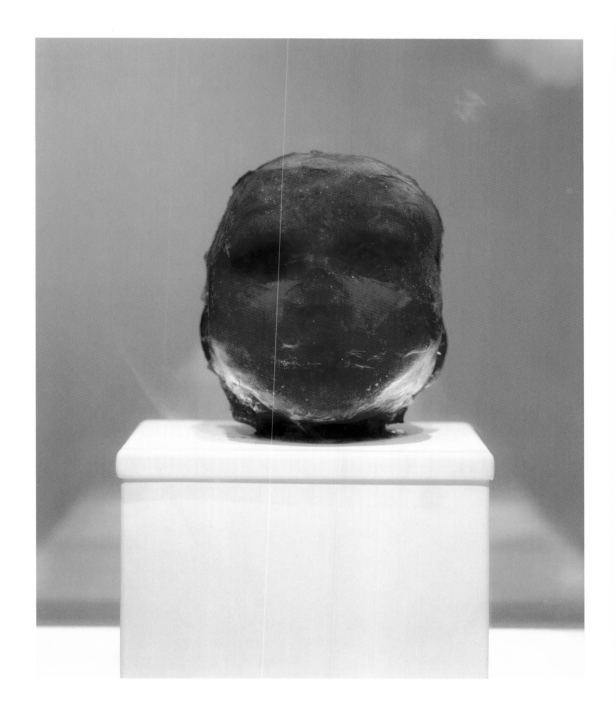

Alessandro Raho
Dame Judi Dench, 2004

Oil on canvas
2521 x 1759mm (99¼ x 69¼")
Commissioned by the
National Portrait Gallery,
London

Known for garbing his sitters in theatrical attire, in this instance Raho decided instead to capture Britain's much loved actress Judi Dench in a simple white coat. Situated against a bleak white background, Dench is caught in a languidly casual pose. The portrait is an attempt, according to Raho, to 'trap something I saw in her while she waited in the main hall of the National Portrait Gallery, unaware of me'. Meticulously painted over a six-month period, the portrait is based on 200 photographs taken by the artist during an intensive studio session with the actress.

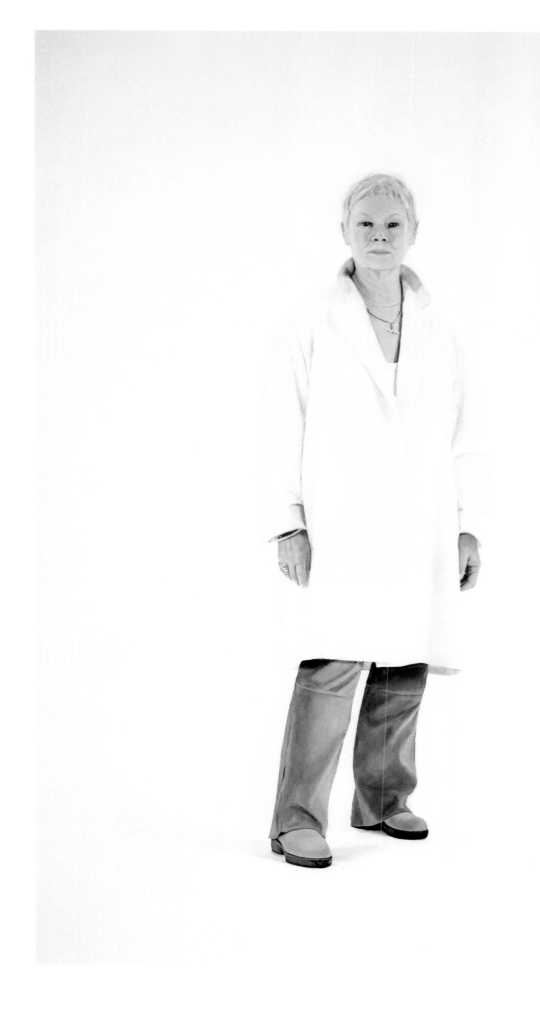

Portrait, 2000

Oil on canvas
670 x 390mm
(26³⁄₈ x 15³⁄₈")

Luc Tuymans, famous for his pallid palette and subtle chromatic reserve, often creates an eerie aura around his paintings. The comically reductive title of this work, *Portrait*, suggests elements that are unknown, or unfinished, and somehow sinister. Working from magazines and newspapers, Tuymans says '… everything has already been painted, so reproduction is the only route forward.' Instead of striving for a realist representation of the world as we see it, or remember it, Tuymans is concerned with the act of representation itself; specifically, with the disconnection between image and representation. The subject of this portrait, with her blank face and black, thick-rimmed glasses, is more than suggestive of an underlying violence.

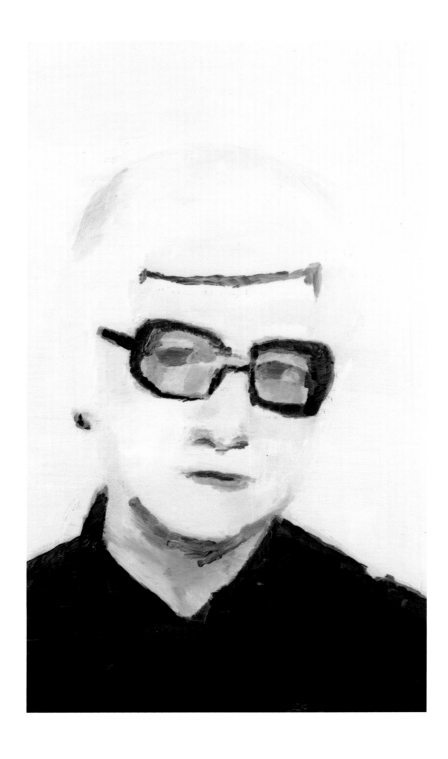

Alex Katz
Ada, 2004

Oil on canvas
2438 x 851mm (96 x 33")

Anticipating the Pop movement of the 1960s, Alex Katz's cool, modernist and urbane style has developed into an œuvre of work that remains comfortably poised between realism and abstraction. Katz's portraits are replete with subtle social and psychological insights.

Since 1957, Katz's wife Ada has served as both model and muse for the artist. Katz paints Ada in different situations, sometimes placing her in scenarios borrowed from film stills. In this most recent series, Katz did not just paint his sitters, but also styled them in designer clothes, creating an elegance already propagated by his contemporary aesthetic. Ada's ambiguously introverted smile is characteristic of Katz's keen observations.

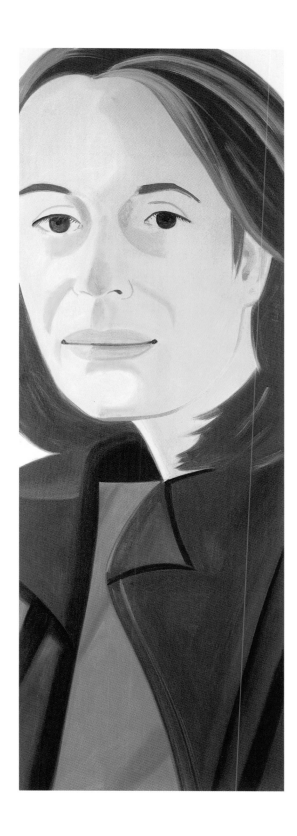

Elizabeth Peyton
Luing (Tony), 2001

Oil on MDF
279.4 x 355.6mm (11 x 14in")

Elizabeth Peyton paints portraits of friends and famous people, treating both subject matters in much the same manner. She applies paint airily, sometimes leaving the surface of the canvas exposed. However, the watery texture of the paint is complimented by her use of bold colours, and a particular fondness for luscious red lips and rosy cheeks. She paints her boyfriend, Tony, with an especially strong affection. Whether famous people or friends, the subjects of her portraits tend to be decadent, fragile, and slightly edgy. However, despite their apparent privileges, the sitters often reflect a subtle aura of discontent, as might be detected in this sexy and somewhat sombre portrait.

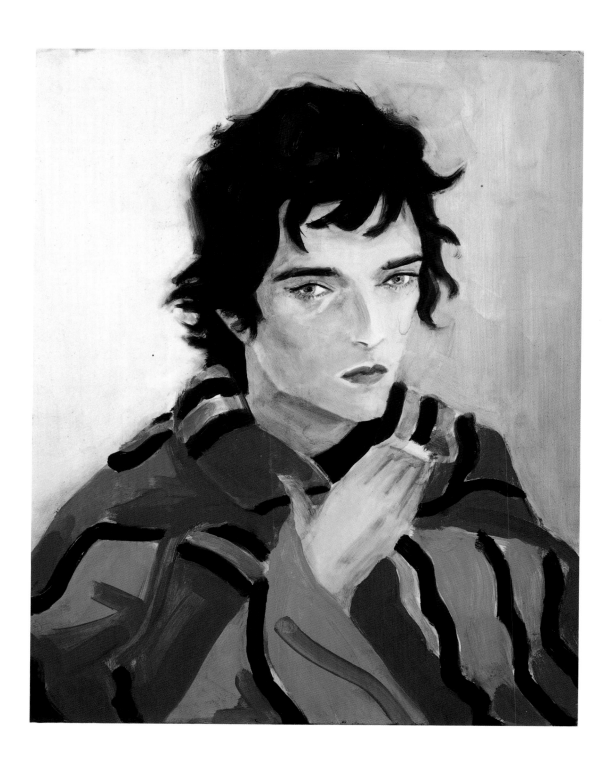

Vik Muniz
Jorge, from 'Pictures
of Magazines', 2003

C-print
2290 x 1830mm (90 x 72⅛'')

Jorge, is a photograph of a piece made from confetti-sized bits of paper punched from magazines. The series, 'Pictures of Magazines', looks at people made famous through various means, including television, sport, and even word of mouth. Muniz makes portraits of well-known people ranging from movie stars to manicurists. In reconstructing 'celebrities' through collage, Muniz is unable to achieve a perfect rendering of his subject. As such, the pictures reflect the way in which we construct porous images of people we have never met. The sitter of this portrait, fellow Brazilian Seu Jorge, is a musician, actor and friend of Muniz.

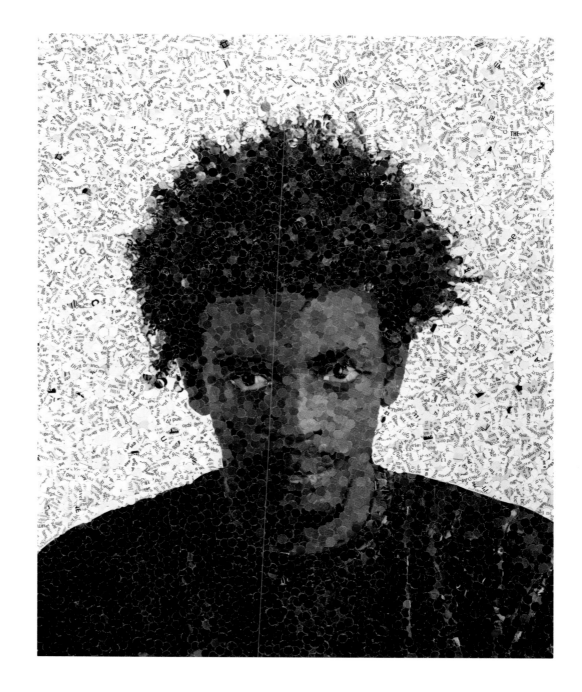

Francesco Clemente
Bill T. Jones, 2002

Oil on canvas
1073 x 2134mm (42 x 84")

Noticing subtle shifts in
depth and faint emergences
of shadows, Clemente's
portrait of dancer and
choreographer Bill T. Jones is
a characteristically expressive
portrayal of the human
physique. Jones choreographs
dance routines that often
confront issues of race, class,
and sexuality, while employing
an innovative combination of
spirit and imagination. In this
portrait, Clemente positions
Jones in the reclining posture
of a nude, yet depicts him fully
clothed. The pose is strikingly
similar to that assumed by
Clemente in his self-portraits.
These self-portraits, which
made Clemente famous in
the early 1980s, resonate
in many of his subsequent
portrait paintings.

John Currin
Thanksgiving, 2003

Oil on canvas
1730 x 1320mm (68⅛ x 52")

Although replete with art-historical references, Currin's form of figurative imagery embraces the grotesque. Sometimes called the 'post-feminist Rockwell', Currin runs awry with notions of the ideal of beauty and of the humdrum platitude of domesticity. In *Thanksgiving*, Currin mocks the family rituals of the middle class. A communal gastronomic event is overridden by a sense of gross self-indulgence. The robust turkey in the foreground of the painting is masterfully rendered to evoke the sensuality of flesh, both in its sexual and Epicurean capacities. Everything about these caricatures of femininity – all accentuated depictions of Currin's wife, Rachel – is amiss.

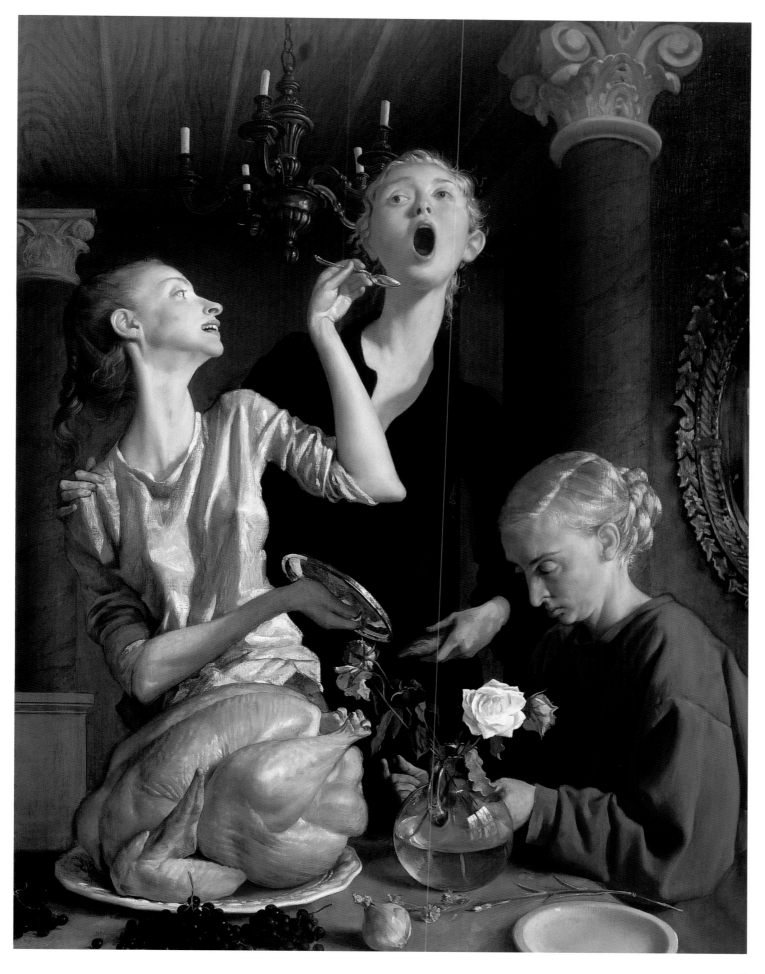

Philip Hale
Thomas Adès, 2002

Oil on canvas
2138 x 1073mm
(84 1/8 x 42 1/4")
Commissioned by the
National Portrait Gallery,
London, with the support
of the Jerwood Charity

The setting and pose for this portrait of the young composer and artistic director of the Aldeburgh Festival was born out of an intense photography session. The sitter, certain that he did not wish to be portrayed in the traditional setting of concert hall or rehearsal room, chose a dark and anonymous corner of his London home as a backdrop. In the sweep of the full-length figure, which echoes the shape of a musical note, and the attention to detail, with a play on texture and surfaces, this painting is rooted in the swagger portrait tradition.

However, the existentialist angst of this unconventional pose — with Adès's twisted body and right hand contorted into a finger exercise after an injury — calls to mind the etiolated isolation of Egon Schiele's figures.

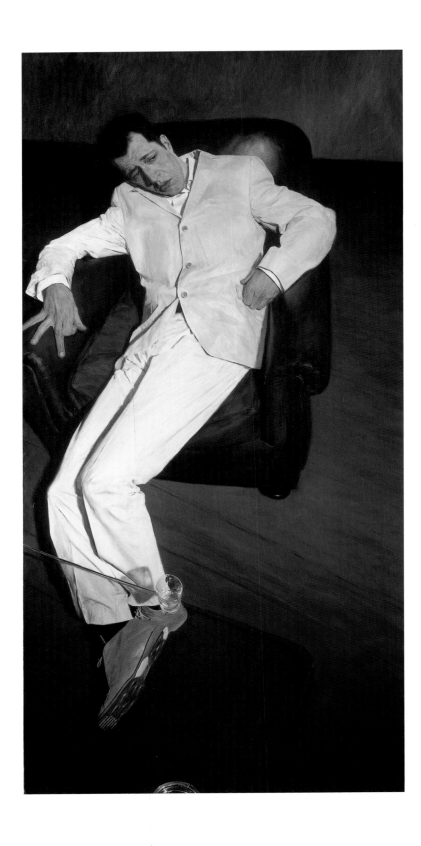

Stephen Conroy
**The Man from
Turtle Island, 2002**

Oil on canvas
1830 x 1220mm
(72⅛ x 48⅛")

Stephen Conroy's style echoes that of the Old Masters and he pays close attention to the use of light and shade in his pictorial representations. *The Man from Turtle Island*, a slightly enigmatic title for the work, depicts a formally clad man in an awkward pose.

His upward gaze is ambiguously searching, pleading, despairing, or perhaps just whimsical. His hands, hidden behind his back, might reveal more of the sentiments of the situation, but as they are, they reveal nothing. Conroy often depicts his people in formal poses,

and sometimes his scenes recall an Edwardian era. But perhaps most of all, it is the pensive nature of his subjects, as in this portrait, that typifies his work.

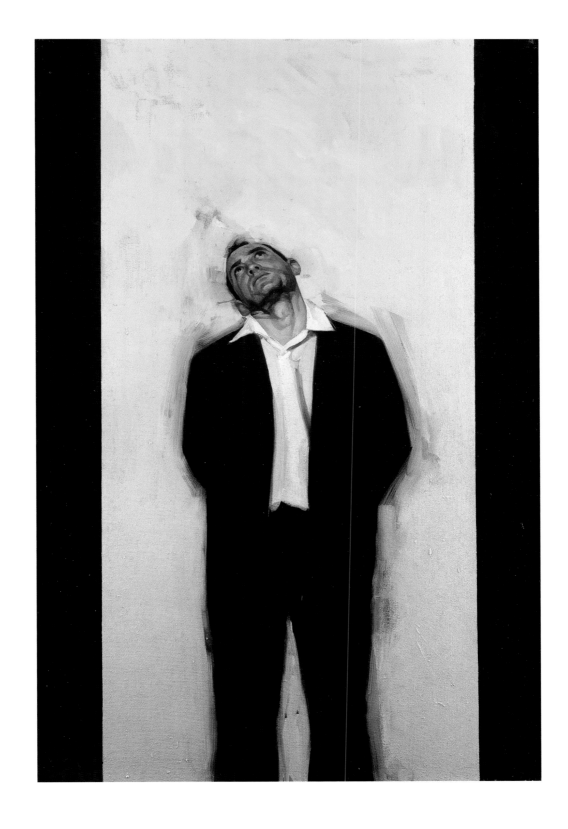

'I am interested in
the paradox between
identity and uniformity,
in the power and
the vulnerability
of each individual
and each group.'

Rineke Dijkstra
Shany, Herzliya, Israel,
August 1, 2003

C-print
1260 x1070mm
(49⁵⁄₈ x 42⅛")

In this series of portraits, Dijkstra photographs young men and women who have recently enlisted in military service. Shany is photographed at the induction centre in Herzliya, Israel, over eighteen months. The location prevented the artist from photographing her subjects at a leisurely pace. However, each portrait is an intimate revelation of individual identity and personal expression in the face of conformity demanded by military culture. Shany is first photographed as a smiling, gap-toothed tomboy. This final portrait, a straight-forward, mug-shot style photograph of the subject in a form-fitting military T-shirt, reveals a self-assurance that reflects a physical and mental transformation in Shany, and her passage from innocence to experience.

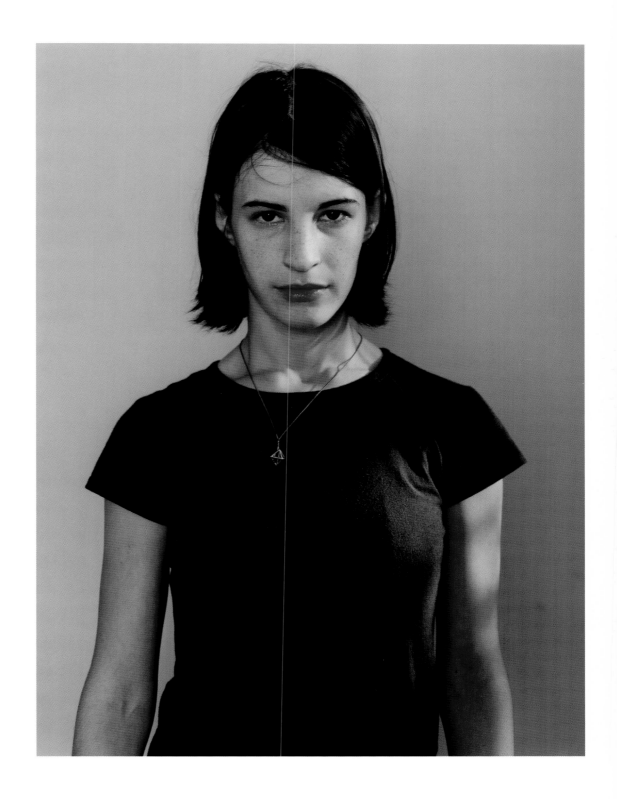

Jason Brooks
Zoe, 2003–4

Acrylic on linen
2750 x 2130mm
(108 x 83⅞")

With a subtle nod to photorealism, Jason Brooks's portraits appear from a distance to be crisply developed photographs. However, a close inspection renders them indecipherable. Brooks photographs his subjects and then paints the image using an airbrush. He employs a variety of instruments, such as scalpels and dentist drills, to accentuate the imperfections of the human complexion. The skin of his subjects is quite literally transmogrified into the skin of the painting. Brooks often portrays tattooed women, such as the subject of this painting.

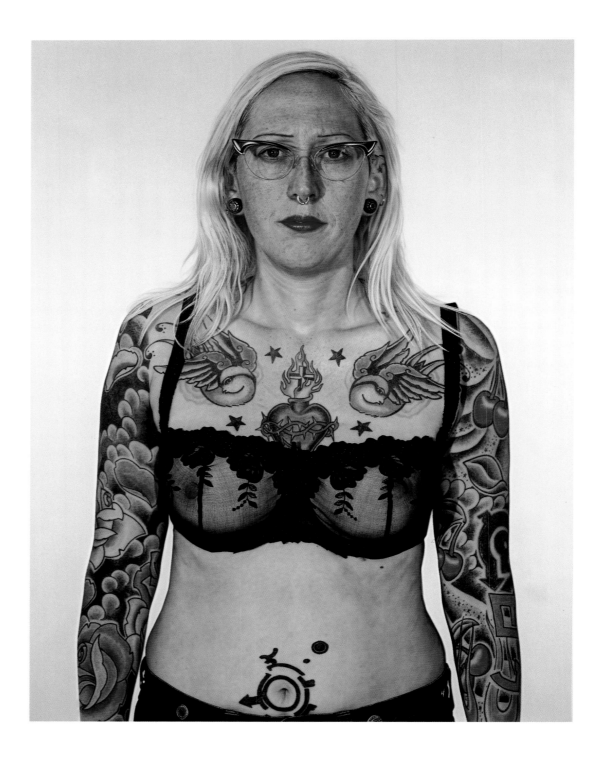

Tim Gardner
Untitled (Carmichael Standing by Rain Barrel), 2003

Watercolour on paper
203.3 x 301.6mm (8 x 11$^7/_8$")

In the style of photorealism, Gardner works from photographs of family and friends. Sometimes incorporating his native Canadian landscape, the portraits juxtapose seemingly tranquil surroundings with the turbulence of the inner lives of young men in their formative years.

In taking familiar, and sometimes mundane, situations and carefully rendering every detail of the scene in watercolour, Gardner creates a sense of mystery; fleeting moments take on a new significance. This portrait shows the awkward severity of a young man in

uniform as he challenges the viewer's gaze.

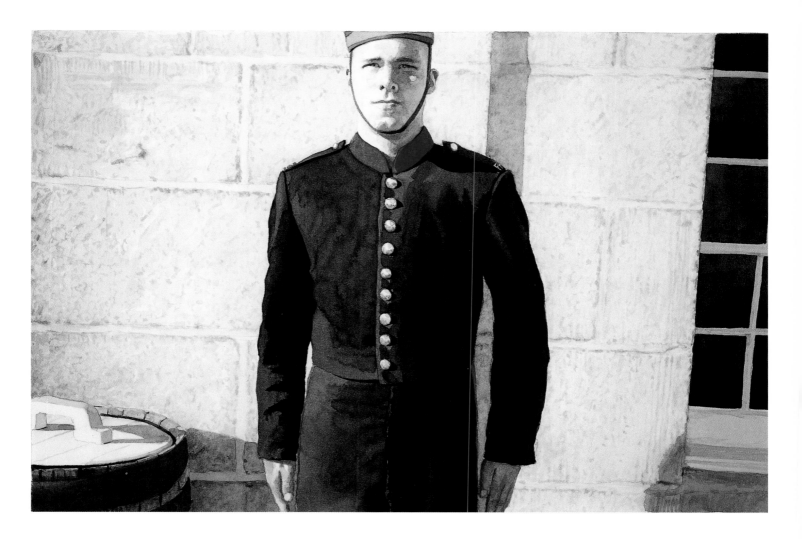

Decal, CD
Variable dimensions (maximum size unlimited) Edition of 3, AP

The one man 'collective', assume vivid astro focus, works in a variety of mediums and draws from a plethora of inspiration. This portrait of Yoko Ono is intended to be installed on the floor and can be printed to any size. avaf gleefully appropriates art, music, images, and motifs from any resource he finds stimulating, including such disparate influences as psychedelia, glam, pop, and kitsch. In this case, the final montage portrait looks as equally drawn from Brazilian carnival costumes as it does from an acid trip, or even hippie renditions of Tibetan devotional imagery.

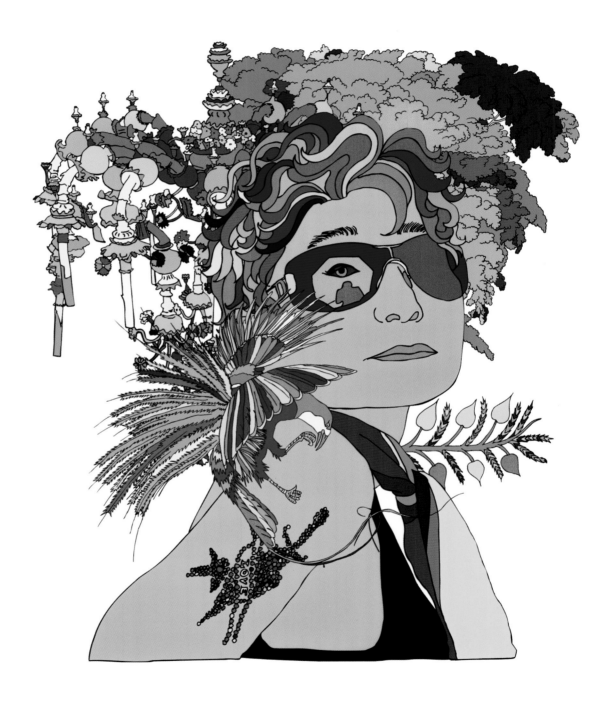

Gary Hume
Green Nicola, 2003

Gloss paint on aluminium
1800 x 1390mm
(70^{9}/$_{10}$ x 54^{7}/$_{8}$")

In this portrait, Gary Hume depicts fellow British artist Nicola Tyson. The portrait typifies his love of bright colours and adeptness in creating simple compositions. The shiny aluminium surface is bold and the process is simple, but the portrait is imbued with Hume's painterly touch. Hume's style draws inspiration from the worlds of fashion, poster design, and painting, gaining complexity from the tensions that exist between each. While the portrait might also reference certain aspects of advertising, or billboard displays, the reference is more critique than homage.

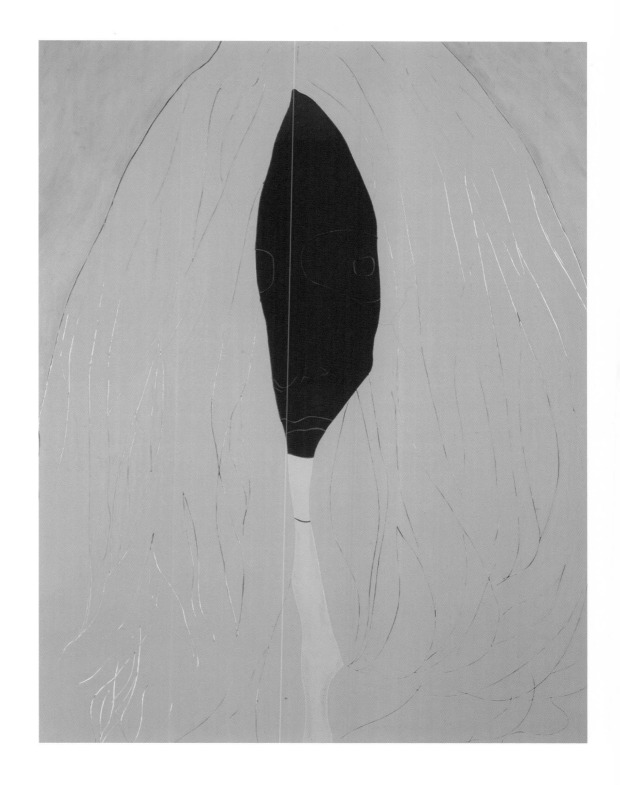

Andrew Tift
Alexander and Eun Ju, 2004

Acrylic on canvas
1127 x 973mm (44 x 38")

Tift recalls, 'Alexander wrote to me after he saw some of my work in the BP Portrait Award. He wanted a portrait of him and his then pregnant Korean wife Eun Ju in the style of Van Eyck's *Portrait of Giovanni Arnolfini and his wife*. This is a painting that I had always loved myself but it would be difficult to reflect such a painting without resorting to pastiche, so the feel had to be different. We wanted a more atmospheric, even sinister mood with the heavy chiaroscuro lighting and little pockets of light emerging from the shadows. We also wanted to echo their links with the Far East. Time after time I turn up at people's houses for the first sitting and it is immediately intimate. Within a few hours of meeting Alexander I had been all around his house and he stood naked before me in front of his fireplace.'

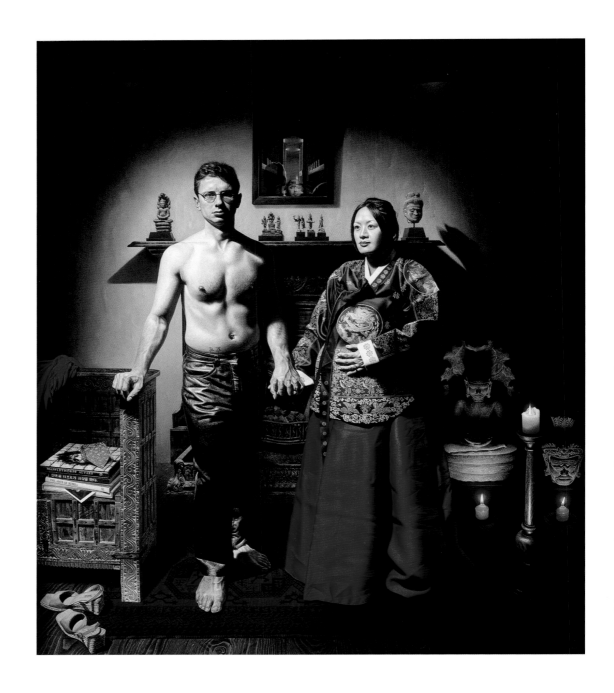

Catherine Yass
Star: Karisma Kapoor, 2000

Ilfochrome transparency,
lightbox
880 x 1310 x 12.5mm
(34 $^{5}/_{8}$ x 51 $^{5}/_{8}$")

Yass became particularly conscious of the Indian film industry while living in London's multicultural East End. She travelled to Mumbai to make this series, which depicts six of India's most popular film stars, along with four photographs of cinema interiors. Her portraits employ a bright and varied colour scheme, intensified by her use of light boxes. Viewing the light boxes as a form of sculpture, Yass says, 'light boxes also have an internal space, like the space inside us'. This portrait of Karisma Kapoor, a member of Indian cinema's Kapoor clan, reflects the expansive colour repertoire of most Bollywood films. Utilizing positive and negative images, Yass's portraits exist somewhere between reality and dreams, like the fictional world of Bollywood.

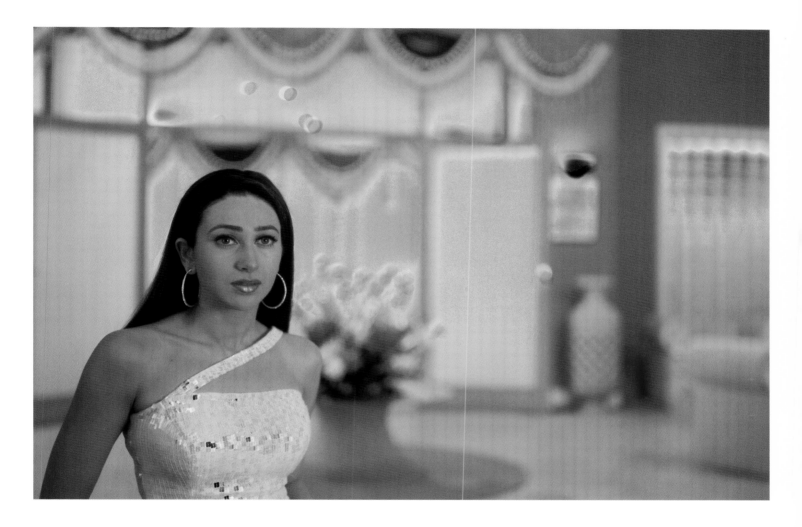

Philip-Lorca diCorcia
Head #11, 2000

Fujicolour crystal archive print
mounted onto plexiglass
1216 x 1521mm
(47 7/8 x 59 5/16")

This photograph is taken from diCorcia's 1999–2001 series 'Heads'. Tempering spontaneity with method, each photograph was candidly shot in New York City's Times Square using lighting techniques that both illuminate and isolate each 'head' amidst the hustle of the city streets. The simplicity of diCorcia's composition enables the seemingly insignificant details of each person, such as their clothing, to resonate with meaning and to reveal otherwise hidden dimensions of the subject's identity. As a result, diCorcia's brand of street photography balances the grandly anonymous with the intimately personal and allows the observer to contemplate both the nuances of mass culture and the depiction of human emotion that registers on the faces of the subjects.

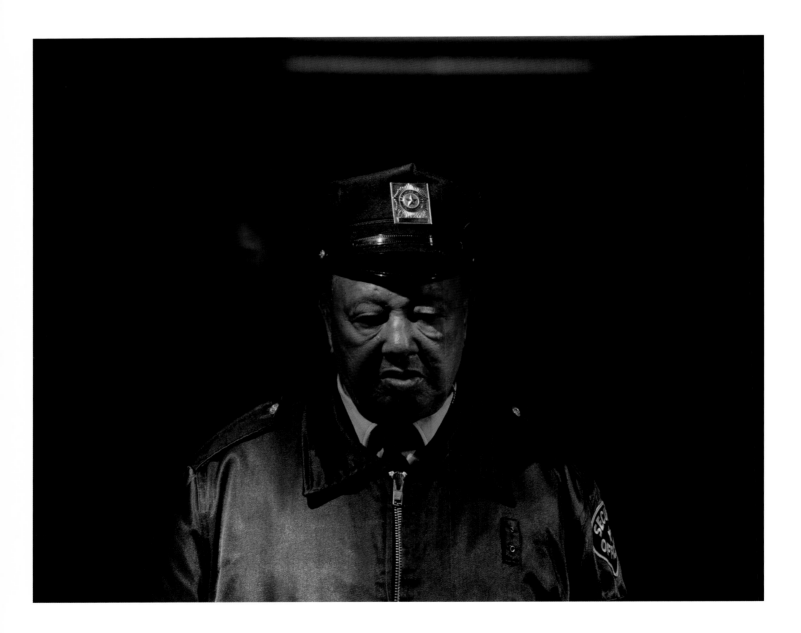

Andres Serrano
**Boy Scout John Schneider,
Troop 422, 2002**

C-print
1524 x 1257mm (60 x 49")

Serrano's recent series, 'America', from which *Boy Scout John Schneider, Troop 422*, derives, is a surprising direction for the artist who is known for his depiction of the profane, the sinister, and the taboo. Following the 11 September attacks, Serrano spent three years creating a series of 112 photographs of Americans. His selections aimed to reflect the cultural diversity of America and to represent everyone from the boy scout to the Playboy Bunny. Borrowing from the genre of advertising photography, the pictures use spots of dramatic lighting to highlight the subject. Here, the boy's ruddy cheeks and dimpled smile radiate a sense of innocence and pride. This large-scale series is a striking celebration of America's residual vibrancy in the face of adversity.

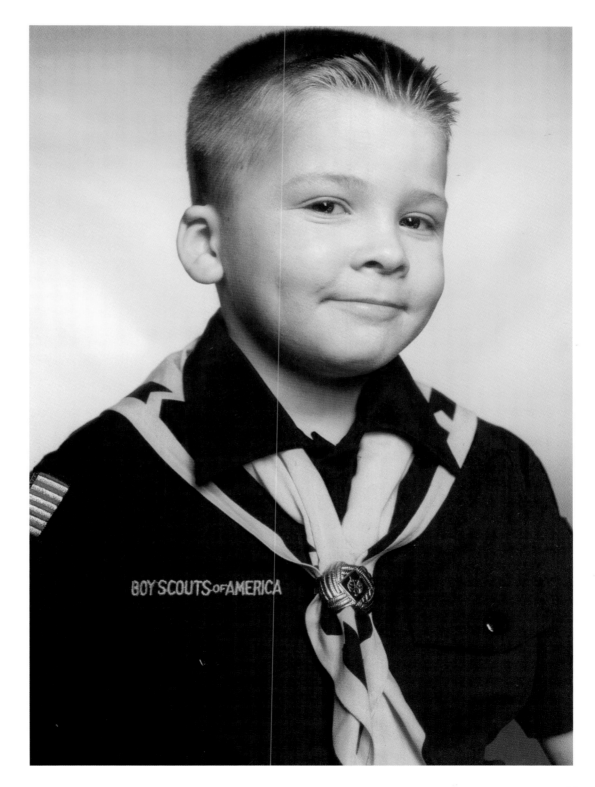

Jiří David
Untitled from the series
'No Compassion' (Bush), 2001

C-print
1000 x 1500mm
(39 3/8 x 59 1/8")

'No Compassion' is a series of portraits depicting world leaders in the midst of artificial tears. Through computer manipulation, David superimposes his own tears on the likes of Tony Blair, George W. Bush, Osama Bin Laden, Saddam Hussein and others. That these world protagonists are not actually crying becomes a moot point; the portraits are not gimmicks or satires, they are imaginative glimpses into the humanness of all larger-than-life figures. David selects world agents without judgements on their relative goodness or badness and affords them an instance of compassion. This closely cropped image of George W. Bush is a rare invitation to imagine the forty-third President of the United States in a moment of explicit weakness or empathy.

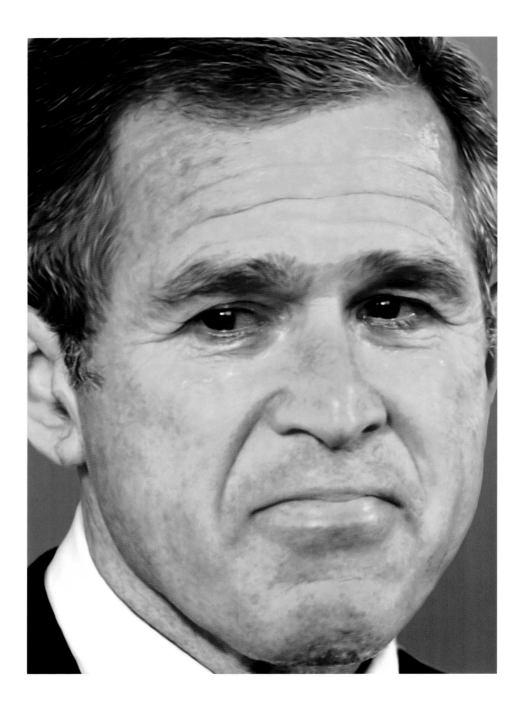

Sam Taylor-Wood
Ed Harris, from the series
'Crying Men', 2002

C-print mounted on aluminium
862 x 1117mm
(33¹³/₁₆ x 43¹³/₁₆")

This portrait of Ed Harris is from a series of works in which Sam Taylor-Wood instructed famous actors to cry in front of the camera. Her aim, she says, was to 'take these people who represent power, who represent masculinity, or represent this whole big dominating media of our life and break it down and make them vulnerable'. In asking the men to perform, Taylor-Wood prevents the possibility of a passive sitter. Instead, she elicits emotional and distinctly individual performances from the actors, displaying the fragility of both fame and masculinity. Here, Harris is caught with slumped shoulders and painful sobs, a moment of apparent introspection and despair.

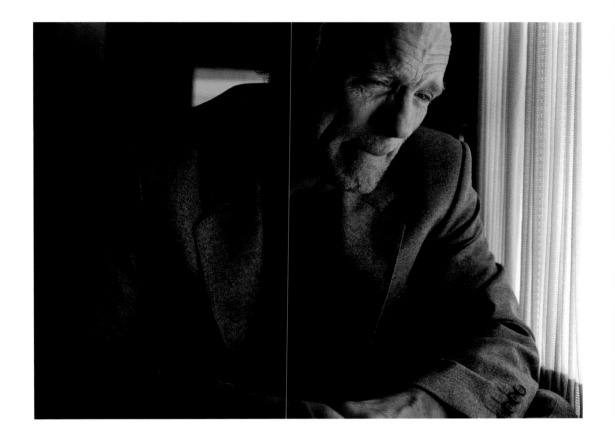

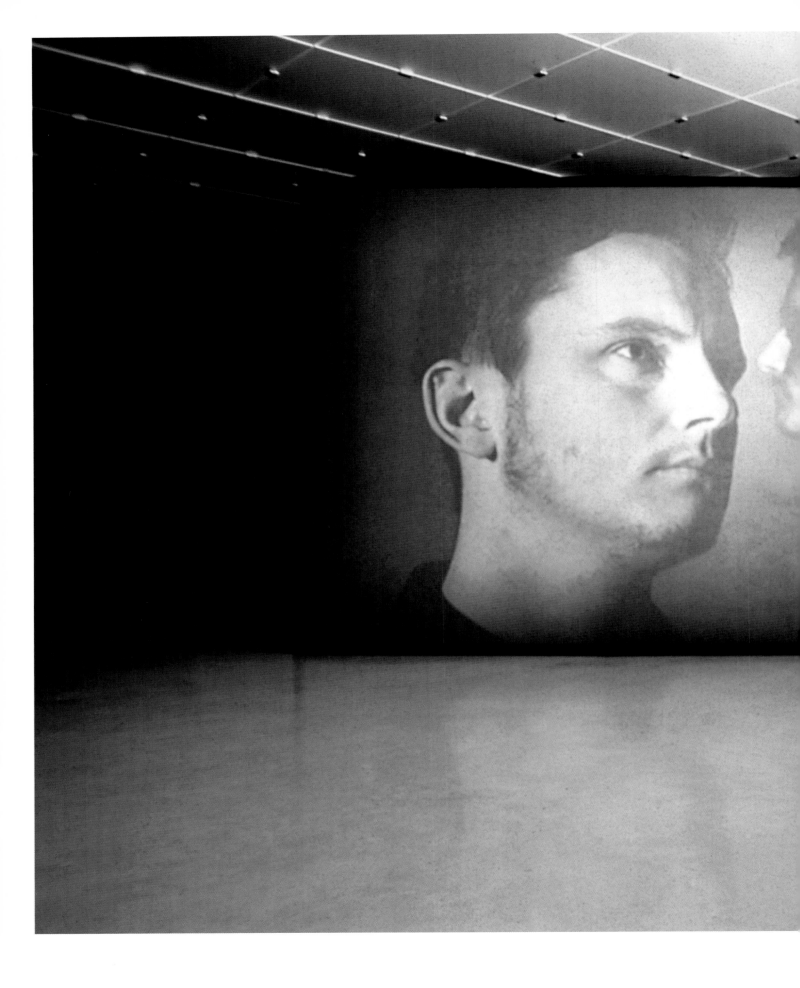

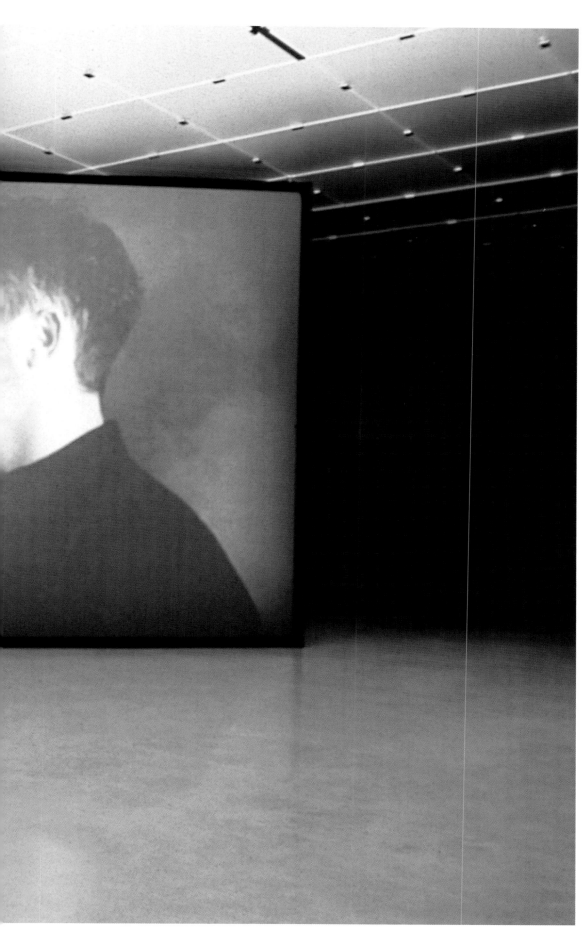

Douglas Gordon
Fog (still of installation), 2002

Double DVD projection
onto a large single screen

Inspired by James Hogg's nineteenth-century Scottish novel, *The Private Memoirs and Confessions of a Justified Sinner, Fog* tracks a man as he looks at his own shadow. In the novel, the protagonist confronts his double in the devil and the experience causes him to commit acts of evil, such as the murder of his brother. Exploring the idea of the doppelgänger, and the dialectic of good and evil, *Fog* is a projection onto both sides of a transparent screen. The camera circles around a man who looks like Gordon, but is not. The images on the two sides of the screen are out of sync, so at times the man appears to be looking at himself looking at his shadow.

Yasumasa Morimura
**An Inner Dialogue with
Frida Kahlo,
'Hand-shaped earring', 2001**

**C-print
1200 x 96mm (47 x 37 ⁷/₈")**

Morimura employs photographic techniques to reproduce his own image in the likeness of various pop stars and art-historical icons. In this piece, Morimura assumes the identity of Frida Kahlo, the acclaimed Mexican artist whose life was marked by passion and pain.

Morimura's (partial) appropriation of identity is a pointed critique on both notions of beauty and occidental conventions of art history. His subversive use of iconic figures from high-brow and low-brow culture rings with familiarity, yet is wrought with confusion.

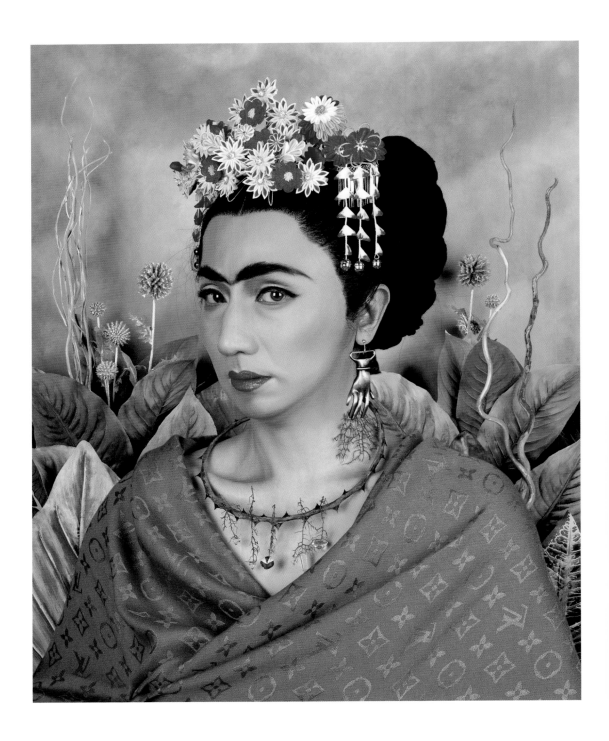

Gillian Wearing
**Self-Portrait at Three
years old, 2004**

**Digital C-print
1820 x 1220mm
(71 x 48⅛")**

This portrait confronts our assumptions of the role of self-disclosure in portraiture. In a playful twist, Wearing photographs herself donned in a prosthetic mask of her own face at the age of three. The trickery, however, is dubiously deceptive; she both *is* and *is not* herself. The mask covers the entire face, except for two eyeholes. The space that exists around the eyeholes is our one glimpse into the 'truth' of the scenario, and is revealed by Wearing's penetrating adult gaze. Sometimes dressing up as members of her family, or herself at varying ages, Wearing raises questions about memory and identity, as well as the tenuous role of photography as a vehicle of truth in representation.

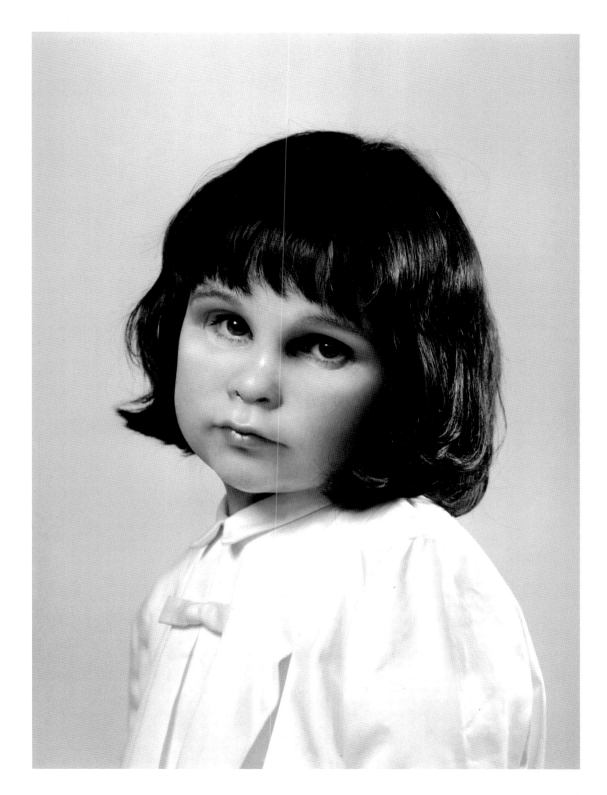

Distressed bronze
cast with gold plating
195 x 175 x 235mm
(7 ⁵⁄₈ x 6 ⁷⁄₈ x 9¼")

The basis of Emin's artistic practice is self-disclosure. In various media, Emin exposes all of the shameful, turbulent and sometimes self-deprecating moments of her existence. Establishing a career out of these tabloid-worthy revelations, Emin is capable of moments of more serene introspection, as demonstrated by the self-portrait *Death Mask*. Though morbidly titled, *Death Mask* captures Emin's familiar face in the depths of tranquillity, eyes closed and facial features relaxed. With its beautiful surface, *Death Mask* suggests a kind of passive resistance to, and acceptance of, the trials and tribulations of life.

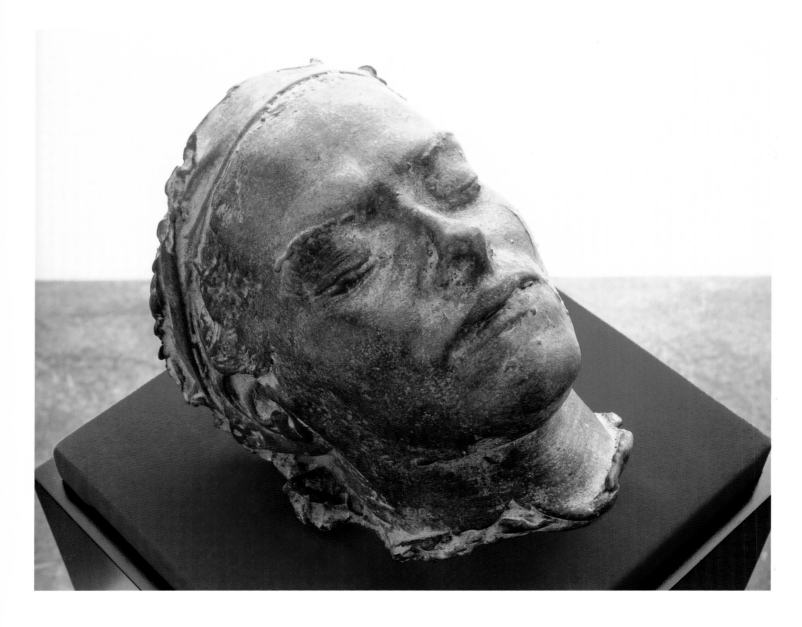

Don Brown
Yoko XII (Twin), 2004

Jesmonite and acrylic paint
930 x 390 x 260mm
(36⅝ x 15⅜ x 10")

Don Brown is interested in the imitative capacity of art. Playfully confronting issues of scale and material, he makes sculptures of himself and his wife, Yoko, in varying sizes. While maintaining the body's relative proportionality, Brown reduces his sculptures to seventy-five and sometimes fifty per cent of their normal size. The result is confounding: despite their pure white exterior, the sculptures have an anthropomorphic and obsessive quality. Brown's rendering of Yoko is often vaguely sexualised and despite the influence of classical sculpture, Yoko remains firmly in the present. In *Yoko XII (Twin)*, the two Yoko figures adopt a languid pose that defies the rigidity of the medium. Their casual embrace is tender, emotive and vulnerable.

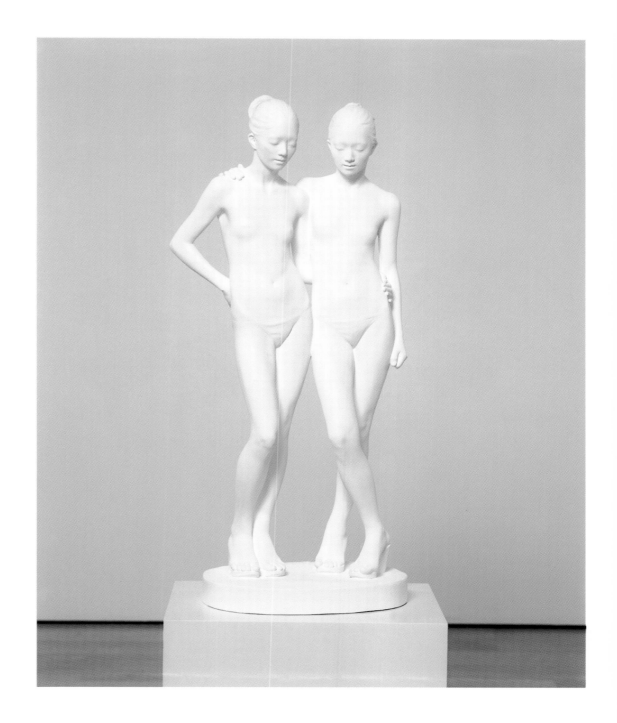

Kate Moss, 2003

Daguerreotype
215.9 x 165.1mm (8 x 6")

Highlighting the daguerreotype's capacity for detailed representation, Close's portrait of fashion icon Kate Moss is a paradox of perception. On the one hand, Moss is represented with absolute clarity; freckles, pores and tangled hairs are all plainly visible. On the other hand, the portrait is a complete departure from familiar images of the waif-like beauty, airbrushed to perfection in glossy magazine spreads. Close's use of the short focal length of the camera lens makes the face appear to emerge from a dense background, creating a haunting apparition of the well-known model. Close explores the potential to make the familiar strange, and therefore to separate the self from the portrait.

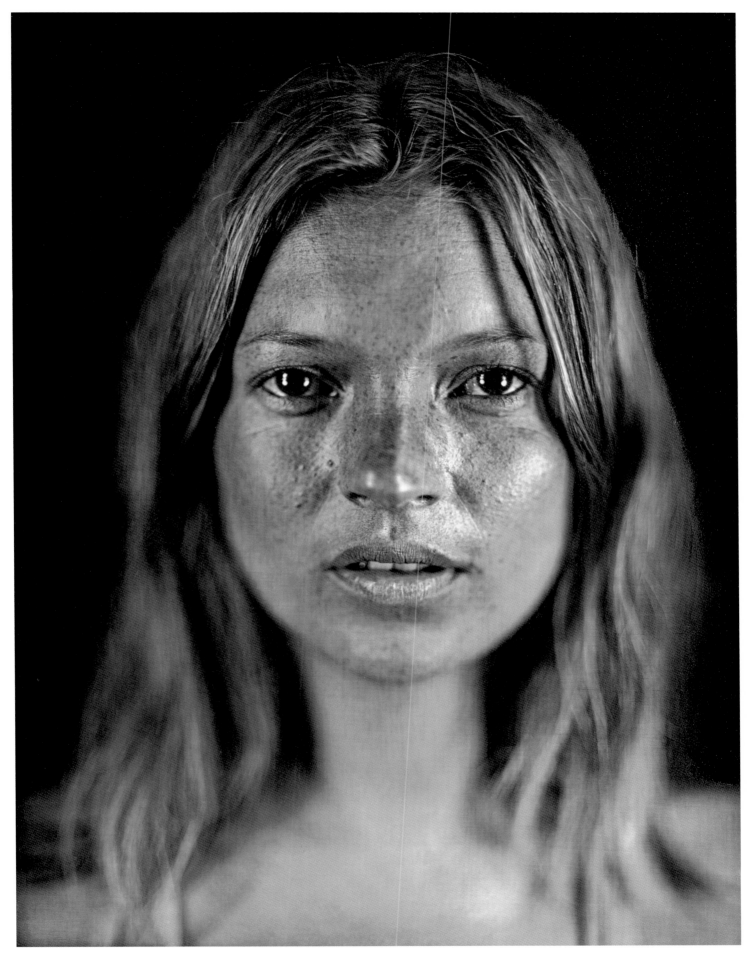

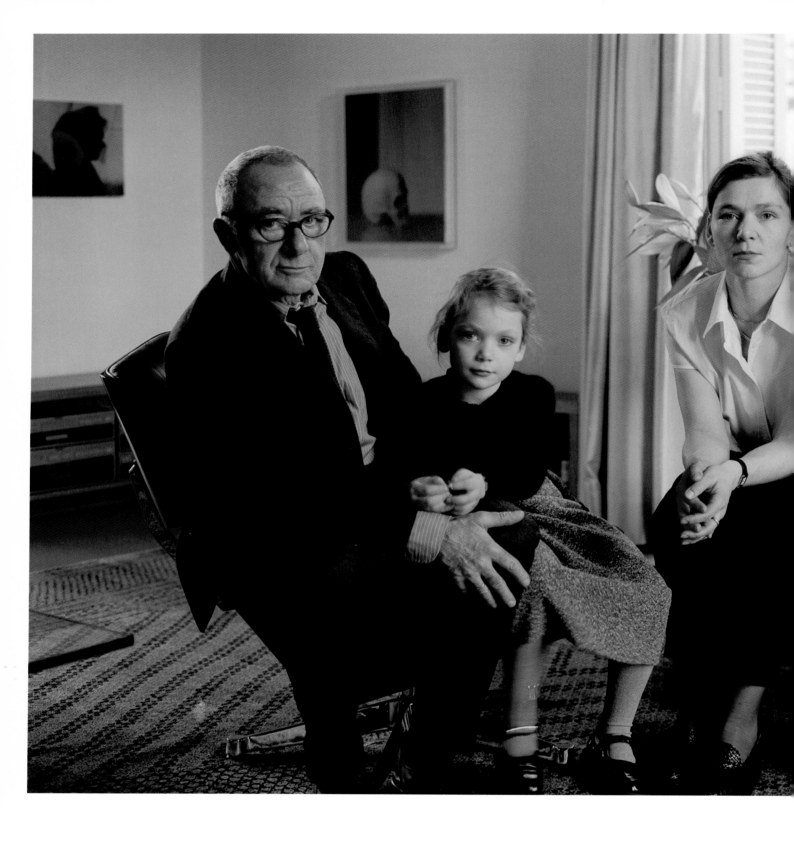

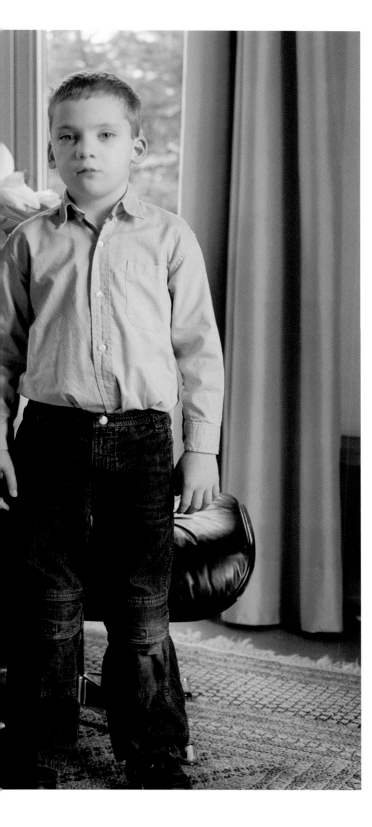

The Richter Family II,
Cologne, 2002

C-print plexi-mounted
1020 x 1614mm
(40$^{3}/_{16}$ x 63$^{9}/_{16}$")

Thomas Struth's photographs
bring into focus more detail
than the naked eye can observe.
As such, they are as much
about the act of looking, as
they are about what is being
looked at. This portrait of the
Richter family is typical of
Struth's family portraits. Here,
Struth's objective gaze does
not offer a narrative for the
image, but rather slows down
time for the viewer's own
inspection of the situation.
Gerhard Richter, once Struth's
professor at the Academy
of Fine Arts in Düsseldorf,
shared with Struth an interest
in the relationship between
photography and painting,
and also the practice of
creating images in a series.
In this portrait, the intensity
of Richter's eyes give away
a sense of his complex
intellectual relationship with
the artist.

Weng Peijun
Academic Degree from the series 'Great Family Aspirations', 2000

C-print

Using the style of propaganda posters from the Cultural Revolution, Weng Peijun explores contemporary China as it searches for identity in a moment of transition. Weng says his work 'debates unconscious utopian tendencies,' or the desire to achieve more than is actually feasible for the majority of the population. However, he also recognises that many Chinese citizens are slowly realising their dreams. To make his portraits more realistic, Weng often photographs his own family. Here, the family poses as a family of three, a reference to the after-effects of China's one child policy. They wear graduation clothing more common to Oxford or Cambridge universities, than China, a fact that reflects the tension between intellectuals and the Red Guard.

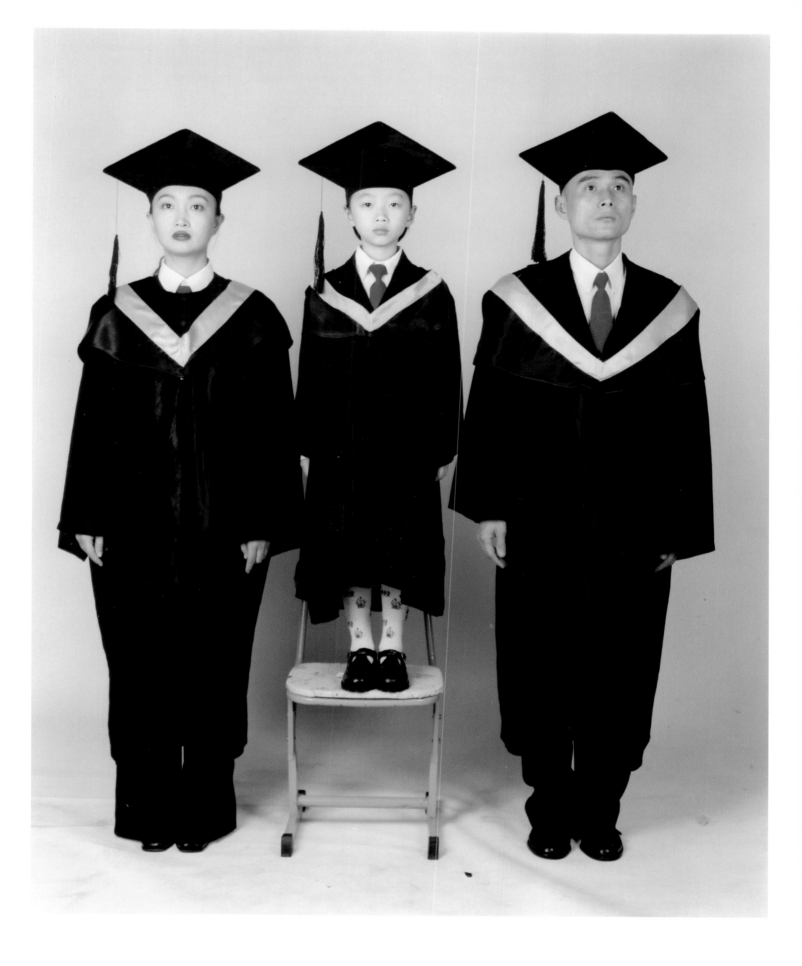

Malick Sidibé
Vues de dos, 2001

Gelatin silver print,
painted glass frame
215.9 x 152.4mm (8 x 6")

In his most recent series, Sidibé takes portraits of the backs of people. This practice reflects the Muslim tradition that discourages images of the self. However, Sidibé's compositions investigate more than the human form. His subjects wear heavily patterned batiks, and sometimes the studio floor and background are lined with different African fabrics. As a result, the pictures become semi-geometric abstract compositions. Although originally intended for an African audience in Mali, Sidibé's work is now an important compilation of experience for international viewers.

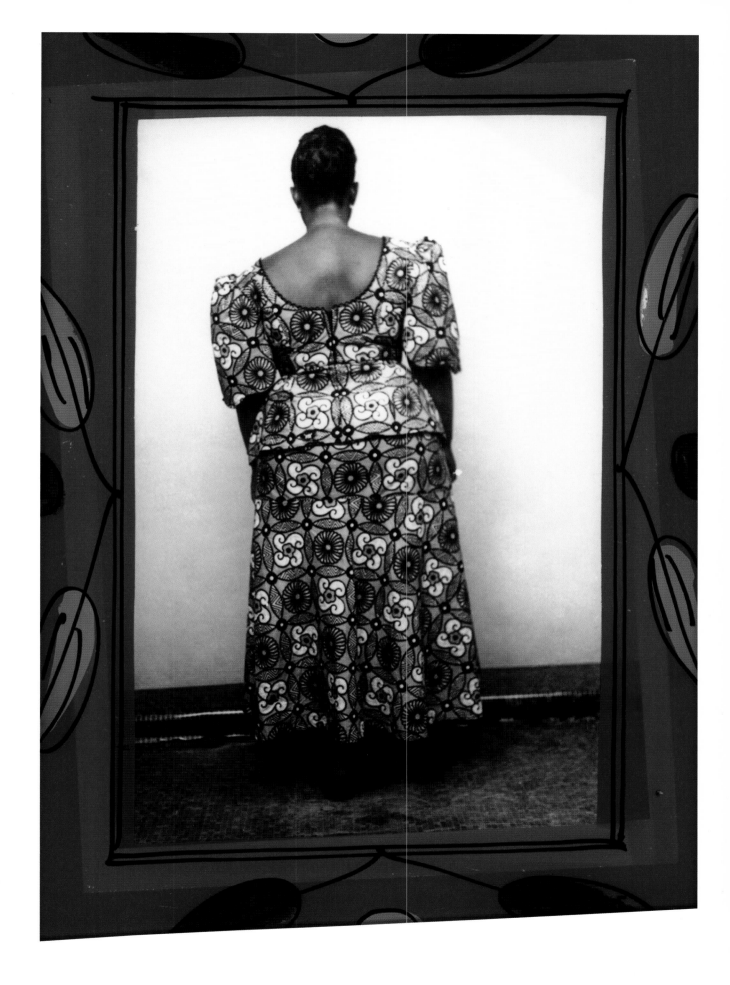

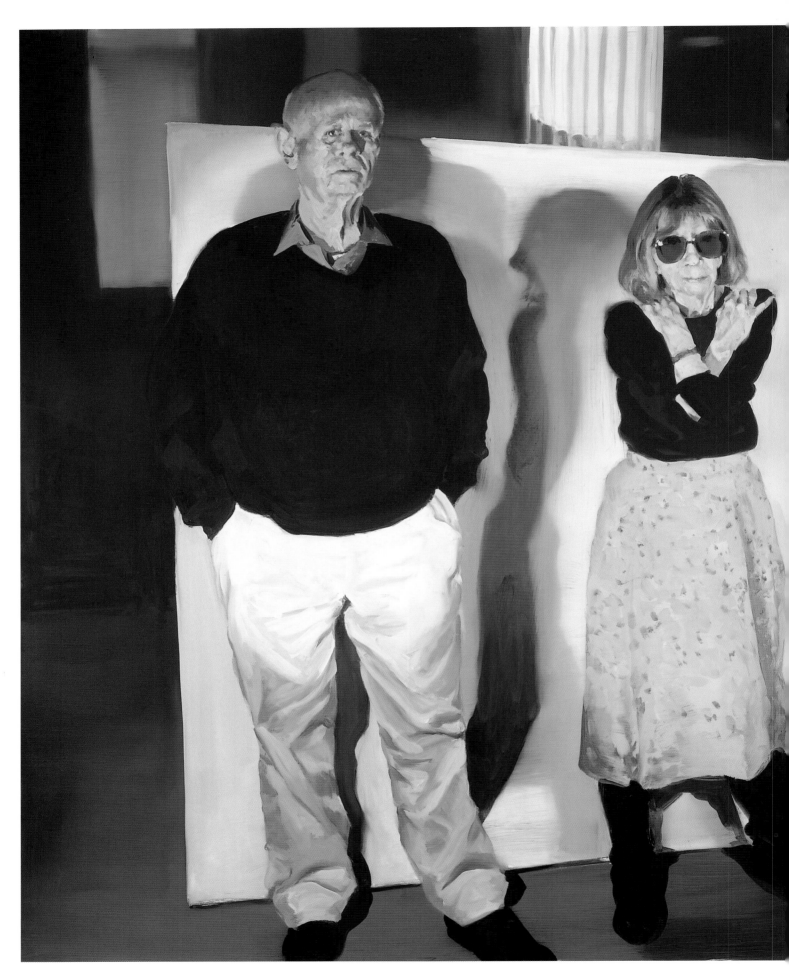

Eric Fischl
Joan and John, 2001–2

Oil on linen
1780 x 1900mm (70 x 75")

Eric Fischl is most famous for his paintings of American life, often in suburban settings with sexual or psychological overtones. Over the years he has also made portraits in which the viewer is encouraged to explore the overlap of the real and the fictional. The portrait *Joan and John* is of the late writer John Gregory Dunne and his wife, the great American essayist and novelist, Joan Didion. The genre of the portrait, at its most simply stated, is a way of honouring important players of an era. It is a means of acknowledging them and to making monumental their moment. Fischl's portraits, for the most part, are of people that he admires who may also happen to be his friends: those who have not only enriched his life but have contributed greatly to the texture and quality of cultural life.

'I'm always striving
for that magic moment
when paint becomes
an illusion of reality.'

Tai-Shan Schierenberg
Seamus Heaney, 2004

Oil on canvas
967 x 915mm (38 x 36")
Acquired by the
National Portrait Gallery,
London

Schierenberg was commissioned by Queen's University Belfast to create this astute rendition of Irish poet and Nobel Laureate, Seamus Heaney. Often compared to Lucian Freud, Schierenberg uses paint to depict flesh in immense detail. He works with his sitters for two or three sittings, making oil sketches, and then painstakingly finishes the details in his studio, with the use of photographs. Schierenberg says, 'It is not until the fourth or fifth attempt at painting a subject that I feel I may have begun to capture their real essence as people.'

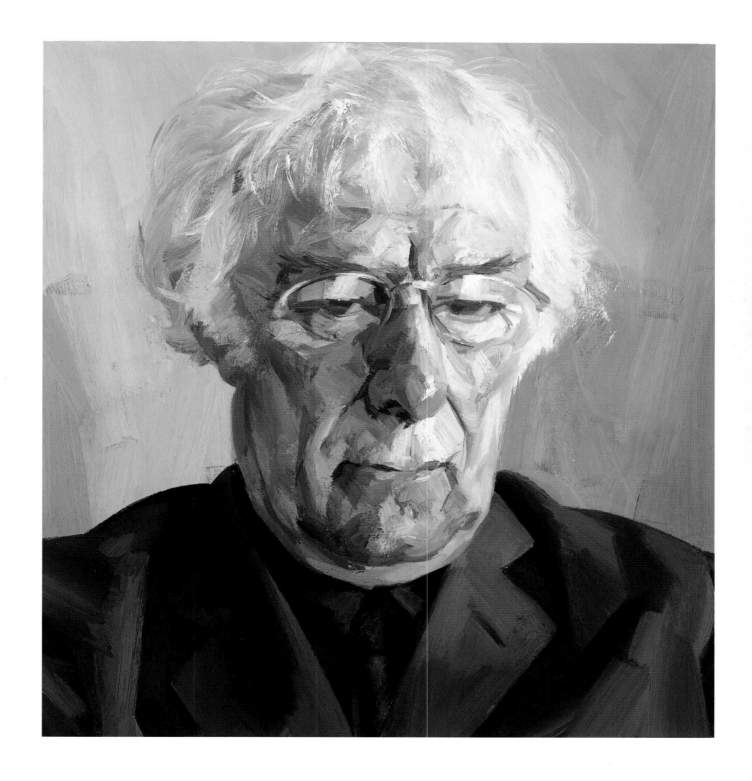

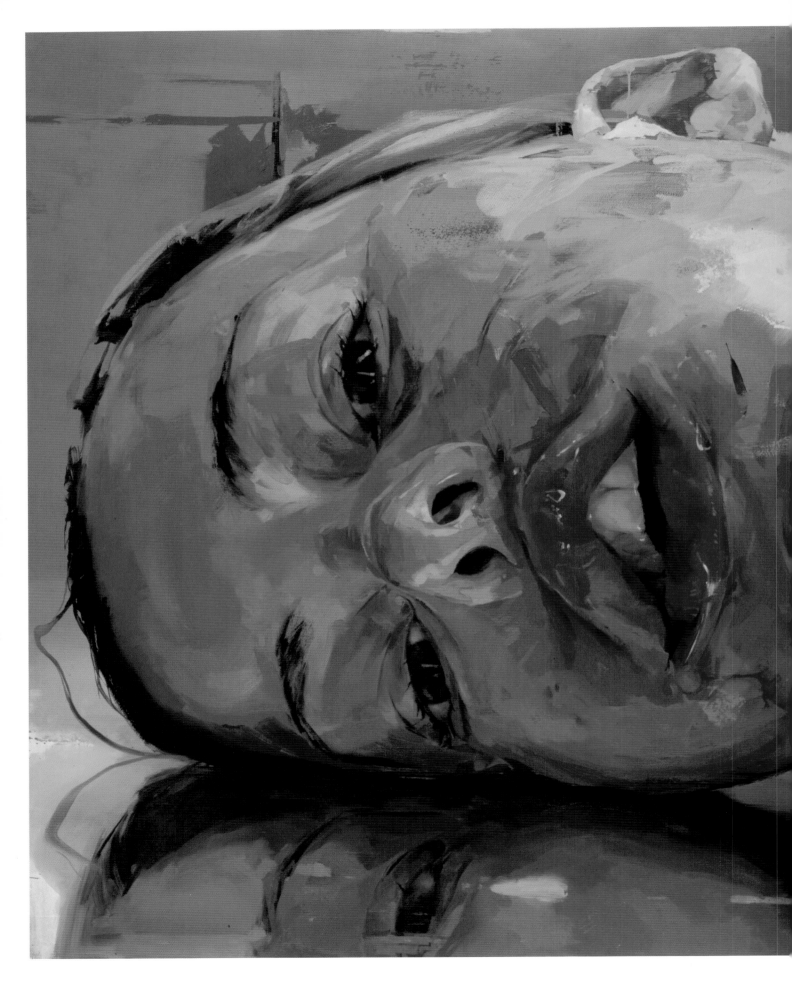

Oil on canvas
2133 x 2439mm (84 x 96")

Reverse demonstrates Saville's skill at using her own body as a prop. The painting is part of a sequence of self-portraits, all of which came out of the artist's exposure to plastic surgery in New York City. During this time, Saville witnessed the manipulation of the human body, and subsequently sought to incorporate a similar quality in her work. In *Reverse*, 'The flesh becomes like a material,' Saville says, which allows her work to retain its characteristically raw, emotive style. 'I do hope I play out the contradictions that I feel, all the anxieties and dilemmas,' Saville comments. 'I see it as empowering that I manage to use my body to make something positive, whether I like it or not.' It is with both this positive attitude and her dedication to a truthful portrayal of the human condition that Saville approaches her work.

Tony Bevan
Alfred Brendel, 2005

Acrylic on canvas
756 x 670mm (29¾ x 26⅜")
Commissioned by the
National Portrait Gallery,
London

Tony Bevan's portraits combine powerful physicality with psychological enquiry. Lines map the surface of the subject, resembling the flow patterns in Byzantine portraits, as well as penetrating deeper. The cropping is characteristically severe, intensifying the presence of the subject. In Bevan's portrait of the famous pianist Brendel the bold area of black may suggest a grand piano, but it is principally a framing device that concentrates attention on the sitter. Alfred Brendel is one of the world's greatest musicians, renowned for his interpretations of the works of Haydn, Mozart, Beethoven, Schubert, Brahms and Liszt.

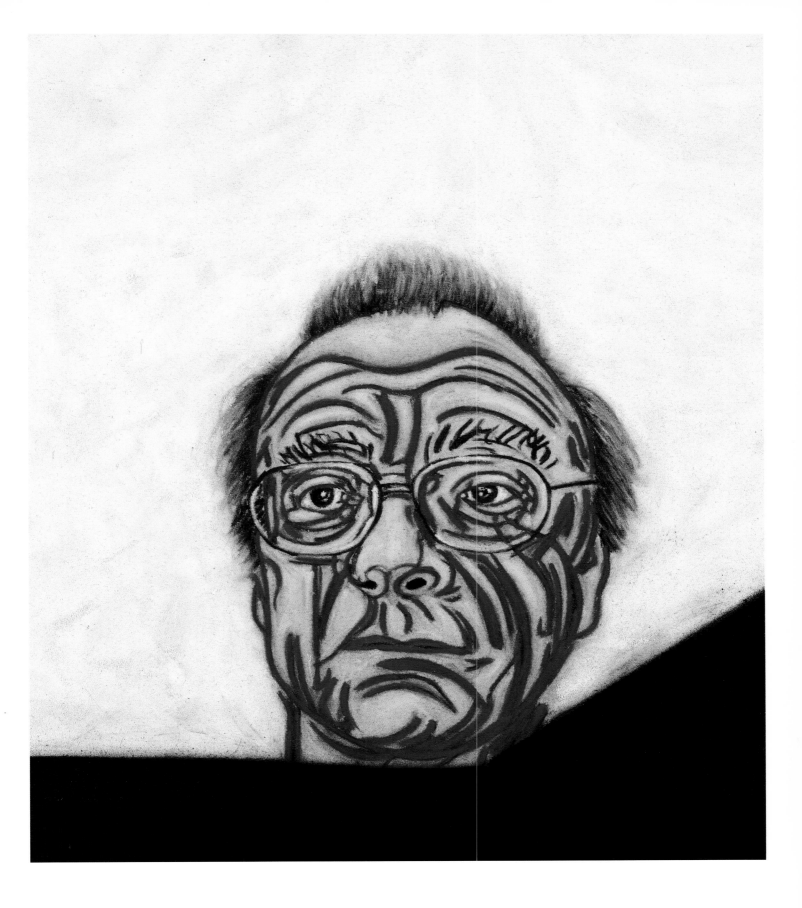

Head of Jake, 2002–3

Oil on board
508 x 457mm (20 x 18")

The portraits that Frank Auerbach paints are of family members and close friends. This is a portrait of his son Jake. The thick impasto paint reveals the movement of Auerbach's brush stroke and palette knife. Known for his heavy application of paint and his obsessive desire to rework a painting, Auerbach says a painting is finished when it 'stands up and takes on an existence of its own. It just stands there and looks at you, and you think, "I can't fiddle with this, it's got nothing to do with me".' Somehow, through the chaos of vibrant colours and bold markings, a strong outline of facial features emerges. The portrait is visually striking, yet also thoughtful and introspective.

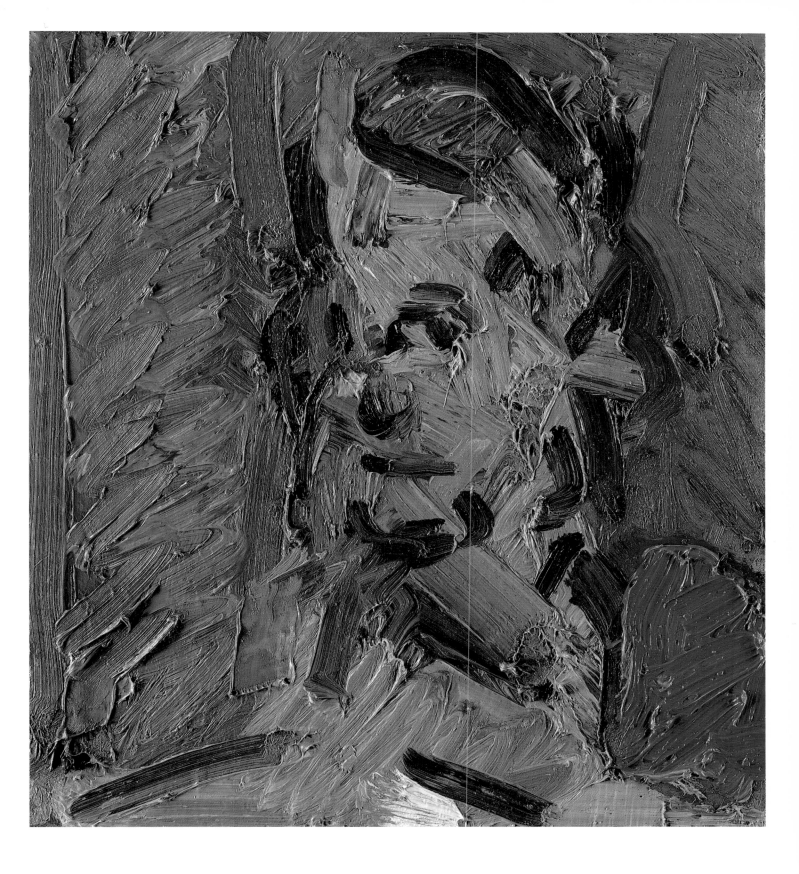

'Faces are the most
interesting things we see;
other people fascinate me,
and the most interesting
aspect of other people –
the point where we go
inside them – is the face.
It tells all.'

David Hockney
Peter Goulds Standing, 2005

Oil on canvas
1212.9 x 908.1mm (47 x 35")

David Hockney has been engaged with portraiture throughout his career. His self-portraits and portraits of his family and friends represent a visual diary of his life. Hockney's creative development and concerns about representation can also be traced through his portrait work. This portrait of his Los Angeles dealer, Peter Goulds, is one of a series of full-length standing figures produced entirely from life in 2005. These paintings are the culmination of many of Hockney's preoccupations with the painted portrait over the past fifty years. They follow on from a series of complex double portraits in watercolour also produced from life in 2002 and 2003.

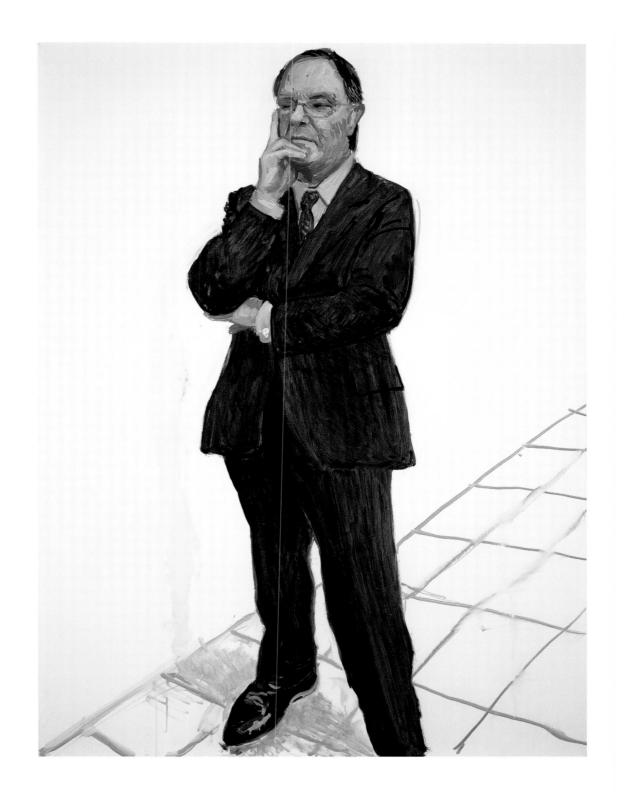

'I look at the hidden parts,
which cannot be seen
by the outside gaze.
I work in the "space" of
a canvas with its defined
boundaries with direct
marks and colours.
I add in objects to the
painting, props which
can be seen as
metaphors for life.'

Lucy Jones
Asleep, Seeing, or Dead, 2000

Oil on canvas
2185 x 1570mm
(86⅛ x 61⅛")

Often meeting the viewer's gaze straight on, Lucy Jones's self-portraits are unabashedly honest. Jones sometimes describes herself as feeling 'divided' because the left side of her body functions better than her right side. In this self-portrait the canvas is divided into two, to reflect this tension. Jones's figures are disjointed and sometimes contorted into strange positions, as if the boundaries of the canvas are the only things that prevent them from toppling into real space. Painting herself in this manner allows Jones to analyse the misfit in all of us. She says, 'Painting is like slowly taking bits of myself out of a box and beginning to examine them.' Despite the awkward placement of the figures in this portrait, its rich, energetic and other-worldly palette creates a strong and arresting presence.

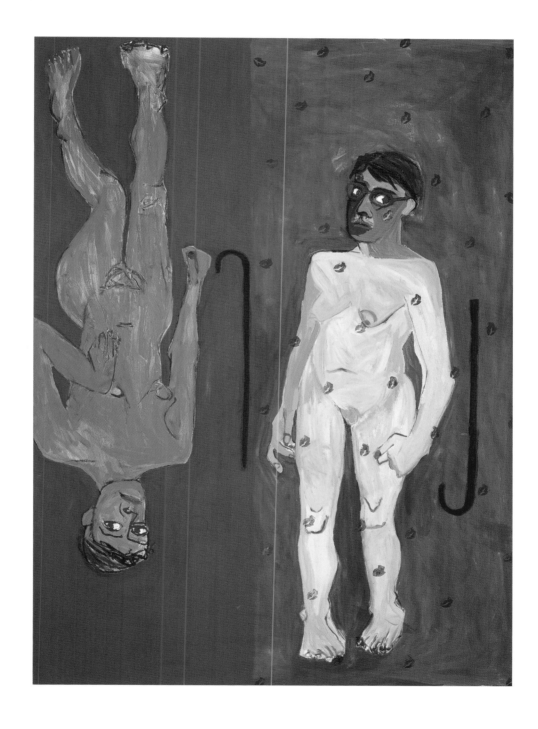

Maggi Hambling
Michael Jackson, 2004

Oil on canvas
965 x 915mm (38 x 36")

Hambling's portrait of the 'King of Pop' was originally intended to be part of the Royal Academy's *Summer Exhibition.* Submitted with a note that professed Michael Jackson's innocence against child molestation charges, the portrait, however, was rejected for its politics (not its virtuosity). Hambling depicts Michael Jackson in vibrant colours and swirling brushstrokes, demonstrating her ability to show movement, in a genre often defined by its stillness. Here, the figure on the one side and the feet on the other, are arranged into a perfectly balanced composition, bursting with energy. The sense of movement in the feet is apropos for the singer made famous by his eccentric dance moves.

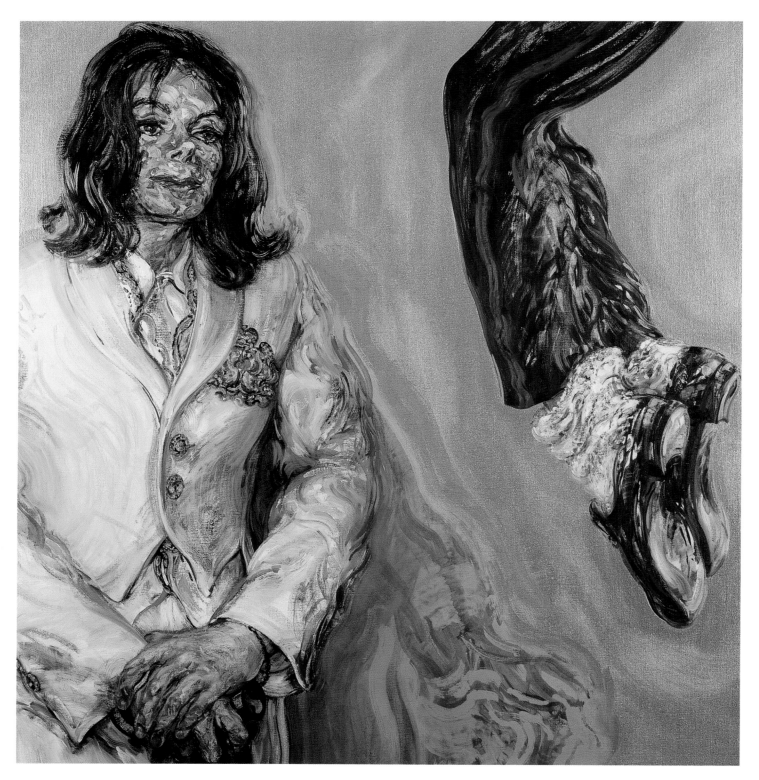

Christoph Schellberg
MC Schafter, 2002

Acrylic on canvas
1950 x 1500mm
(79 x 59") each

Christoph Schellberg paints portraits of fellow artists and stars of the art scene. He says, 'I regard everyone I have painted as sensational artists'. Of his practice of portraiture he says, 'I am an artist dedicated to painting colour and light, who just happens to have chosen portraiture as his theme.' The sitter for this piece, MC Schafter, attended the Kunstakadernie with Schellberg and became a friend of the artist. She is an architect and a founding member of the artist's group Hobbypop. The group ran a space in Düsseldorf that became an important meeting point for artists in the city. Schafter, a dynamic personality and a strong character, is also a complex person with melancholic tendencies, a duality that is represented in Schellberg's diptych.

Julian Opie
(from left to right)
Alex, bassist; Damon, singer;
Dave, drummer; Graham,
guitarist, 2000

C-prints on paper laid on panel
868 x 758mm (34⅛ x 29⅞")
Given to the National Portrait
Gallery, London by the National
Art Collections Fund with
support from the Lisson Gallery

Opie employs his signature flat style to create this portrait of Blur, England's much-adored pop band. Taking the cover of Blur's 'Best of Blur' album (2000), the portraits have become an iconic image in pop history and culture. Opie says, 'I try to make a universal symbol for each individual I draw.' Opie's ability to make recognizable portraits of well-known people through the use of simple features and heavy black lines, generated through sophisticated computer editing, has the effect of neutralizing the star status of his subjects, an effect well-suited for the band known for the 'boys-next-door' image. Opie's use of brightly coloured monochromatic backgrounds gives the portraits a lively sense of energy.

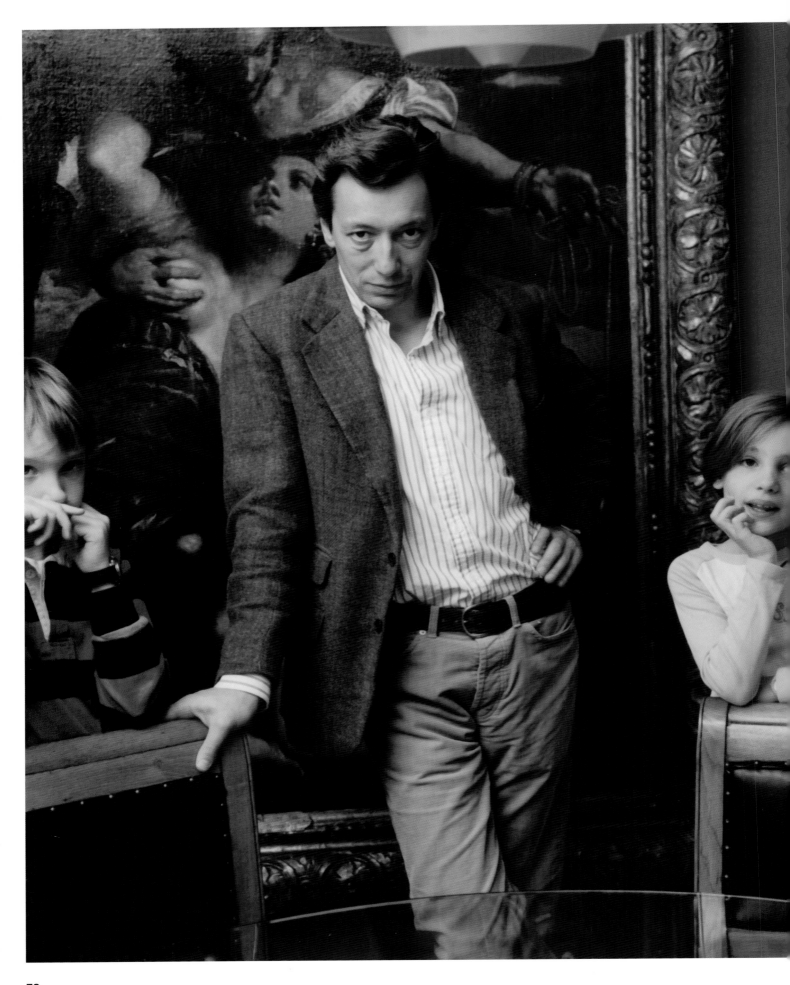

Tina Barney
The French Family, 2002

C-print
Two sizes: 762 x 1016mm
(30 x 40"); 1219.5 x 1524mm
(48 x 60")

Tina Barney's portraits
reveal the lives of privileged
people from a practised
investigator's perspective.
Often photographing family
and friends, Barney arranges
her subjects in their own
environment. They are at home,
surrounded by their objects,
such as the lavishly framed
Renaissance painting in the
background of this portrait.
In this milieu, Barney is able to
reveal complex interpersonal
relationships. Here, she captures
an affluent French family in
their home. The forward facing
countenances of the parents
are in sharp contrast to the
children's expressions, offering
a suggestive glimpse into the
private dynamics of this family.

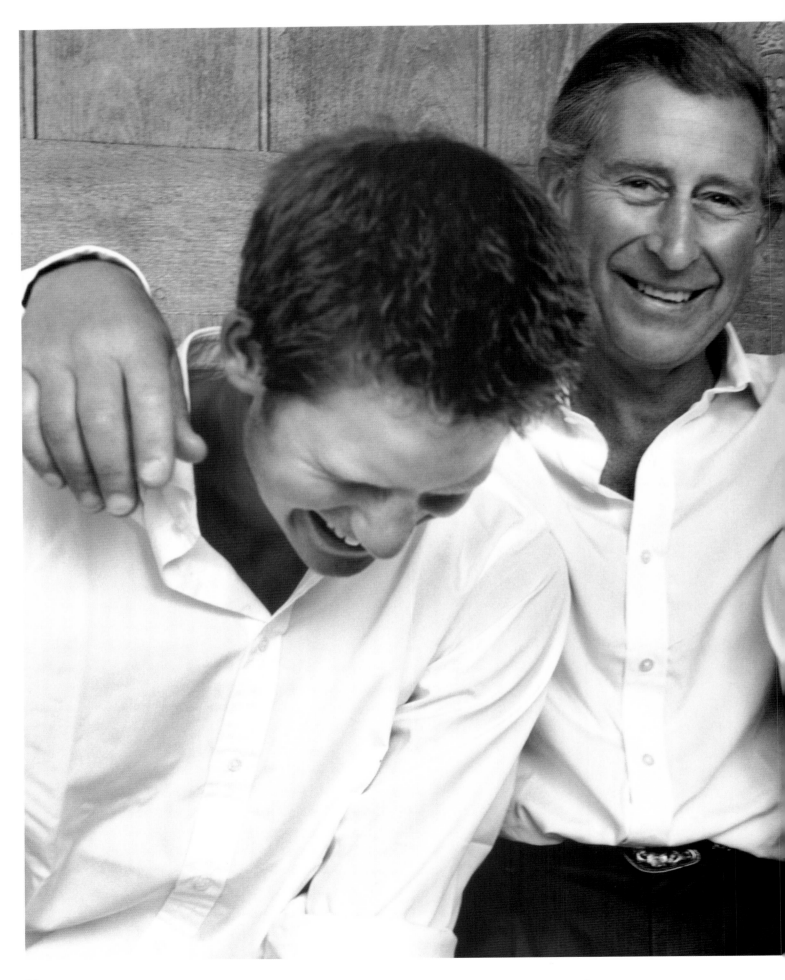

The Prince of Wales with sons Prince William and Prince Harry, 2004

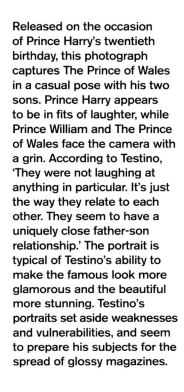

Released on the occasion of Prince Harry's twentieth birthday, this photograph captures The Prince of Wales in a casual pose with his two sons. Prince Harry appears to be in fits of laughter, while Prince William and The Prince of Wales face the camera with a grin. According to Testino, 'They were not laughing at anything in particular. It's just the way they relate to each other. They seem to have a uniquely close father-son relationship.' The portrait is typical of Testino's ability to make the famous look more glamorous and the beautiful more stunning. Testino's portraits set aside weaknesses and vulnerabilities, and seem to prepare his subjects for the spread of glossy magazines.

'I am both appropriating
and quoting this late
sixteenth-century work
in an attempt to articulate
the contemporary
poignancy of such
a private gesture and
its context through
a performative approach
to photography
and portraiture.'

Melanie Manchot

Emma and Charlie, from the 'Fontainebleau' series, 2001

C-print
1000 x 1250mm
(39³/₈ x 49")

Melanie Manchot's work investigates private situations and gestures, often depicting moments of contact between two people. The touch in *Emma and Charlie* is both intimate and staged. One of a series of four triptychs, the work takes as its inspiration, a painting by an unknown artist from the school of Fontainebleau, which is supposed to depict Gabrielle d'Estrées, the mistress of King Henry IV of France, with an unidentified partner who may have been her sister. According to popular belief, the touch alludes to the mistress's later pregnancy. As a painting and photograph, the scene is ambiguously erotic; it observes a moment when the private becomes, and is indeed intended for, the public.

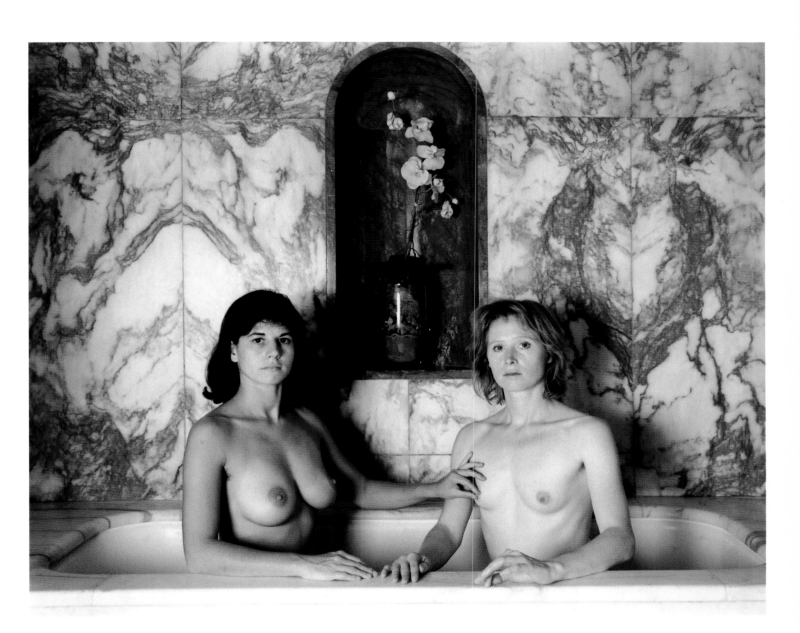

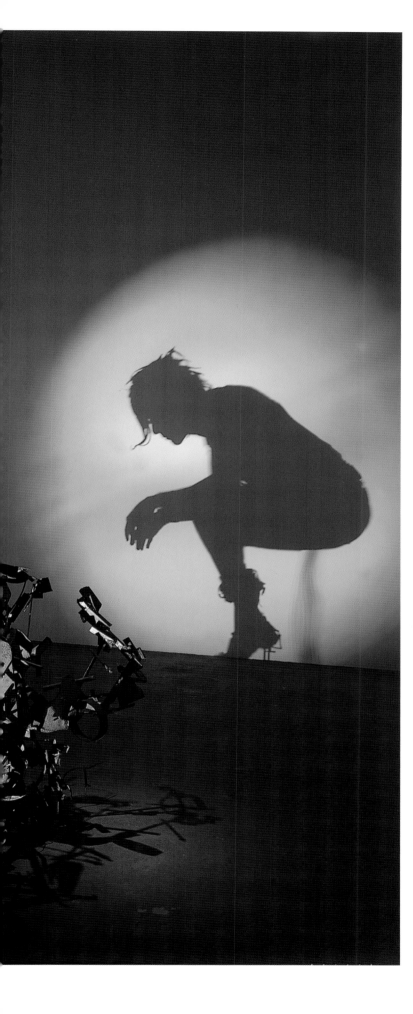

He/She, 2004

Welded metal, light projector
He: 1850 x 960 x 1480mm
(72 x 37 x 58")
She: 1140 x 1000 x 1860mm
(44⁷/₈ x 39³/₈ x 73")

Tim Noble and Sue Webster
make delicate shadow
compositions by compiling
scraps of steel rubbish into
sculpture and then casting
a projection of light onto the
object. In this case, the result
is two silhouetted forms of the
artist couple, both caught in
the act of urination. Emerging
from a punk culture, Noble and
Webster's work has a strong
element of subversion to it,
questioning the values of the
art world and the aesthetics of
modern sculpture. Their choice
of materials undermines the
authorship of the artists and
challenges consumerism in our
'throw away' culture.

Sky Tag, 2004

Four-panel piece
1500 x 1260mm
(59⅛ x 49⅝")

Long settled in London's multiracial East End neighbourhood, Gilbert & George still find inspiration in what they find outside their front door. Making multiple, large-scale photographic panels with narrow black frames, Gilbert & George's series, the 'Perversive Pictures', captures both the zeitgeist and the tension of their multicultural surroundings. In this picture, Gilbert & George use digital manipulation to morph their own self-portraits. Sometimes they split the images of themselves in half and conjoin the two disparate sides. Here, the scrawl in the background is a direct reflection of the highly stylised naming 'tags' still used by graffiti artists in the street.

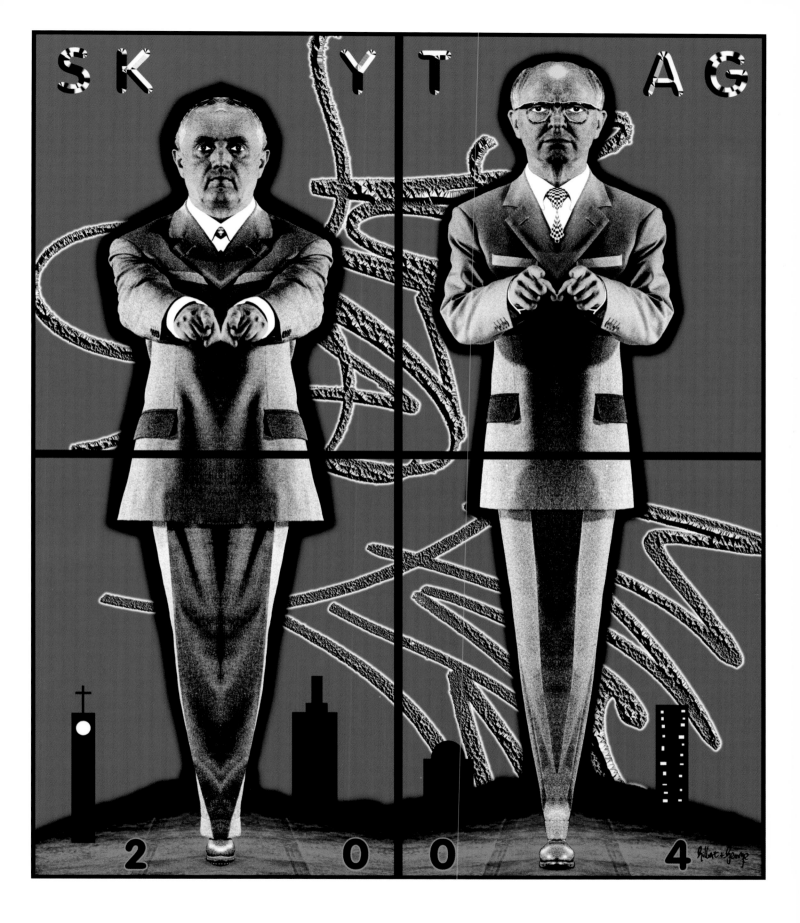

Zhang Huan
Family Tree, 2000

C-prints on Fuji archival paper
1270 x 1016mm (50 x 40")
each (9 images)

Zhang Huan's serial self-portrait examines identity in a media-saturated society. In this performative work, Huan had three calligraphers write on his face from early morning until night. He instructed the calligraphers to maintain a serious composure and to be diligent in writing, even when the text became indecipherable. Huan's blackening face followed the dwindling daylight, until it was completely covered with ink. 'I cannot tell who I am. My identity has disappeared.' Written on Huan's face is a story about the spirit of family.

The story is a well-known Chinese fable about meeting challenges with determination. Huan's serial self-portrait is a physical exploration of history and personal identity.

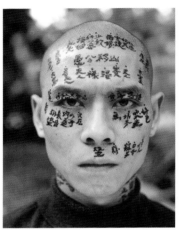
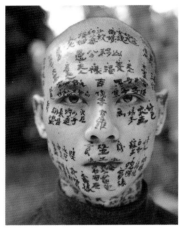
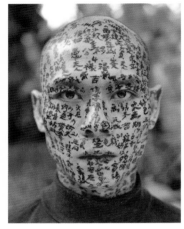
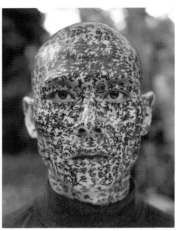
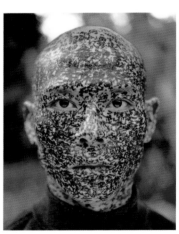
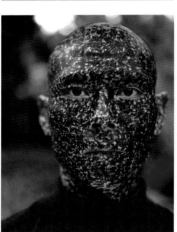
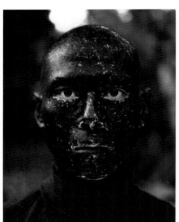
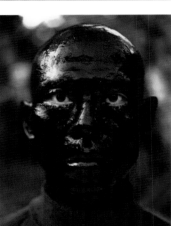

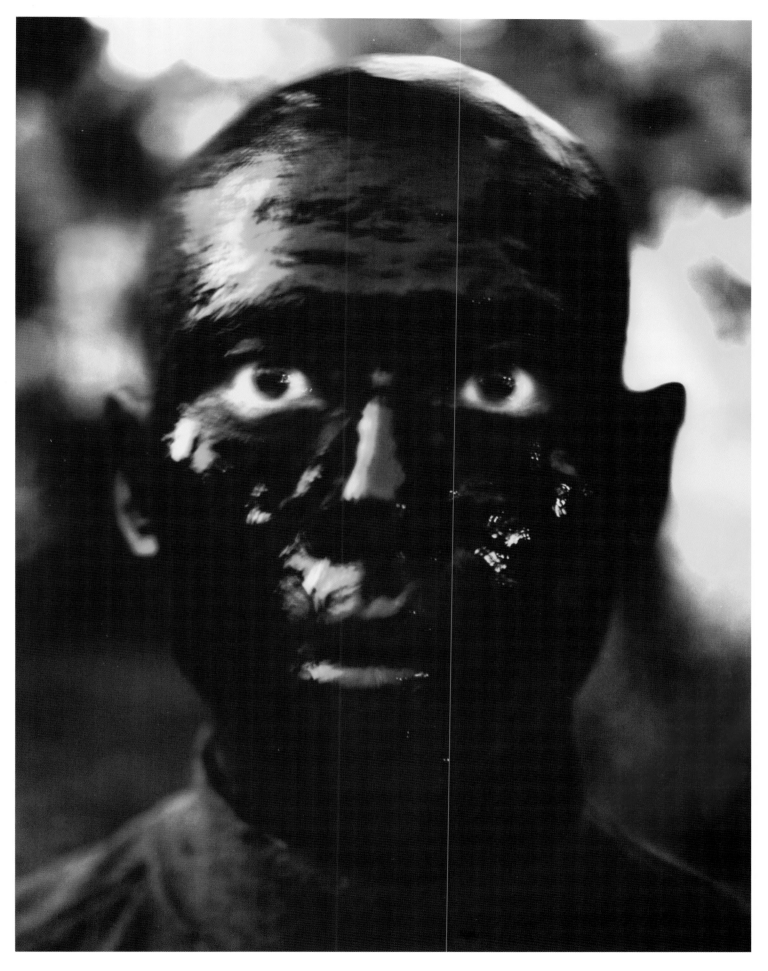

Peter Kennard
Face 9, 2002

Oil and silver-gelatin on canvas
558 x 457mm (22 x 18")

Face 9 is from a series of small oil paintings depicting anonymous people of different races, genders, and ages. The portrait's hollow eyes confront the viewer in pleading, perplexing melancholia as the face retreats into, or emerges from, a cloudy background.

The image seems to be crying out for something that is incommunicable. Kennard has painted faces without mouths, an elimination that highlights the power of language and the sometimes limited opportunities for resistance in the face of oppression. A subtler version of political expression, this portrait is perhaps a rumination on the dangers of globalisation based on military action. However, the anonymity of the image seems to speak of a universal, and perhaps unidentifiable, fear.

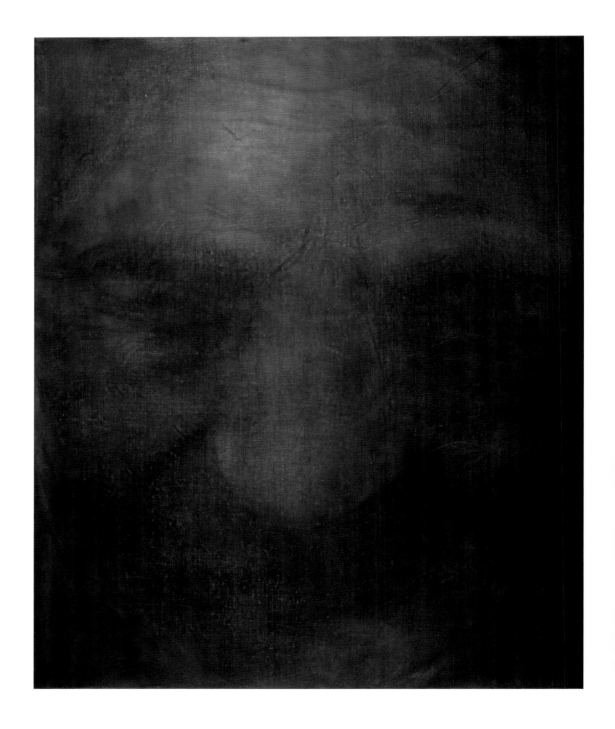

Nicola Hicks
Self-Portrait, 2001

Charcoal on brown paper
1300 x 1270mm (51⅛ x 50")

Rendered in charcoal on brown paper, this self-portrait demonstrates Hicks's affinity for base materials. The coloured nose and ruddy cheeks give the impression of harsh weather conditions but whether or not these conditions have been kept at bay is unclear. However, Hicks's chin is raised in wilful determination. The abundance of clothing in the portrait accentuates the facial features that are left exposed. Hicks often works with a combination of human and animal forms, a point illustrated here through the horn-like structures of the hat.

Catherine Goodman
My Sister Sophie, 2004

Oil on linen
1525 x 1270mm (60 x 50")

Goodman's figurative paintings convey an immense amount of detail, and an intense communication with her sitters. According to Goodman, 'I don't ever talk while I'm painting. If people can handle it, that's what I prefer. It's very interesting to spend a lot of time with people in silence.' This portrait is an intimate and honest rendition of the artist's disabled sister. Here, Goodman employs her characteristic palette of deep lilac and violet hues. The sitter's stance is neither confrontational nor evasive; her slightly contemplative countenance conveys a sense of trust, perhaps in the artist, or the viewer.

Dryden Goodwin
Jon, 2004

Red watercolour on paper
570 x 380mm (22 x 15")

Goodwin depicts people in moments of anticipation and introspection. He takes photographs of people experiencing such emotions in the public sphere, often unbeknownst to them. In doing so, Goodwin creates a fictional dynamic of intimacy between artist, viewer and subject. The plight of the subject is familiar, yet his individual story is unknown. In capturing this moment, Goodwin disturbs the linear narrative of time. The anguish of anticipation and the privacy of thought become subjects for indefinite analysis. *Jon* is a watercolour made from a photograph. The continual reworking of the image reflects the sitter's anxiety in the situation.

Francisco Toledo
Self-Portrait XXXVIII, 2000

Mixed colour intaglio
280 x 220mm (11 x 8⅝")

Francisco Toledo draws inspiration from the real and fanciful worlds, often combining the two. He borrows images conjured by the local folklore of his native Mexico and the mythology of the Zapotec culture. Toledo often uses fish, fowl, and other beasts in his works. However, his works are not limited to such inspiration, and here Toledo juxtaposes, and even morphs, unlikely components of the natural and imaginative landscapes to create this self-portrait.

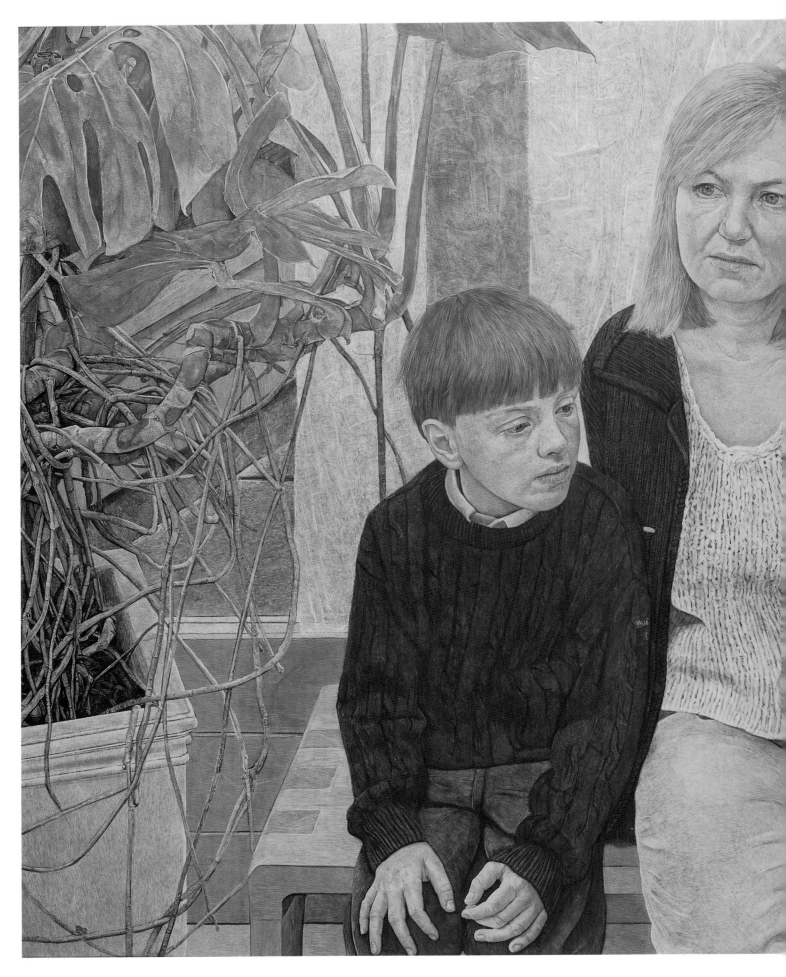

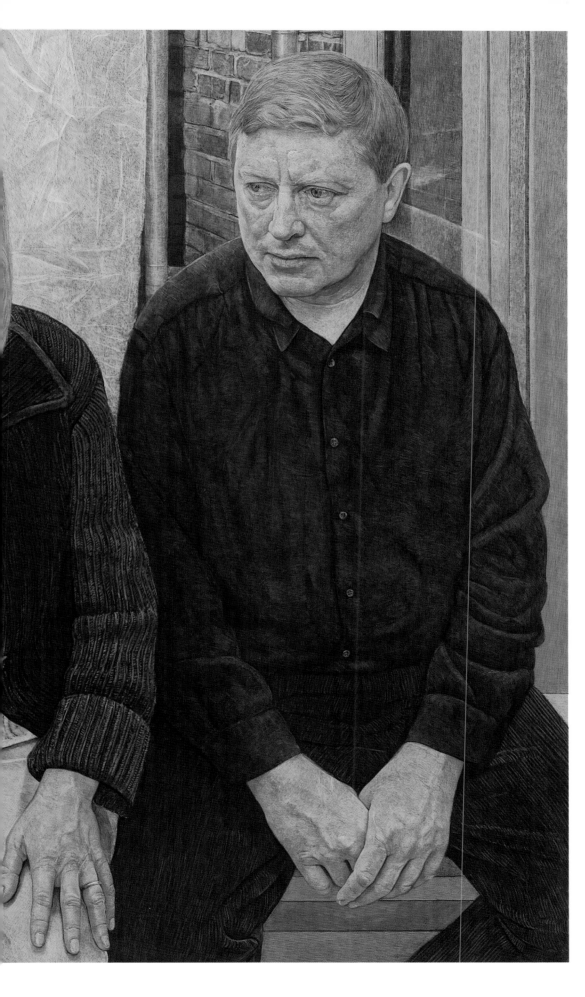

Antony Williams
Robert, Anne, and
Henry Tann, 2004

Egg tempera
1168.4 x 1708.15mm (46 x 67")

Antony Williams captures
the Tann family in silent
contemplation. Each sitter's
eyes are fixed on different
locations, suggesting
something about the dynamic
within the family. Williams's
portraits reflect his own
sensibility, while maintaining
a high degree of realism. He
says, 'I work almost exclusively
in egg tempera, which can be
a painstaking and exacting
medium, but one which allows
me to express a feeling I have
about the look of the world.
All my work is the product of
direct and intense observation,
which can produce as a
result a heightened sense
of realism, where every
surface detail is given almost
equal consideration.'

'I cannot escape,
in my observations,
from the irony that the
visual languages of
naturalism and realism
are simple codes, every
bit as artificial as the
greatest excesses of
the baroque.'

Stuart Pearson Wright
J.K. Rowling, 2005

Mixed media
972 x 720mm (38¼ x 28⅜")
Commissioned by the
National Portrait Gallery,
London with support from BP

Stuart Pearson Wright has an uncanny ability to create meticulous reflections of the real world, while still imbuing his creations with an imaginative visual perspective. Wright's rendering of J.K. Rowling places the acclaimed British author of children's fiction as if posed in the Edinburgh café in which she first wrote the Harry Potter stories. Wright has produced a lasting portrayal of Rowling's features, as part of a *trompe-l'œil* ensemble, creating a delightful depiction of this elusive and famously camera-shy writer.

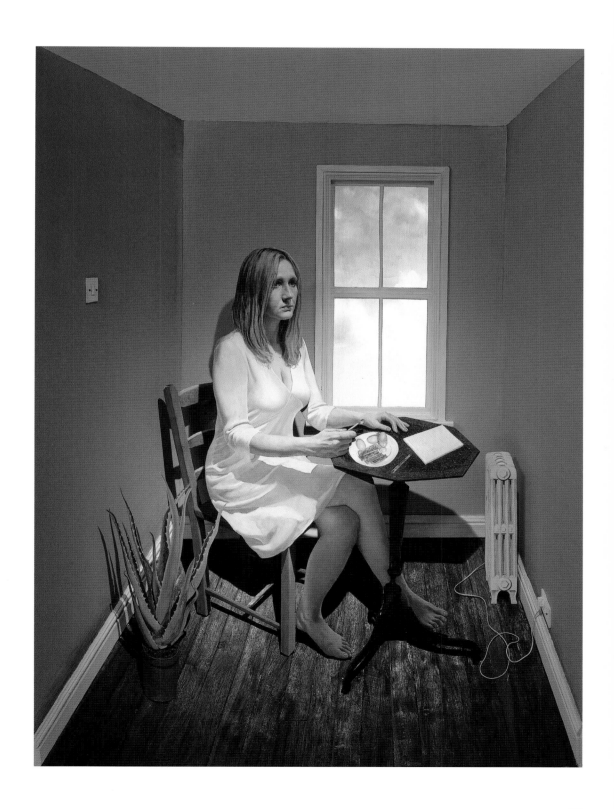

Beat Streuli
From the series
'New York', 2001

C-print
1510 x 2010mm (59 x 79")

Once again returning his focus to New York City, Beat Streuli captures the anonymity of urban existence. Amongst the crowds and the milieu of the modern metropolis, individuals survive in a lonely and sometimes hostile environment. Streuli portrays the individual as he moves through the crowd, as a dispensable part of the mass. However, instead of highlighting moments of awkwardness, or distress, Streuli tends to portray people in unconscious moments of grace, as in this portrait of a well-suited man caught in the midst of a confident stride. As a silent observer, Streuli takes photographs of people, unbeknownst to them, navigating through the mundane moments of their lives.

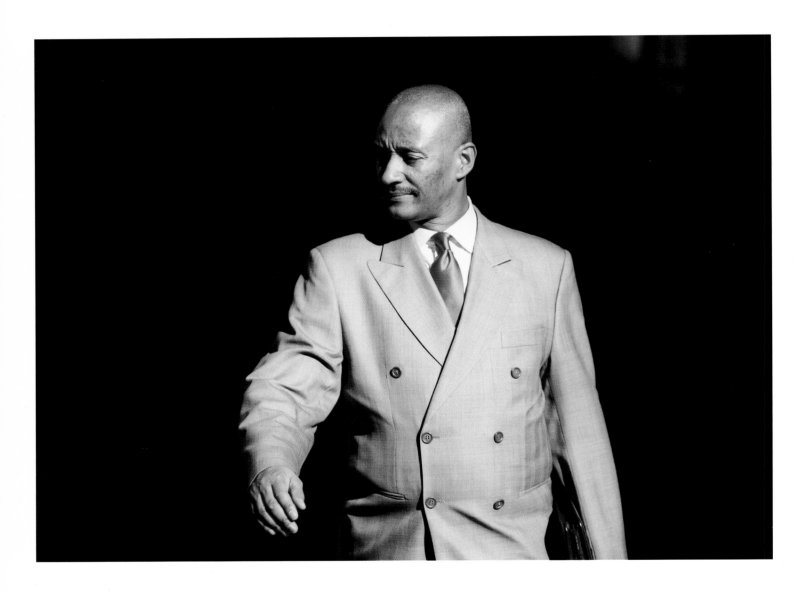

Shirana Shahbazi
Andro-01-2003

C-print on aluminium
Variable dimensions

Sometimes called the 'ambassadress of the unspectacular', Shahbazi captures everyday aspects of life, defying expectations that an Iranian artist must aim for political content in her work. Instead, she makes carefully staged photographs that appear to be haphazard recordings of life. Andro, the subject of this piece, is Shahbazi's artist friend, and the photograph was taken in Zurich. Shahbazi's work includes both Iranian and international subjects, and her art explores the concepts of 'culture' and 'tradition', the co-existence of different cultures, and transcultural attitudes.

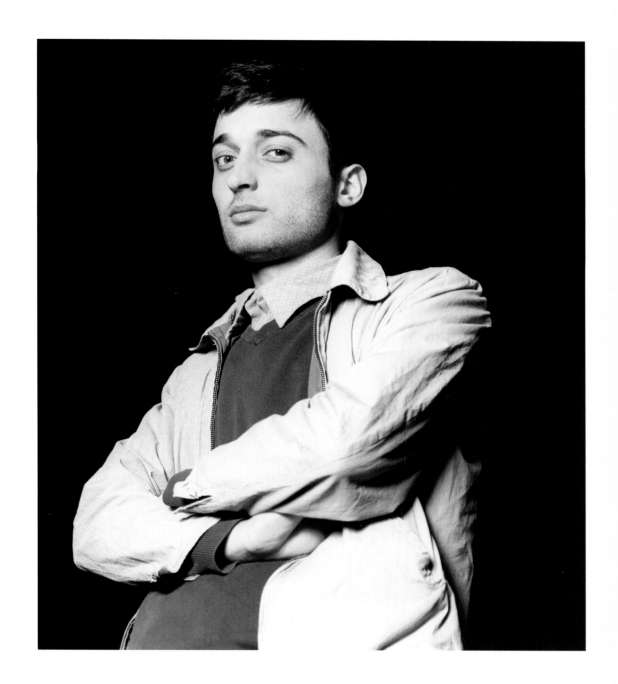

Evan Penny
Gerry, 2003

Silicone, pigment, hair,
fabric, aluminium
2489.2 x 2336.8 x 1574.8mm
(98 x 92 x 62")

Evan Penny's hyper-realist sculpture of actor and friend, Gerry Quigley, exemplifies his interest in the dialectic between the artificial and the real. Like most of the artist's work, which builds on and expands the tradition of photorealism, Penny's twice life-sized rendering of Quigley magnifies the details and subtleties of the human skin. Penny then photographs his sculpture and exhibits the two works together. He says, 'My interest is to situate the sculptures perceptually between the way we might see each other in real time and space and the way we imagine our equivalent in a photographic representation. The intention is that the work be seen in a context where the sculptural and photographic images, mirroring each other, subtly shift, confound, and inform anticipated readings.'

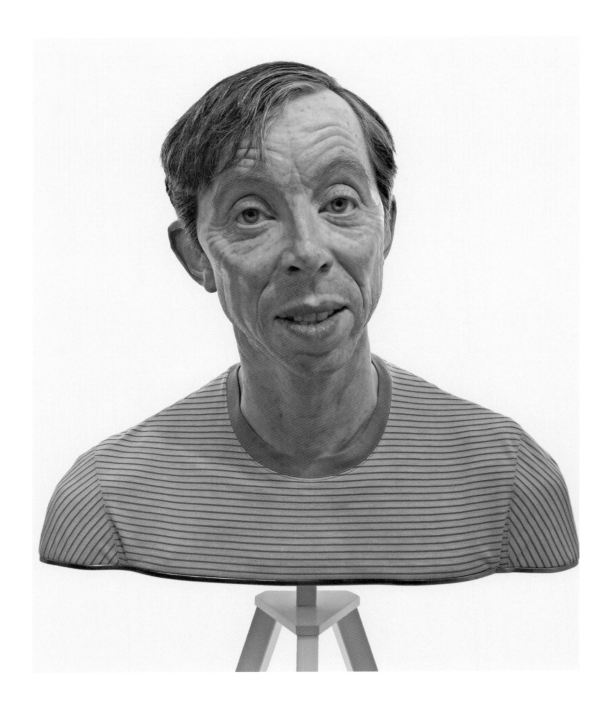

**Hombres Pintados No.1,
1999–2000**

C-print
400 x 370mm (15 x 14⁵⁄₈")

Mónica Castillo spent the 1990s exploring the self-portrait in various media. Seeking to sever the tradition of self-portraiture from reductive biographical interpretations, particularly those imparted on Latin American artists, Castillo became interested in confusing the categories of subject and representation. Inspired also by the way in which Hispanic Catholic imagery acts as a substitution for – not a representation of – that which it signifies, she began painting the living subject, as demonstrated in *Hombres Pintados*. Of this process she claims, 'Working with live bodies is part of my intent to reflect on my personal relationship with painting.' In *Hombres Pintados*, the extreme close-up of a shut eye reveals everything and nothing of the subject at the same time.

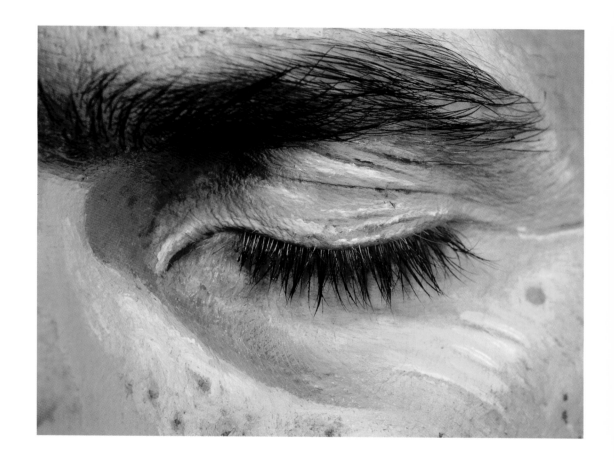

Pinar Yolaçan
Untitled, 2003

C-print
1016 x 822.3mm
(40 x 32 3/8")

This photograph comes from a series of performances that were documented as photographs, entitled 'Perishables'. Yolaçan placed adverts in newspapers, requesting the participation of elderly Caucasian women. In this portrait, she embellishes the neck of her subject with chicken's flesh. The performance seeks to investigate ideas within the psychology of adornment and notions of clothing as an extension of the corporeal self. The woman's facial expression, pinched and somewhat pained, reflects the baseness of the material, dead flesh, and what it really means to come into contact with such material. In blurring the boundaries of her subject's own skin with that of the chicken, Yolaçan hopes to question our sense of the 'other', and its categorization as such.

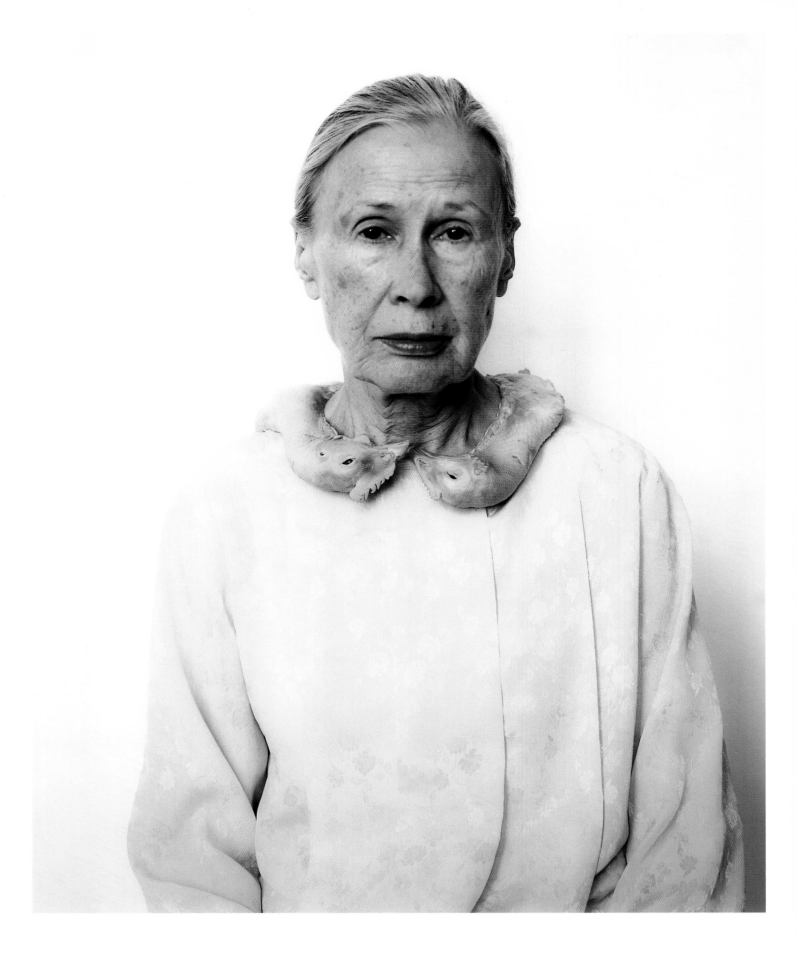

Juergen Teller
Yves Saint Laurent, 2000

C-print
254 x 304.8mm (10 x 12")

This portrait of fashion legend Yves Saint Laurent is direct and arresting. Juergen Teller, an icon of contemporary fashion photography, is well-known for his authentic realist style. Teller does not impose a persona onto his sitters, but rather finds beauty in their imperfections, developing and drawing out their idiosyncrasies. He makes no distinction between the famous and the anonymous and photographs each in the same manner. Here, Yves Saint Laurent's strangely smirking expression and seemingly unblinking gaze behind his thick-rimmed glasses give the impression of intimacy between artist and sitter, and even viewer and sitter.

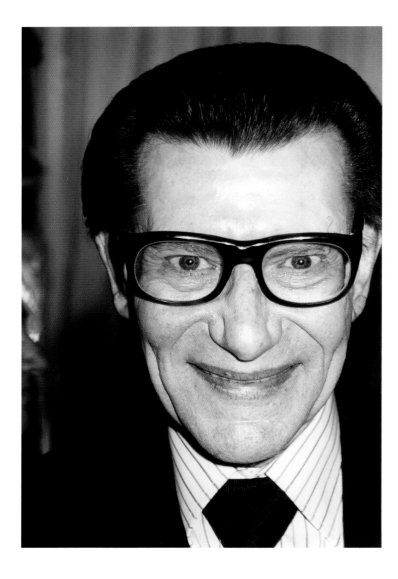

Wolfgang Tillmans
Peter Saville, 2002

C-print
610 x 508mm (24 x 20")
Purchased by the
National Portrait Gallery,
London through the
Deloitte Acquisition fund

Peter Saville, one of the few graphic designers to become a household name, is here depicted in the manner of refined coolness that he is known for. Tillmans works collaboratively with his sitters, allowing himself to become a participant in the scene.

While some portraitists seek to reveal subtle psychological nuances in their sitters, Tilllmans instead strives to convey a direct experience. His portraits are like snapshots, moments that are revealing only in their spontaneity. Tillmans often depicts his

subjects in control of their surroundings, as in this portrait of the luxuriously robed and casually posed Peter Saville.

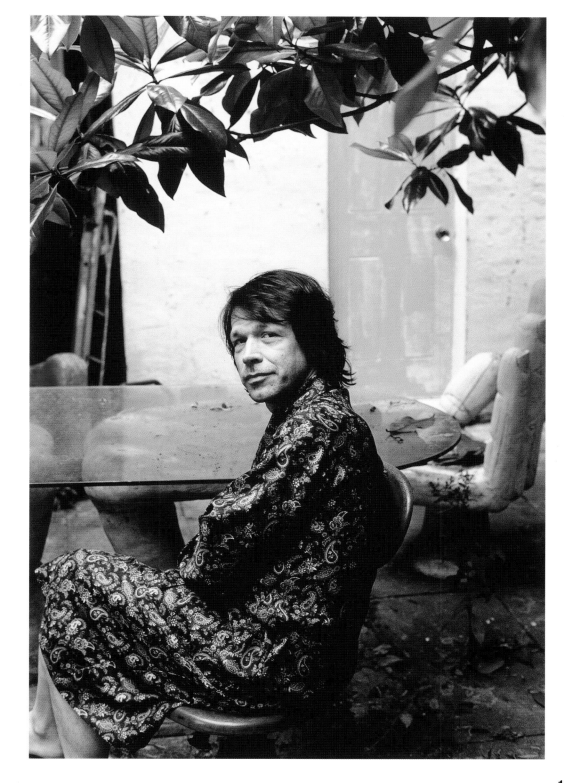

Gary Schneider
Shirley, 2001

C-print
1524 x 1219mm (60 x 48")

Shirley is from the series
'Portraits', a four-year project
of colour photographs. The
exposures are taken in a
dark space, with a flashlight.
In this series Schneider uses
a very long exposure time,
approximately ten minutes.
The accumulations of discrete
exposures, one part of the
face at a time, are recorded on
one sheet of transparency film.
Schneider's and the sitter's
performance are traced in film
time. A series of expressions is
recorded over time. This is not
a snapshot. Many of the portraits
are of the artist's friends.

According to Schneider,
these portraits say as much
about him as they do about
the subjects.

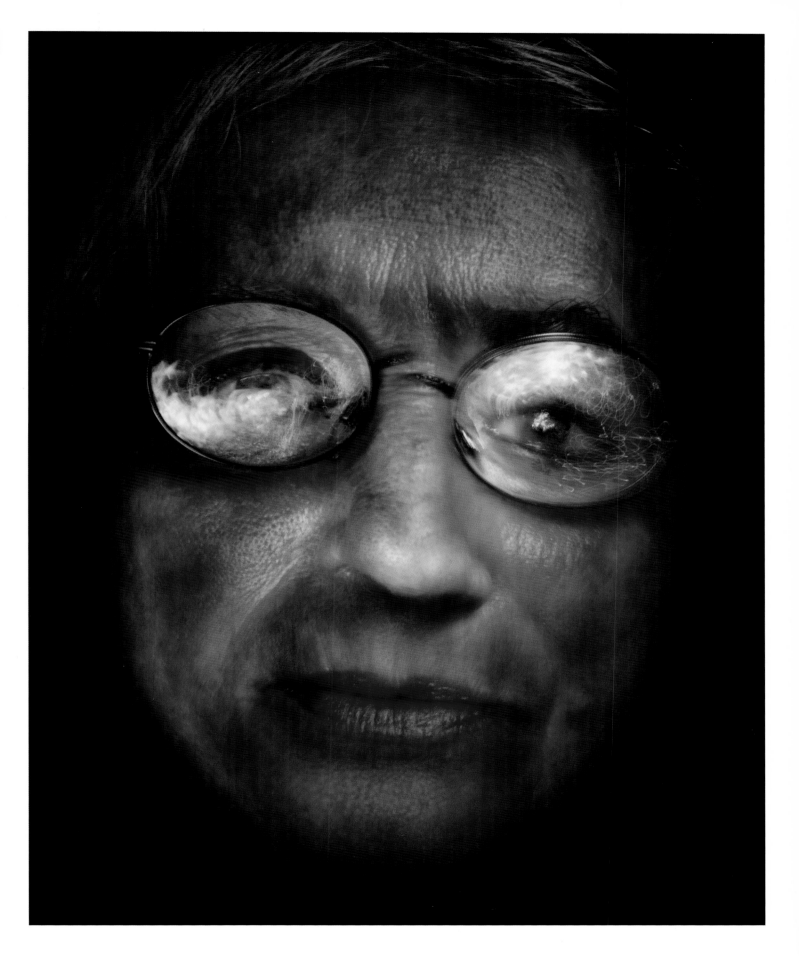

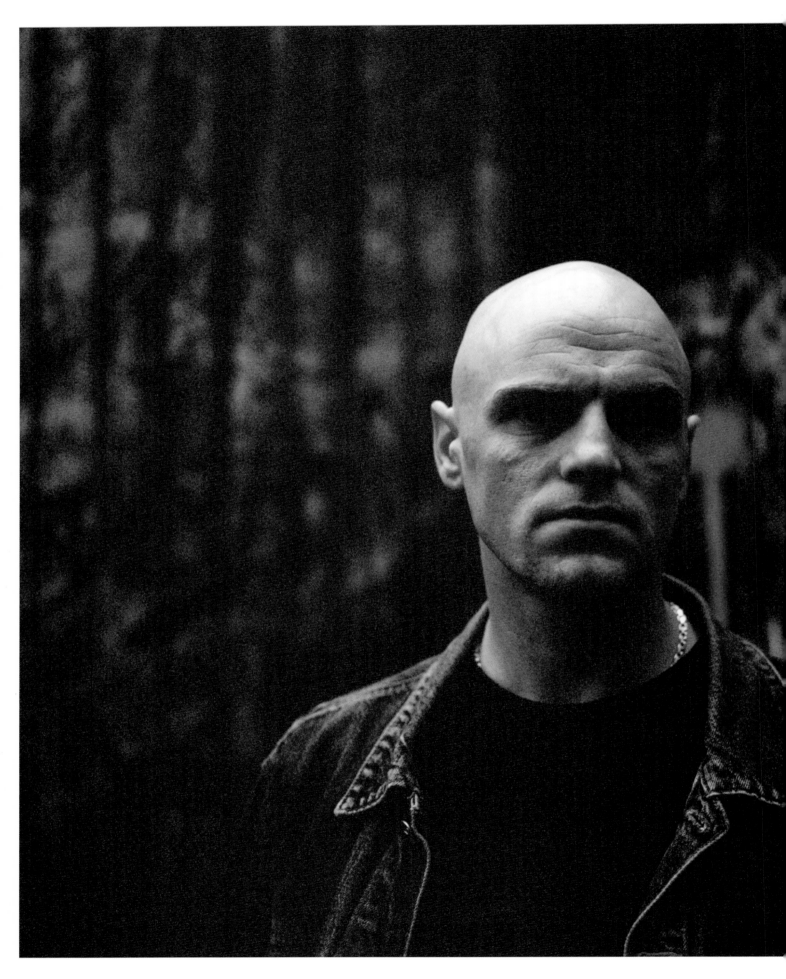

Willie Doherty
**Non-Specific Threat V
(Nauseating Barbarity), 2003**

**C-print
1650 x 1920mm (65 x 75⁵⁄₈")**

Doherty's portraits are difficult to see. This visual strain reflects the impossibility of discerning the 'real truth' of the situation. Doherty captures a man who appears to fit the media-established image of a skinhead. His threat to us is ambiguous, but he definitely appears as threatening. Using his native Northern Ireland as a model, Doherty often reflects upon violent and terrorist situations around the world. He analyses how we determine who the enemy is, and by what criteria we judge them. The character in this portrait, an actor who plays the 'bad guy' in a television series, was chosen because he didn't change his physical appearance for the role, or for this portrait. Emerging out of a backdrop of graffiti and shadows, the subject hovers between reality and fiction.

'What is intriguing with the sugar-cane cutters is their response to the camera, how they portray themselves … their elegant poses transform them into androgynous beings; sometimes the strong presence of the machetes transforms them into samurai warriors.'

Zwelethu Mthethwa
Untitled, from the
'Sugar Cane' series, 2003

C-print
1499 x 1943mm (59 x 76")

A painter and a photographer,
Mthethwa considers both
mediums to be of equal
importance to his practice,
and one informs the other.
Mthethwa photographs ordinary
citizens and rural migrants in
post-apartheid South Africa.
In the 'Sugar Cane' series,

he captures sugar-cane cutters
in the fields where they work.
Portraying his subjects with
a compassionate dignity, he
reveals the continuing hardships
they endure, despite allegedly
beneficial political changes in
the country. Their intense gazes
are in stark contrast to the often

picturesque natural backdrop.
He allows his subjects' gestures,
tools, clothes, and posture to
express their individual stories.

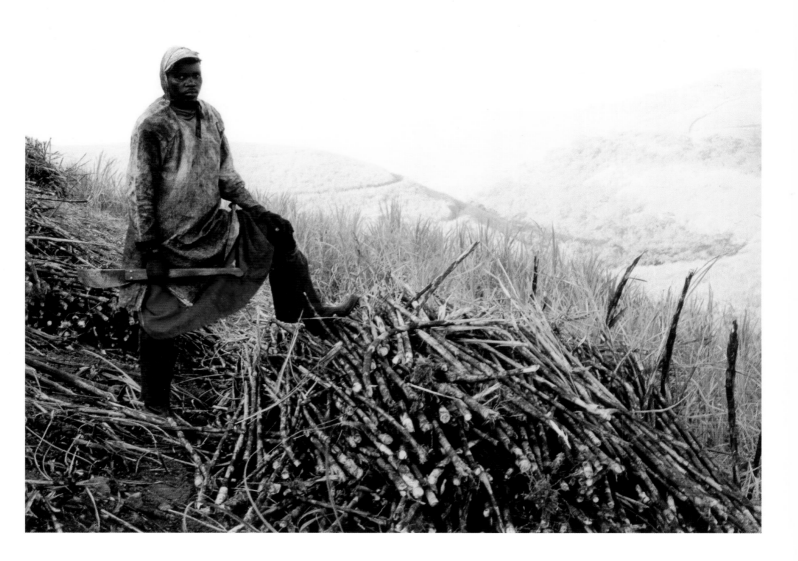

Atul Dodiya
Father, 2002

Enamel paint on metal
shutters, acrylic and
marble dust on canvas
228 x 152mm (9 x 6")

Creating part painting and part installation, Atul Dodiya paints on the surface of shop metal shutters. In India's street culture, these structures are usually painted with adverts for everyday products. Viewers are encouraged to raise Dodiya's heavy shutters and to reveal another fanciful figurative painting. The front of the shutters is a portrait, whether of a famous political leader, or, as in this case, the artist's father. The opening of the shutters reflects the disparities present in modern Indian culture: East and West, old and new, public and private, among others. With each lifting of the shutters, the painting becomes slightly weathered, and both the physical exertion of the lifting and the weathering of the shutters' surface are integral components of the work of art.

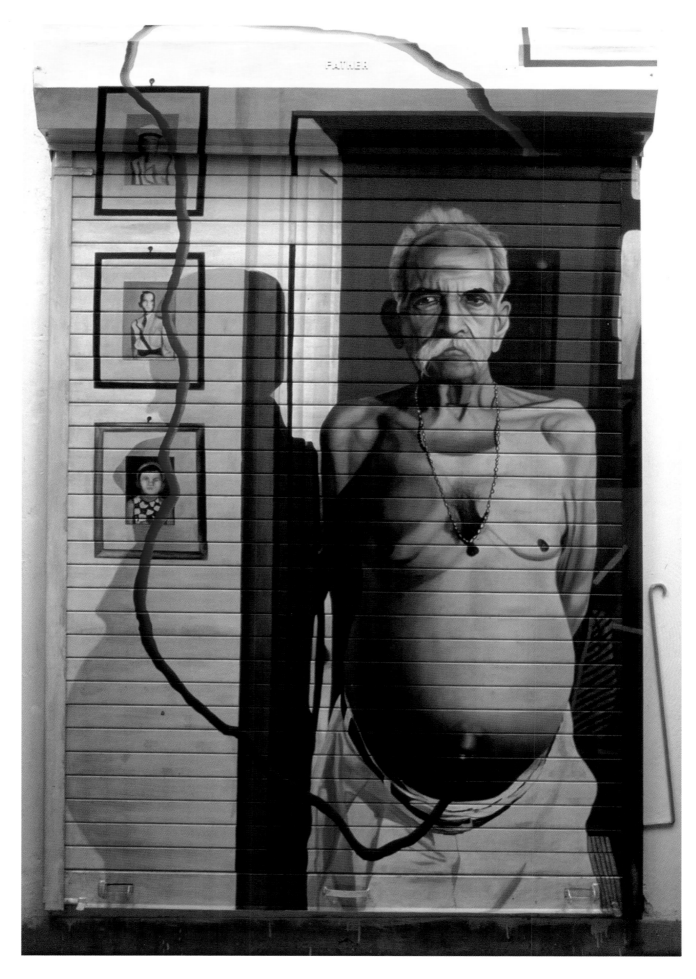

Takashi Homma
From the series 'Children
of Tokyo', 2000–01

C-print

The larger-than-life-sized young
sitter in this portrait recoils
from the camera, confronting it
with a distrustful stare. Homma
doesn't manipulate his subjects,
but instead allows them to
respond naturally to the camera.
The 'Children of Tokyo' series
portrays a generation of youth
growing up in Tokyo's 'kogai',
or suburban 'new-town'
developments. Like the artificial
landscapes they grew up in,
the children often appear as
emotionally detached. While the
suburbs signify, on one level,
a certain degree of economic
security and alleged placidity,
it has become increasingly
apparent that they are also
rife with social iniquities.
Homma's portraits are
a quiet observation of the
lives of future generations.

Craigie Horsfield
Albert Martín, Avigunda de Puig de Jorba, Vallbona, Barcelona, December 1995

Black-and-white photograph 1360 x 1200mm (53 x 47")

This portrait is from the series 'The Barcelona Project: The City of People'. The project, investigating the specificity of places and communities, developed out of a close collaboration with the citizens of Barcelona. The face in the portrait, carrying the traces of memory and history that compose an individual being, reveals something of the surrounding environment, and also a sense of the here and now. Horsfield often follows his portrait studies with practical projects around the city. His photographs have a velvet-like texture, the result of spending much time on their processing.

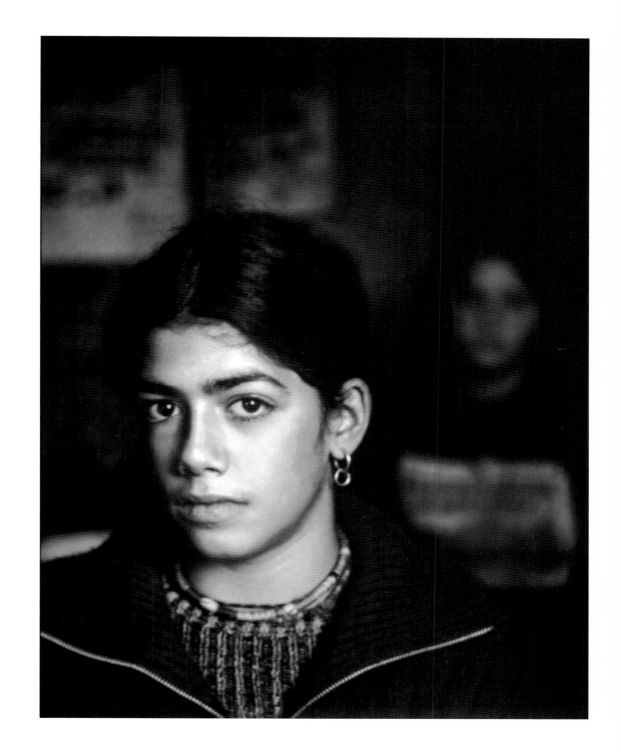

Bettina von Zwehl
#5 from the series
'Alina', 2004

C-print
598 x 464mm (23 x 18")

Bettina von Zwehl made this series of twelve photographs during a residency at the Royal College of Music in London. For this project, von Zwehl sat with her subjects in a darkened room while she played a piece of music by the Estonian composer, Arvo Pärt entitled 'Für Alina'. At an unexpected moment, she activated flashlights, catching her subjects in the midst of apparent contemplation. It is difficult to ascertain much detail about her sitters as they are stripped of individual expression, each wearing white tops against a monochrome background. This portrait captures the girl in a meditative, and seemingly sombre, moment, though the cause of such effect remains enigmatic to the viewer.

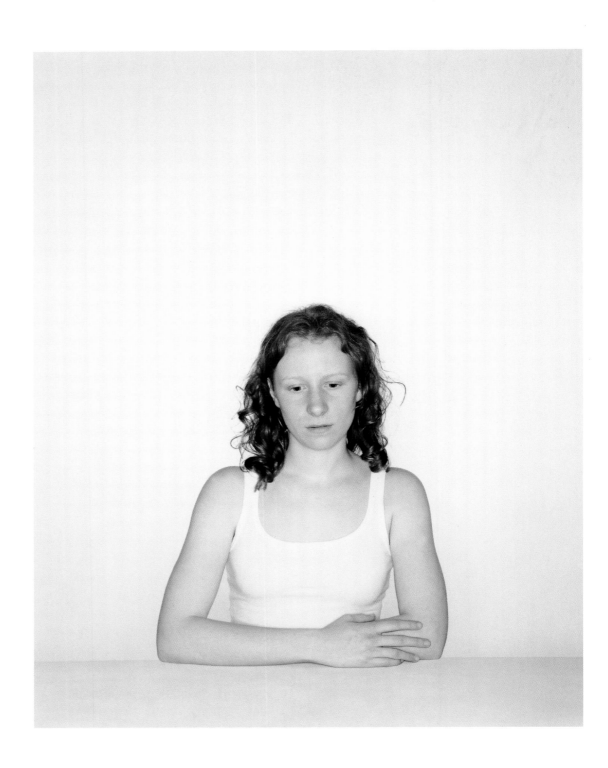

Katy Grannan
Jesse and Robert, Mystic Lake, Medford, MA, 2003

C-print
1220 x 1524mm (48⅛ x 60")

Grannan photographs unknown Americans, including adolescents, young mothers, middle-aged men, and couples. She finds many of her sitters by placing ads in local newspapers, and the resulting portraits incorporate the underlying narrative of a first encounter and the unique dynamic between each sitter and the artist. Whether her subjects are photographed in the privacy of their own homes or in hidden, carved out settings in public parks, their portraits are often raw and unsettling, made with a leap of faith, a combination of trust, intimacy, and role-playing.

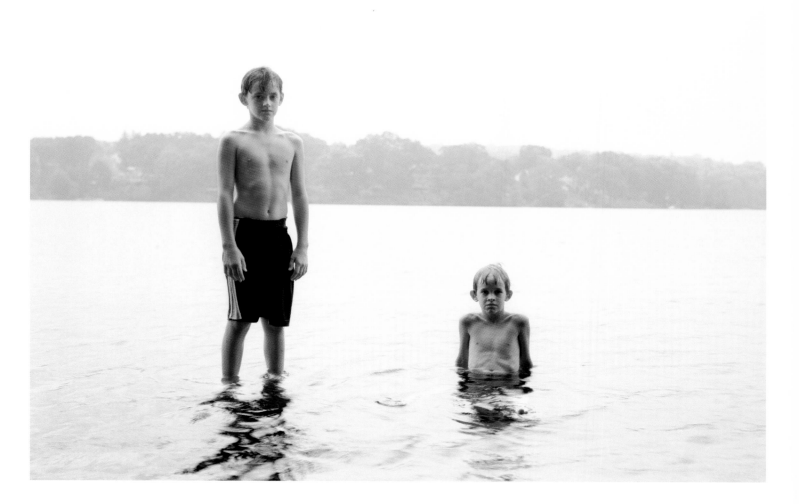

Darvish Fakhr
Mullah Ali, 2005

Oil on canvas
760 x 560mm (30 x 22")

During his recent visit to Iran, Darvish Fakhr, winner of the 2004 BP Travel award, completed a series of portraits of people in the old Persian bazaar in Tehran. Fakhr is concerned with exposing the commonalities that exist between the Western world and the Middle East, when so often it is the differences that become the focus of interest. This portrait shows a man carrying traditional Middle Eastern bread alongside a can of Coca-Cola, the ubiquitous symbol of globalisation and a world economy. His intimate portraits reveal the range of emotions implicit within people that face considerable turmoil, even as they go about the tasks of their daily lives.

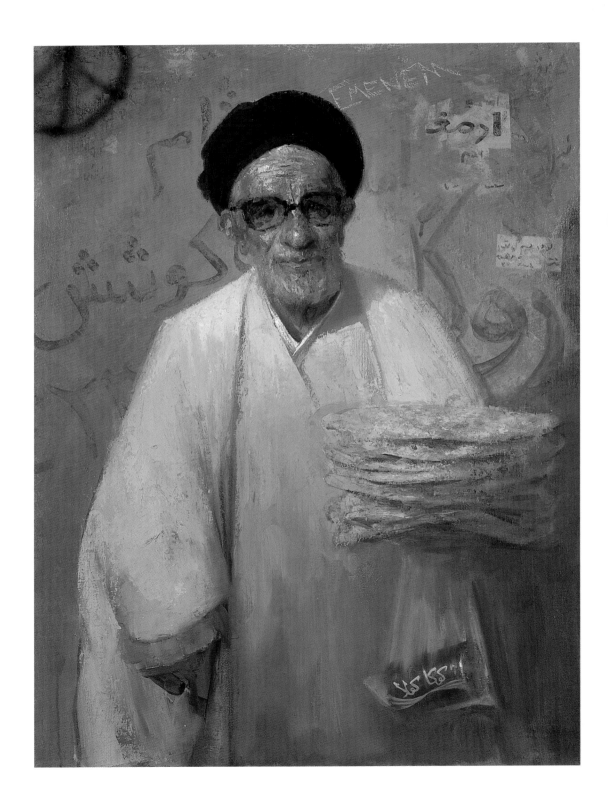

David Cobley
Ken Dodd, 2004

Oil on linen
915 x 1070mm (36 x 42")

Cobley's portrait captures the underlying eccentricity of comedian and entertainer, Ken Dodd. Known for his manic hairstyle and protruding teeth, Dodd developed a loyal following over the years with his off-beat comic routine. A self-professed fan of Dodd,

Cobley describes Dodd's performance, 'Between the frenetic madness of tickling sticks, big bass drums and up to six jokes a minute, he sings a beautifully poignant lullaby to his wooden doll Dickie Mint.' The portrait is unusually composed, with

Dodd's splayed hand as the focal point. The retreating succession of mirrored images creates a slightly unreal environment, with a strong emphasis on being off-stage.

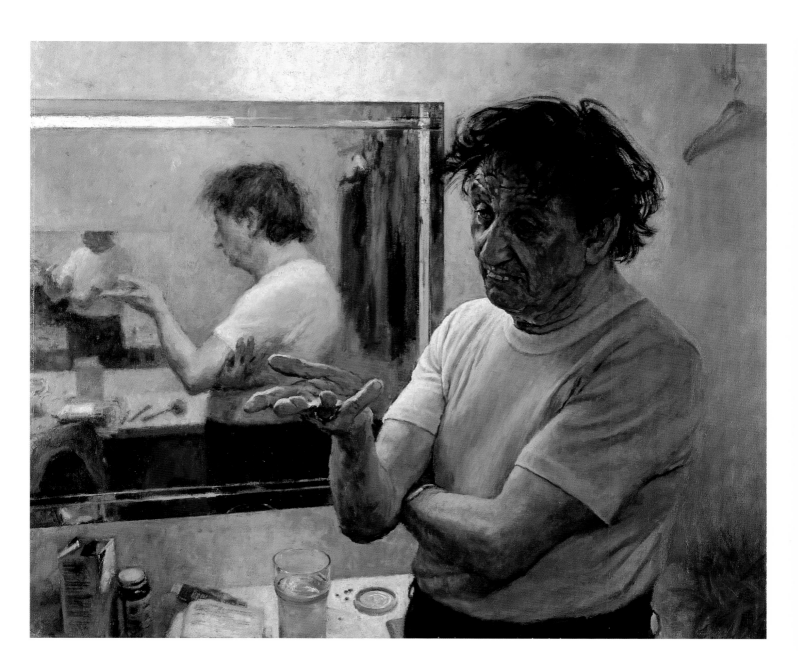

Jonathan Yeo
Rupert Murdoch, 2004

Oil on canvas
1274 x 766mm (50 x 30⅛")

This portrait of media tycoon Rupert Murdoch reflects Jonathan Yeo's confluent style of photographic realism and the painterly touch. Both working with his medium and remaining precise to his subject, Yeo creates a penetrating depth of character in his portraits.

Here, he crops the painting at an unusual point, narrowing our focus on the face of his subject. Yeo concentrates our attention on Murdoch's eyes, instigating a critical exchange between viewer and subject.

Paul Benney
The Marquess of Bath, 2004

Oil on canvas
914.4 x 1117.6mm (36 x 44")

Benney's portrait of Alexander Thynne, the 7th Marquess of Bath, is rendered in the artist's characteristically pared down painterly style. The Marquess is an author and a politician, having written several novels and sat in the House of Lords. Of his experience with the sitter, Benney remarks, 'In painting from life, there are often surprising and unexpected insights into the life of the sitter, this was no exception. Alexander Thynne is a man of many contradictions, almost Shakespearean in his approach to life. My task was to create an image that encapsulates both the internal persona and public perception of this often misunderstood man.'

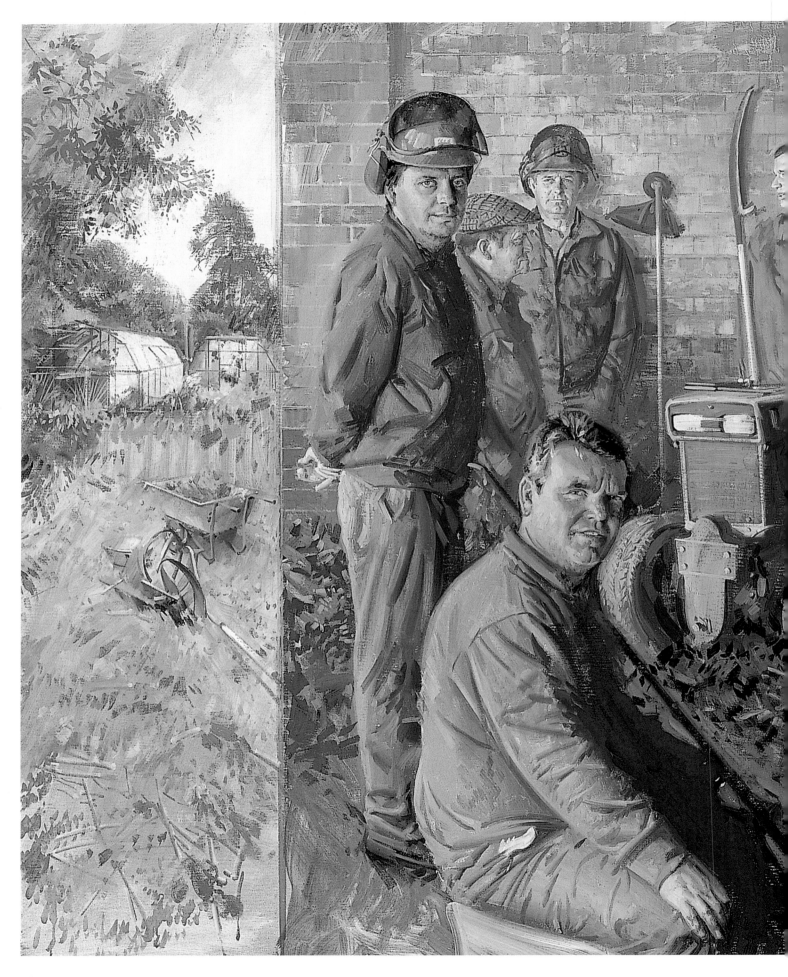

Andrew Festing
**The Woodmen and Gardeners,
2002**

Oil on canvas
1016 x 1524 mm (40 x 60")

While there is an assumption that portraiture is a practice begun in, and most commonly reserved for, the upper echelons of society, there are many notable exceptions to this presumption. One of the most ambitious commissions for a series of portraits of employees in modern times was initiated by the Earl of Leicester (then Viscount Coke) in 1993, when he commissioned Andrew Festing to paint his staff on his Holkham Hall estate in Norfolk. This portrait depicts outdoorsmen in their working environment, striking casual poses, dressed in their workers' garb.

David Mach
Lord Chief Justice, Lord Woolf,
2003

Nickel-plated metal
coat hangers
2210 x 1524mm (87 x 60")

Turning traditional sculpture on its head, David Mach uses a variety of everyday objects, to create his often large-scale pieces. Mach began making sculptures from coat hangers in 1992, attracted by their cheap, throw-away nature. The process of transforming them into extraordinary sculptures is a long and arduous one. First the head is modelled, then a mould is made and a hard plastic form created around which the coat hangers can be individually bent and welded. The protruding hooks create a kind of halo around the subject; a visual vibration that both draws in and distances the viewer. This portrait of the Lord Chief Justice was commissioned for the Royal Courts of Justice, providing a traditional backdrop for an unconventional portrait.

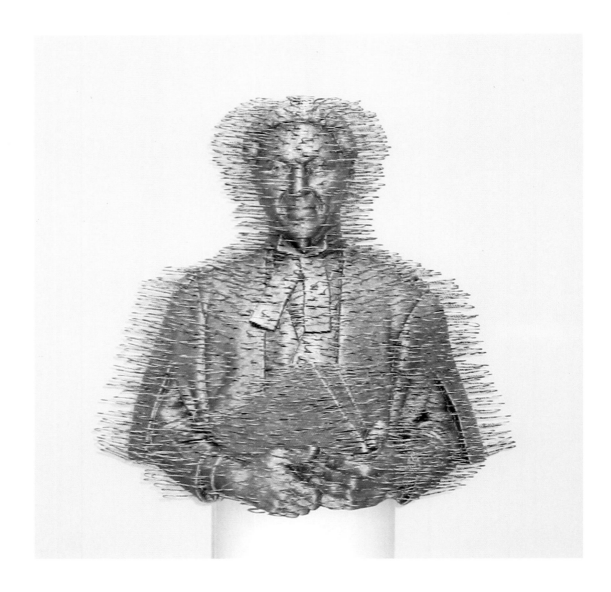

Tom Phillips
Sir John Sulston, 2004

Oil on canvas
510 x 510mm
(20⅛ x 20⅛")

Here, Tom Phillips depicts geneticist and 2002 Nobel Laureate, Sir John Sulston. Phillips's process is slow, involving many sittings with his subject. As a result, the portrait is not a record of a particular moment, but rather, according to Phillips, 'an amalgam of many moments and states of mind.' He says, 'getting a likeness is not the problem: any professional should be able to achieve that in a couple of sessions. The task seems to lie in reconciling a set of possible likenesses into a unity that has the feel of the subject actually being there.'

Setting Sir John against a background of the scientist's own notions of the nematode worm (which are in a sense, like the portrait, drawings from life), Phillips has captured the thoughtful exuberance of the renowned champion of the human genome project.

Hew Locke
Jungle Queen I, 2003

Wood and cardboard base, glue, mixed media (pom-poms, feather trim, beads, toys etc.)
2750 x 1600 x 400mm
(108 3/8 x 63 x 15")

Hew Locke is fascinated by the Royal Family as a symbol of Britishness. Growing up in Guyana, Locke was surrounded by images of Queen Elizabeth II. Locke says, 'My feelings about the Royals are deeply ambivalent, I am fascinated by the survival of the institution.' In *Jungle*

Queen I toy soldiers snipe at each other from behind artificial flowers, whilst lurid animals peer out at the viewer. It is both portrait and ecosystem; as our figurehead tries but fails to stand against attack from the plastic vegetation in the plastic jungle.

St Claire (Thirty Seven Wanks Across Northern Spain), 2003

Glazed ceramic
840 x 550mm
(33 1/8 x 21 5/8")

Perry's earthenware urns are masterfully created. Their surfaces are textured using intricate carving skills and then detailed with a combination of etching and photo transfer techniques. However, their physical beauty is in stark contrast to the lewd pictorial representations that cover the urns. Perry uses pots as a medium to tell a narrative, and one that is often a perverse tale of the evils of society. Sometimes he details himself into the stories, or as in this case, his female alter-ego, 'Claire'. Using expressionist drawings and handwritten text, Perry's urns draw inspiration from art history, consumer culture and the sex industries to tell their complex tales – a portrait story.

'In a world obsessed
with materialism
and the cult of celebrity,
secular icons have
come to replace the
traditional spiritual role
models offered by
world faiths.'

The Singh Twins:
Amrit and Rabindra
From Zero to Hero, 2002

Poster, gouache, and gold
dust on mountboard
380 x 520mm (15 x 20")

Inspired by a traditional eighteenth-century Indian miniature, *From Zero to Hero* depicts England's celebrity couple of the moment: football star David Beckham, and his pop star wife, Victoria. The portrait seeks to examine celebrity culture and the ways in which the media and commercialisation of sport transform the everyday man into a universal hero. Dubbed the 'New Royal Family' by the paparazzi, the Beckhams' placement on a throne alludes to the fact that they have displaced the British Royal Family's traditional role as the media's number one seller. Crowned the new King and Queen of English pop culture, the Singhs' portrait is a wry comment on such a phenomenon.

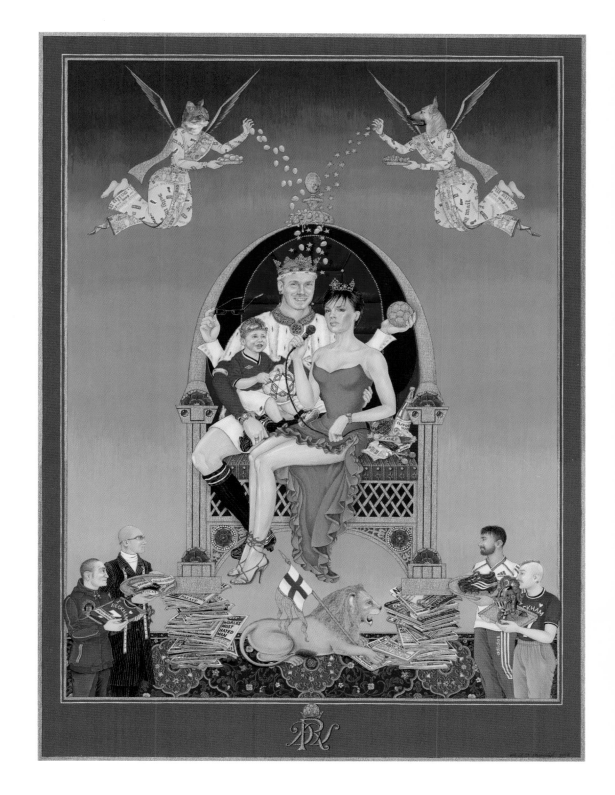

Victoria Russell
Fiona Shaw, 2002

Oil on canvas
1828 x 1220mm (72 x 48")
Commissioned by the
National Portrait Gallery
with the support of BP

This portrait of the acclaimed contemporary classical British actress, Fiona Shaw, is characteristic of Russell's commitment to capturing the essence of her sitters. The background has been stripped of any distractions, leaving the viewer alone with the sitter.

This enables the viewer to become fully aware of the subject. The drapery in the background also acts as a reference to the theatre, the stage. Russell is concerned with empowering her sitters and often depicts her female sitters in minimal and unconventional clothing,

a vehicle for re-appropriating female identity. Russell's interest in representations of the female has a certain resonance with Shaw, who has challenged the role of women in theatre. In 1995, Shaw famously played the part of Richard II.

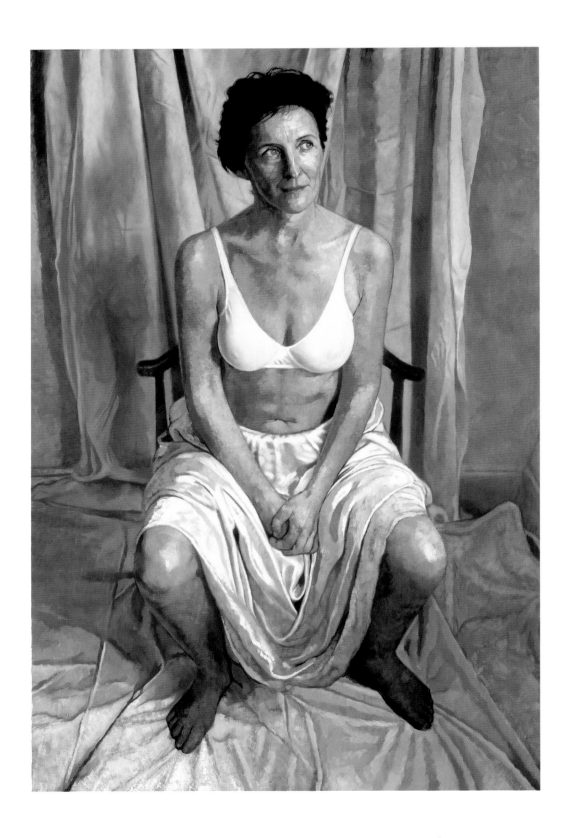

Daphne Todd
Me in a magnifying mirror, 2001

Oil on panel
412.8 x 406.4mm (16 x 16″)

Todd writes: 'This particular work emphasizes the process that takes place when I'm painting any portrait – namely taking various elements and putting them together to make a visual statement about what I see before me. It is not what anyone else sees and I have made no attempt to present an image of myself that others would more easily recognize. There is no <u>whole</u> image in a magnifying mirror, it is distorted and fragmented and, of course, back to front. Indeed, every slight movement of my head produces a whole new set of shapes and projections.' 'This painting represents merely an interesting selection of what I could see in that little mirror and its surroundings – no more and no less. It does not represent Daphne Todd, her life and work.'

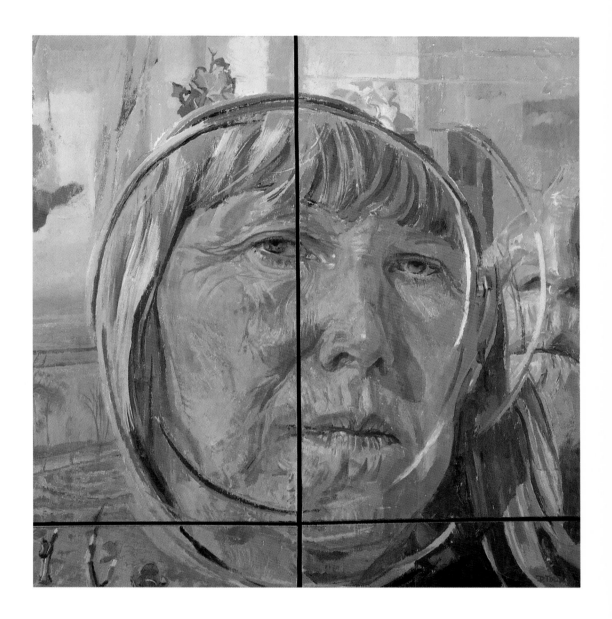

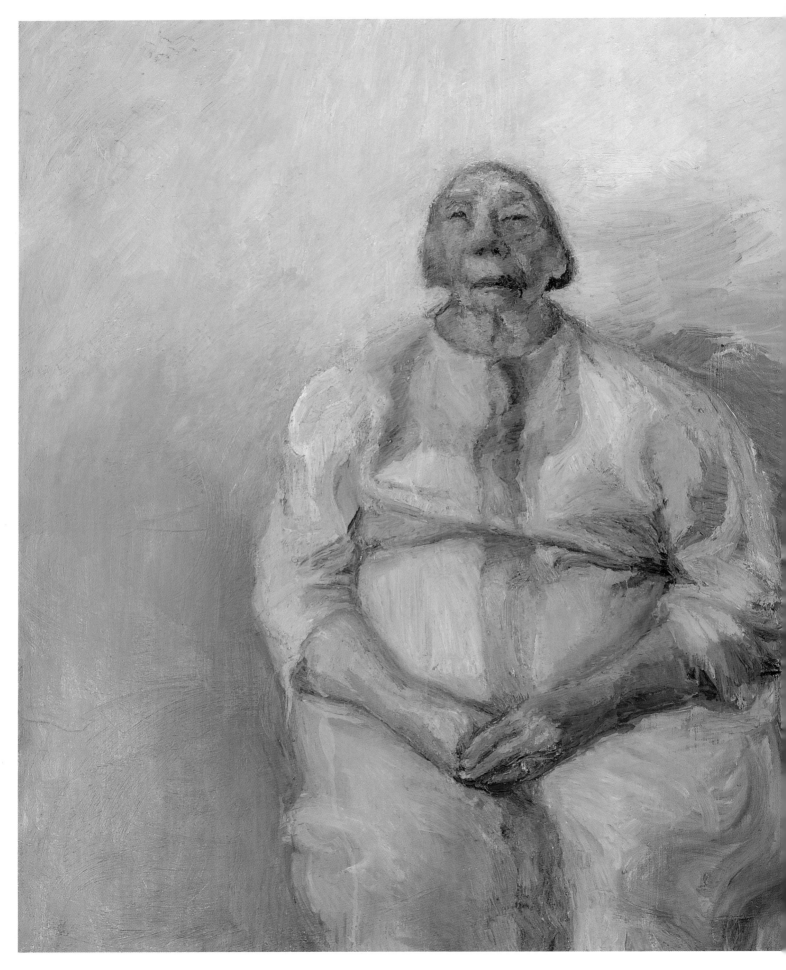

My Mother in a Saint's Dress, 2003

Oil on canvas
916 x 916mm (36 x 36")

Celia Paul's paintings are an intimate study of people she knows well, members of her family, and most importantly, her mother. Paul's sombre paintings reflect an inner darkness in her subjects. She says, 'My work is about people and their emotions.' Paul uses shadows on the face and around the figure to convey a sense of searching and introspection in her portraits. Often, as in this portrait, her mother is represented with a dark line that runs down the front of her dress. This scar-like marking appears as a repository of secrets. Echoing Old Master tradition, Paul has a keen sense of light that establishes a spiritual quality in her works. In painting her mother she says, 'I think that the central thing for her is her faith, so that to do a full deep portrait of her, I want that to be included.'

Lucian Freud
The Brigadier, 2003–4

Oil on canvas
2235 x 1384mm (88 x 54")

This more than life-size portrait of Andrew Parker Bowles, an old riding companion of Freud, portrays the sitter in an awkward moment of suspension. With one hand firmly gripping the chair and the other raised, as if in conversation, or contemplation, Bowles assumes a whimsical countenance. His stately English military attire suggests nobility and temperance, while his billowing stomach suggest habitual over-indulgences. Though formally clad, Bowles's fleshy hands and face dominate the portrait. With his characteristic painterly technique, Freud accentuates the nuances of human skin, while carefully balancing the angles of his sitter's posture, and the composition of the subject.

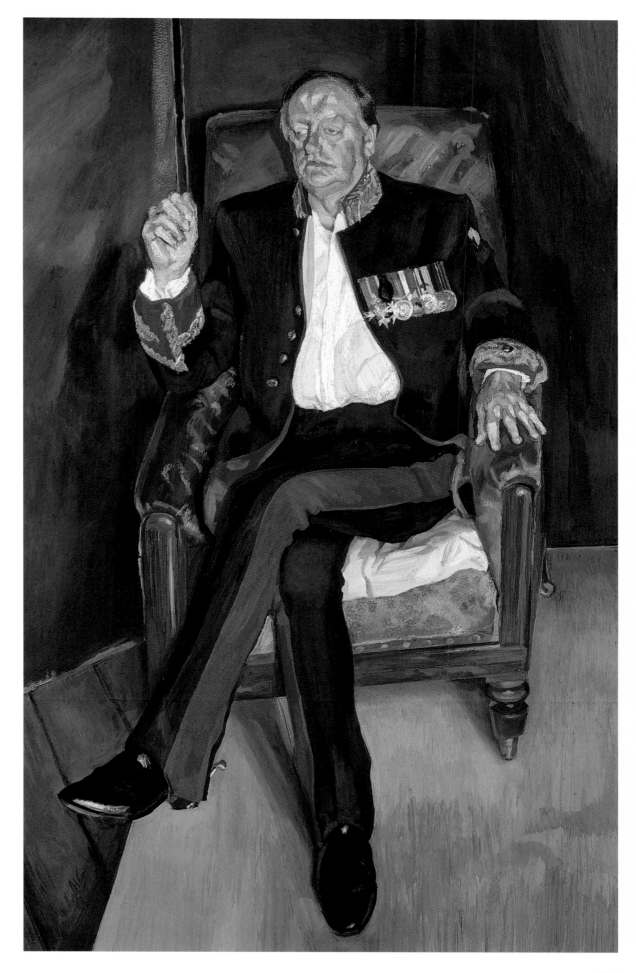

**assume vivid astro focus
y.o., 2002
Decal, CD and certificate
of authenticity
Variable dimensions
(maximum size unlimited)
Edition of 3, AP
Courtesy John Connelly
Presents, New York and
Peres Projects, Los Angeles
and Berlin**

Born in Rio de Janeiro, Brazil, assume vivid astro focus received a Bachelor of Communication Studies, Cinema, Publicity and Advertising, at the Pontificia Universisale Catolica, Rio de Janeiro, 1992, and studied on the General Studies Programme, International Center of Photography in New York, 1999. His solo shows have travelled worldwide, and are self-titled and numbered. In 1996 he was resident artist at the Banff Centre for the Arts, developing the project 'Cidade Secreta'(Secret City) together with Jose Fujocka Neto for the exhibition *Altered Spaces: Rituals of Exchange*, Walter Philips Gallery, Banff. He was winner of the Premio Estimulo para Ensaio Fotografico (Incentive Grant for Photo Essay, sponsored by São Paulo's State Council for the Arts, Brazil, 1994), and was recipient of the 2002 Rema Hort Mann Foundation Grant for Emerging Artists. He lives and works in New York.

**Frank Auerbach
Head of Jake, 2002–3
Oil on board
508 x 457mm (20 x 18")
© Frank Auerbach, courtesy
Marlborough Fine Art
(London) Ltd**

Frank Auerbach was born in Berlin in 1931. In 1939 he was sent to a private progressive school in Kent, England where he remained until 1947. He attended the St Martin's School of Art (1948–52) and he continued his studies at the Royal College of Art (1952–5). Now an internationally acclaimed artist, Auerbach's first solo exhibition was at the Beaux Arts Gallery in 1956. His work has been exhibited widely throughout Europe and also in the USA and Australia. He represented England at the 1986 Venice Biennale, where he was awarded the Golden Lion Prize. Auerbach's work is dedicated to painting the single model and his North London surroundings in Camden Town, and is characterized by the use of impasto and rich colours.

**Tina Barney
The French Family, 2002
C-print
Two sizes: 762 x 1016mm
(30 x 40")
1219.5 x 1524mm (48 x 60")
Courtesy Janet Borden, Inc.,
New York**

Born in New York City in 1945, Tina Barney first began to study photography in 1971. She has consistently photographed her extended family and friends. By using a large format 4 x 5in camera, she is able to capture extraordinary detail and rich colour. Barney was among the first photographers to present her work in such large scale, allowing viewers to virtually enter the photograph. Her work is included in most major museums in New York, Boston and Washington, DC among others. In 2005 her recent collection, *The Europeans*, was shown at London's Barbican Centre. In 1991, she received an artist's fellowship from the John Simon Guggenheim Memorial Foundation.

**Paul Benney
The Marquess of Bath, 2004
Oil on canvas
914.4 x 1117.6mm
(36 x 44")
© Paul Benney**

Paul Benney is a self-taught artist and was born in London in 1959. He spent much of the 1980s in New York, exhibiting in the East Village. After five shows at the PPOW Gallery, New York, and the inclusion of his work in public and private collections, Benney returned to London to complete a series of portrait commissions of prominent British figures. Recently, a Channel 4 (UK) documentary examined his work, including his paintings of Jerry Hall and Mick Jagger. In 2001, the Mall Galleries in London hosted Benney's first retrospective of twenty years of his work and published *Just Looking*, a monograph of his work.

**Tony Bevan
Alfred Brendel, 2005
Acrylic on canvas
756 x 670mm (29³/₄ x 26³/₈")
© National Portrait Gallery,
London (NPG 6720)**

Tony Bevan was born in Bradford in 1951 and was educated at the Bradford School of Art between 1968 and 1971. He then moved to London to study at Goldsmiths College (1971–4), and he attended the Slade School of Fine Art, London (1974–6). In 1976 he exhibited at the Robert Self Gallery, London. Selected exhibitions include: *Tony Bevan Portraits and Emblems*, Galeria Akumulatory 2, Poznan, Poland, 1983; *The Honest Portrait*, National Portrait Gallery, London, 1985; *Tony Bevan Paintings*, ICA, London, 1987–8; *Tony Bevan*, Whitechapel Art Gallery, London, 1993; *Tony Bevan – Paintings of the 80s and 90s*, Cottbus, Germany, 1997; *Tony Bevan Paintings*, Abbot Hall Gallery, Cumbria, 2003; *Tony Bevan Retrospective*, IVAM Institut Valencia d'Art Modern, 2005.

**Jason Brooks
Zoe, 2003–4
Acrylic on linen
2750 x 2130mm
(108¹/₄ x 83⁷/₈")
© Alderson Fine Art**

Jason Brooks was born in Rotherham, England in 1968. He studied Fine Art at Cheltenham and Gloucester College of Art and Design, attaining his BA in 1991, followed by his MA a year later. Brooks's work has been showcased internationally and in the UK. His practice involves taking photographs with a large format camera, from which he

then paints the image using an airbrush, modifying the surface with a variety of techniques. He is interested in photography as a tool of exposure, using it to dissect the figures as much as possible. His images are of tattooed models, and women urinating in public places. Brooks was awarded the John Moore's Painting Prize in 1997, and was the winner of the NatWest Art Prize, 1999. He lives and works in the UK.

**Don Brown
Yoko XII (Twin), 2004
Jesmonite and acrylic paint
930 x 390 x 260mm
(36⅝ x 15⅜ x 10¼")
© Don Brown, courtesy Sadie
Coles HQ, London**

Don Brown was born in Norfolk, England in 1962 and studied Fine Art at the Central School of Art, London, between 1983 and 1985, and then at the Royal College of Art for three years. He has joined other artists in group exhibitions that have been shown in New York, Brussels, Paris, Rome, Cologne and London. His solo exhibitions have included *Missiles*, at the Lisson Gallery, London, 1996; *Bavaria*, at the Hayward Gallery, London, 1996; at Sadie Coles HQ, in London, 2004; and the Galleria Lorcan O'Neill, Rome, 2005. In 2001, he was commissioned to design the CD jacket cover for Spiritualized. A new book about his work, *Yoko*, was published in 2005. Brown lives and works in London.

**Mónica Castillo
Hombres Pintados No.1,
1999–2000
C-print
400 x 370mm (15¾ x 14⅝")
© Mónica Castillo, courtesy
Galeria OMR, Mexico**

Mónica Castillo was born in Mexico City in 1961. She studied painting, firstly at the Freie Kuntstschule, Stuttgart (1979–80) and then the Akadamie der Bildenden Kunste, Stuttgart, until 1985. Castillo uses mixed media, including painted objects, photographs and videos to experiment with portraiture and the issues of art painting. By painting living objects she continues to question the definition of subject, representation and identity. Her work has been included in numerous exhibitions around the world and her solo exhibitions include *Yo es un otro*, which travelled to the *Museo Sofia Imber* in Caracas, Venezuela and the Museo de Bellas Artes in Santiago, Chile (1997–9); *Mónica Castillo*, Robert Miller Gallery, New York, 2001; an exhibition of work produced between 1993 and 2004, at the Museo de Arte Moderno in Mexico City; and a solo exhibition at the National Museum for Women in the Arts, Washington, 2005.

**Francesco Clemente
Bill T. Jones, 2002
Oil on canvas
1073 x 2134mm (42¼ x 84")
Courtesy Jablonka Galerie,
Cologne. Photograph: Nic
Tenwiggenhorn, Düsseldorf**

Francesco Clemente was born in Naples in 1952, and since the 1970s, has produced a rich and complex body of work. His expressive portrayal of the human body and use of traditional materials departed radically from the Conceptualist aesthetic that dominated the late 1960s and 1970s. An inveterate traveller, Clemente has diversified his imagery, engaging a wide range of cultural traditions and stylistic sources through his travels to Italy, India, and New York, as well as the American Southwest and Caribbean. Clemente moved to Rome in 1970 to study architecture. His friends and mentors at this time included Joseph Bueys and Cy Twombly. In 1980, at the Venice Biennale, the artist's eclectic imagery commanded international attention and contributed to the international revival of Expressionism at the time. In 1981, Clemente moved to New York permanently, drawn to the city's cultural diversity.

**Chuck Close
Kate Moss, 2003
Daguerreotype
215.9 x 165.1mm (8½ x 6½")
© Chuck Close, courtesy
Pace/MacGill Gallery, New York**

Chuck Close was born in 1941 in Monroe, Washington. He studied at the University of Washington, Seattle; the Yale School of Art and the Academy of Fine Arts in Vienna, between

1962 and 1965. Close has, with the exception of one or two forays into photo-pieces, remained loyal to the format of greatly enlarged, totally unadorned and context-less close-ups. Constructed on a giant grid and transposed section by section from his original photographs, it is a process described by Close as 'building it like I'm stacking bricks.' His art however, has not stood still and he has moved from the airbrush paintings with which he made his name to dot drawings, finger paintings, pulp paper collages and oil paintings. His solo exhibitions include: Museum of Contemporary Art, Chicago, 1972; Pompidou Centre, Paris, 1979; Walker Art Center, Minneapolis, 1980–81; Columbia Museum, South Carolina, 1983–4; Yokohama Museum of Art, Japan, 1989; Museum of Modern Art, New York, 1998.

**David Cobley
Ken Dodd, 2004
Oil on linen
915 x 1070mm (36 x 42")
© David Cobley/National
Portrait Gallery, London
(NPG 6702)**

David Cobley was born in Northampton, England in 1954, and grew up in the Midlands. After completing a foundation course at Northampton School of Art, he went to Liverpool School of Art, in order to obtain a diploma in Art and Design, but he dropped out at the end of the first term. The next nine years were spent in Japan where he studied for a degree in Comparative Culture, at Sophia University, Tokyo. On returning to England in 1988, he worked as an illustrator, painting in his spare time.

Gradually portraits took over from illustration work, and he now divides his time between commissioned portraits and work for galleries. His commissions have included portraits of Princess Anne, and this painting of Ken Dodd won the public vote at the Holburne Portrait Prize in 2004.

**Stephen Conroy
The Man from
Turtle Island, 2002
Oil on canvas
1830 x 1220mm
(72⅛ x 48⅛")
© Stephen Conroy,
courtesy Marlborough
Fine Art (London) Ltd**

Conroy is a figure painter and in both his paintings and prints he has created a number of self-portraits. The simplicity of a stark background and a single figure are all that Conroy needs to create the intense and stirring images that characterize his style. Stephen Conroy was born in Helensburgh, Scotland in 1964. In 1982 he attended the Glasgow School of Art, where he completed his postgraduate studies, finishing in 1987. By 1989 Conroy's work had already gained much recognition and praise in the UK and internationally. His work is part of a number of public and private collections including the National Portrait Galleries of Scotland and England; The Metropolitan Museum of Art, New York; the Frissiras Museum, Athens, Greece and the Whitworth Art Gallery in Manchester. The artist lives and works in Scotland.

**John Currin
Thanksgiving, 2003
Oil on canvas
1730 x 1320mm (68⅛ x 52")
© John Currin, courtesy Sadie
Coles HQ, London**

Evocative, varied, and often styled in a deliberately retrograde manner, Currin's depictions of women nearly always induce a sense of the familiar. Currin likes to depict a bizarre and very American world of ageing divorcées, 1970s pin-ups and clichéd gay couples. Although the subject matter may tempt the viewer to feel uncomfortable and enjoy it, the mastery of Currin's technique is utterly seductive, drawing as it does on Old Master paintings and drawings. Currin has had major museum survey exhibitions (Museum of Contemporary Art, Chicago and Whitney Museum of American Art in 2003, and the Serpentine Gallery the same year), and a catalogue raisonné will be published by Rizzoli in 2006. Currin was born in Boulder in 1962. He attained a BFA in 1984, and an MFA from Yale University in 1986, and now lives and works in New York.

**Jiří David
Untitled from the series
'No Compassion' (Bush), 2001
C-print
1000 x 1500mm
(39⅜ x 59⅛")
© Jiří David, courtesy Musée
de l'Elysée, Lausanne**

Jiří David was born in Rumburk, Czechoslovakia, in 1956. He studied at the Academy of Fine Arts in Prague (1982–7). He was a member of the art group *Tvrdohlaví* (Hard Heads) from 1987 to 1991. From 1995 to 2001, he was the Head of Studio Communication at the Academy of Fine Arts in Prague and is currently the Head of Studio Conceptual and Intermedial at the Academy of Arts, Architecture and Design, Prague. His work can be viewed at the Futura Gallery, Holeckova 49, Prague.

**Philip-Lorca diCorcia
Head #11, 2000
Fujicolour crystal archive print
mounted onto plexiglass
1216 x 1521mm
(47⅞ x 59¹⁵⁄₁₆")
© Philip-Lorca diCorcia,
courtesy Pace/MacGill
Gallery, New York**

Philip-Lorca diCorcia was born in Hartford, Connecticut in 1951. He studied at the School of the Museum of Fine Arts, Boston and received his MFA in Photography from Yale University in 1979. He has been a three-time recipient of artist fellowships awarded by the National Endowment for the Arts, and in 2001 won the Infinity Award for Applied Photography from the International Centre of Photography. DiCorcia had his first solo show in 1985 and has been featured in one-person exhibitions worldwide. Often acknowledged as one of the most influential photographers of his generation, diCorcia's work is frequently shown alongside that of his peers in exhibitions intended to address society's cultural zeitgeist.

**Rineke Dijkstra
Shany, Herzliya, Israel,
August 1, 2003A
C-print
1260 x 1070mm
(49⅝ x 42⅛")
Courtesy Marian Goodman
Gallery, New York**

'In my work I look for specific characteristics of individual people in group settings…military service implies that one has to submit to a collective identity. There is always a tension, however, between the values of the community.' Dijkstra's work encompasses numerous series which capture the subject at a decisive moment of transition, often from adolescence to adulthood. She was born in Sittard, the Netherlands in 1959, and attended the Gerrit Rietveld Academy, Amsterdam from 1981 to 1986. She has received numerous awards, including The Kodak Award, the Netherlands, 1987; The Citybank Private Bank Photography Prize, 1998; the Werner Mantz Award, 1994; the Arts Encouragement Award, Amstelveen, 1993; and was nominated for the Young European Photographer's prize in 1990.

**Atul Dodiya
Father, 2002
Enamel paint on metal
shutters, acrylic and
marble dust on canvas
228 x 152mm (9 x 6")
Courtesy of Walsh
Gallery, Chicago**

The artist Atul Dodiya was born in Bombay in 1959. In 1982 he received his Bachelor of Fine Arts from the Sir J.J. School of Art, Bombay. He was awarded the Gold Medal from the Government

of Maharashtra in 1982; a fellowship from the Sir J.J. School of Art, Bombay in 1982; the Sanskrit Award in 1995; the Civitella Tanieri Foundation Fellowship, in Italy, in 1999 and the Sotheby's Prize in 1999. Dodiya has exhibited internationally, and his solo and group exhibitions include *Fifty Years of Art in Bombay*, National Gallery of Art, Bombay, 1997; participation in the Yokohama Triennale in Japan, 2001; (group) *Century City: Art and Culture in the Modern Metropolis*, Tate Modern, London, 2001; and *Espacio Uno*, Reina Sofia National Museum of Contemporary Art, Madrid, 2002.

Willie Doherty
Non-Specific Threat V
(Nauseating Barbarity),
2003
C-print
1650 x 1920mm
(65 x 75⁵⁄₈")
Courtesy Peter Kilchmann
Gallery, Zurich

Doherty was born and raised in Derry, where he still lives today. His use of photography is apt, as he is concerned with issues of personal freedom and identity. As well as working from his own photographs of deserted streets and blighted urban landscapes, Doherty has increasingly begun to appropriate images from television and newspapers, seeking to highlight the unconscious problem of criminalisation that can often begin before a crime has been committed. Doherty also uses his own camera to highlight the process, and through gentle and oblique texts, marks out carefully the additional use of language as a decisive weapon. He is careful not to express partisan opinions

in his work but rather address the more universal issues confronting the people of the city. Doherty studied at the Ulster Polytechnic in Belfast from 1978 to 1981. He was nominated for the Turner Prize in 1994 and 2003.

Tracey Emin
Death Mask, 2002
Distressed bronze
cast with gold plating
195 x 175 x 235mm
(7⁵⁄₈ x 6⁷⁄₈ x 9¼")
Courtesy Jay Jopling/White
Cube (London).
Photograph: Stephen White

Tracey Emin was born in 1963 and grew up in Margate, Kent. Emin completed an MA in painting at the Royal College of Art in London, in 1989. She destroyed the work that she produced during this period when she suffered what she described as her 'emotional suicide' following an abortion. Emin's first solo exhibition at White Cube was in London, in 1993. Thinking it would be her first and last chance exhibition, Emin sardonically titled the show *My Major Retrospective*, and included photographs of her destroyed paintings in a disarmingly frank exploration of her own life. The inclusion of *Everyone I Ever Slept With (1963-1995)* in the Royal Academy's *Sensation* exhibition, again demonstrated Emin's ability to make confrontational and provocative works that question the very definition of what art can be. She was short listed for the Turner Prize in 1999 and has had solo exhibitions internationally.

Darvish Fakhr
Mullah Ali
Oil on canvas
760 x 560mm
(30 x 22")
© Darvish Fakhr

Darvish Fakhr was born in 1969, and received his art education at the Museum School of Art, Boston, where he attained his BFA in 1994, and Slade School of Fine Art, London, where he got his MFA in 1997. He has exhibited in America and the UK, and a selection of his exhibitions include *Discerning Eye*, Mall Gallery, London in 2001 and at the Quod Art Gallery in Brighton. His work was included in the BP Portrait Award exhibition at the National Portrait Gallery in 1998, 1999, 2000, 2003 and 2004. Fakhr lives and works in Brighton.

Andrew Festing
The Woodmen and
Gardeners, 2002
Oil on canvas
1016 x 1524 mm (40 x 60")
© Andrew Festing

Andrew Festing was educated at Ampleforth College and then Sandhurst. He was a Captain in the Rifle Brigade until he retired in 1968. He took up the position of Head of the English Picture Department at Sotheby's until 1981. He then painted full time and was elected a member of the Royal Society of Portrait Painters in 1992, with whom he exhibits annually. He is currently President of this society. He has painted a number of members of the Royal Family, Cardinal Hume, 400 members of the House of Lords and 181 members of the House of Commons.

Eric Fischl
Joan and John, 2001–2
Oil on linen
1780 x 1900mm (70 x 75")
Collection: The Broad Art
Foundation, Santa Monica,
California. Courtesy Mary
Boone Gallery, New York

Born in New York in 1948, Eric Fischl grew up in the suburbs of Long Island. Against a background of alcoholism and a country-club culture obsessed with image, Fischl became focused on the rift between what was experienced and what could not be said. Fischl studied art at the California Institute of the Arts in Valencia, where he received his BFA in 1972. After graduation he moved to Chicago where he worked as a guard at the Museum of Contemporary Art. It was then that he was exposed to the non-mainstream art of Hairy Who. 'The underbelly, carnie world of Ed Paschke and the hilarious sexual vulgarity of Jim Nutt were revelatory experiences for me,' Fischl has said. In 1974, whilst teaching at the Nova Scotia College of Art and Design, he met his future wife, the artist April Gornik. They live and work in New York. Fischl's work has been exhibited worldwide.

Lucian Freud
The Brigadier, 2003–4
Oil on canvas
2235 x 1384mm (88 x 54½")
© Lucian Freud

Lucian Freud was born in Berlin in 1922. A grandson of Sigmund Freud, he came to England with his parents in 1933, and acquired British nationality in 1939. His earliest talent was in drawing, and he began to work full time as an

artist in 1938. In 1951 his *Interior at Paddington* won a prize at the Festival of Britain, and since then he has built up a formidable reputation as one of the most powerful contemporary figurative painters. Portraits and nudes are his specialities, often observed in arresting close-up. His early work was meticulously painted, so he has sometimes been described as a realist, but the subjectivity and intensity of his work has always set him apart from the sober traditional characteristics of most British figurative art.

Tim Gardner
Untitled (Carmichael Standing by Rain Barrel), 2003
Watercolour on paper
203.3 x 301.6mm (8 x 11⁷⁄₈")
© Stuart Shave/
Modern Art, London

Gardner was born in 1973 in Iowa City, USA but now lives and works in Los Angeles. He was educated at the University of Manitoba, Canada, where he received a BFA in 1996, and then at the University of Columbia, New York, where he graduated with an MA in Fine Art in 1999. His first group and solo exhibitions were held in Winnipeg, Canada in 1996, at the FITE Gallery, and the Off/Ice Gallery. Since then Gardner's work has featured in exhibitions concerned with drawing, painting and watercolour painting, in both Europe and America. He has had solo exhibitions with 303 Gallery, New York and Stuart Shave/Modern Art, London. He will have a solo show at the National Gallery, London in 2007.

Gilbert & George
Sky Tag, 2004
Four-panel piece
1500 x 1260mm (59 ⅛ x 49 ⅛")
© Gilbert & George,
courtesy Jay Jopling/White
Cube (London)

Gilbert was born Gilbert Proesch in 1943 in the Italian Dolomites. He studied at the Wolkenstein School of Art and Hallein School of Art, Austria and the Akademie der Kunst, Munich. George was born George Passmore in 1942 in Devon, England and studied at Dartington Hall College of Art; and the Oxford School of Art. Gilbert & George met while students at the St Martin's School of Art, London in 1967, and have lived and worked together in London since 1968. Moving to the working-class neighbourhood of Spitalfields in London, Gilbert & George revolted against art's elitism, naming their work 'Art for all' and declaring themselves 'living sculptures'. In 1986, Gilbert & George were awarded the Turner Prize and in 2005, represented Britain at the Venice Biennale.

Catherine Goodman
My Sister Sophie, 2004
Oil on linen
1525 x 1270mm (60 x 50")
© Catherine Goodman

Catherine Goodman was born in London in 1961. She attended Camberwell School of Arts and Crafts and the Royal Academy Schools before winning the 1987 Royal Academy Gold Medal. In 2002 she won first prize in the BP Portrait Award for her painting of Dom Anthony Sutch, the Benedictine monk and Master of Downside School. A gestural,

tonal painter, whose subjects are landscapes, cityscapes, interiors and people, Goodman's work is rooted in the tradition of the School of London. The artist is Director of the Prince of Wales's Drawing School, a centre that promotes observational drawing in fine art teaching. She lives and works in London, where she exhibits with Marlborough Fine Art.

Dryden Goodwin
Jon, 2004
Red watercolour on paper
570 x 380mm (22½ x 15")
© Dryden Goodwin, courtesy
Stephen Friedman
Gallery, London

Dryden Goodwin's work includes photography, drawing, printmaking, sound, film, and video installation. He was born in Britain in 1971 and lives and works in London. Goodwin studied at the Slade School of Fine Art, between 1992 and 1996. His work has been widely exhibited both in the UK and abroad. In recent years he has been commissioned to make video installation and film works for Tate Britain (*Art Now*, 2002), BALTIC (*The Cathedral*, 2003), Manchester Art Gallery and New Gallery Walsall (*Dilate*, 2003) and Channel 4 (*Animate tv!* 2005). His work was shown at the fiftieth Venice Biennale in 2003, *Century of Artists' Film in Britain*, Tate Britain, 2003–4 and *Reality Check*, a touring show curated by the Photographers' Gallery and the British Council, 2002–4. Goodwin has received major fellowships from Benetton's Art and Communication Institute, Fabrica, Treviso, Italy, 1996–7 and in the UK from The National Endowment for Science, Technology and the Arts (NESTA), 2002–3.

Douglas Gordon
Fog (still from installation),
2002
Double DVD projection
onto a large single screen
Courtesy Douglas Gordon
and Lisson Gallery

Douglas Gordon was born in Glasgow in 1966. His work epitomizes a new fluidity that has developed between video and film in contemporary art. Using both original and appropriated footage, often in the form of video installations, his work explores themes such as temptation and fear, life and death, good and evil, and guilt and innocence. Gordon's work asks for an active involvement on behalf of the viewer in order to convey a perception of human nature as mutable and contradictory. He was awarded the Turner Prize in 1996, the Premio 2000 at the Venice Biennale in 1997, and the Hugo Boss Prize in 1998.

Katy Grannan
Jesse and Robert, Mystic Lake,
Medford, MA, 2003
C-print
1220 x 1524mm (48 ⅛ x 60")
Courtesy Emily Tsingou Gallery,
London

Katy Grannan was born in Arlington, Massachusetts, USA, and lives and works in both San Francisco and New York. She received her BA at the University of Pennsylvania in 1991 and her MFA at Yale University in 1999. She has exhibited all over America and Europe, was one of only four photographers included in the 2004 Whitney Biennial, and received the prestigious Baum Award for an emerging photographer in

2004. Her first monograph, *Model American*, was published by Aperture and Thames and Hudson in 2005, and solo exhibitions of her most recent work will appear at Fraenkel Gallery, San Francisco, Greenberg Van Doren, New York, and Gallery 51, Antwerp. Her work is held in numerous collections, including the Metropolitan Museum of Art, the Whitney Museum of American Art, the Guggenheim Museum, and the International Center of Photography.

Philip Hale
Thomas Adès, 2002
Oil on canvas
2138 x 1073mm (84⅛ x 42¼")
© National Portrait Gallery, London (NPG 6619)

Philip Hale was born in 1963 and raised in Kenya and the east coast of the USA. At the age of sixteen he was apprenticed to the painter Richard Berry and spent three years working with him. Although he is best known in the UK as a portrait painter, he has also done work for Stephen King, including an illustrated edition of *Insomnia*, artwork for the bands TOOL and Serafin as well as development work for Warner Brothers. Hale has expanded his portfolio to include designing chassis for racing motorcycles. He was runner-up in the National Portrait Gallery's BP Portrait Award in 2000 and 2001. Several books of his work include *Goad*, *Mockingbirds*, and *Relaxeder*. He currently lives and works in London.

Maggi Hambling
Michael Jackson, 2004
Oil on canvas
965 x 915mm (38 x 36")
© Maggi Hambling, courtesy Marlborough Fine Art (London) Ltd

Born in Sudbury in Suffolk in 1945, Hambling studied with Lett Haines and Cedric Morris at Hadleigh, and began painting portraits in 1973. She was the first artist in residence at the National Gallery in London (1980–81), and her series of pictures 'Max Wall' was showcased at the National Portrait Gallery in 1983. She was commissioned to paint the portrait of Sir Georg Solti conducting Liszt's *A Faust Symphony* in 1985 and in 1987 the Serpentine Gallery in London hosted one of her solo exhibitions. In 1996 Hambling had an exhibition of sculpture in bronze at Marlborough Fine Art, London, which led on to the commission of *A Statue for Oscar Wilde*. Hambling's paintings and bronzes of Henrietta Moraes were shown at Marlborough Fine Art in 2001, and her sculpture *Scallop (for Benjamin Britten)* was unveiled at the Aldeburgh Festival in 2003. A book *Maggi Hambling – The Works*, published in 2006 by Unicorn Press, includes a series of conversations with Andrew Lambirth.

Nicola Hicks
Self-Portrait, 2001
Charcoal on brown paper
1300 x 1270mm
(51⅛ x 50")
Courtesy Angela Flowers Gallery, London. Photograph: Shaun McCracken

Nicola Hicks was born in 1960 in London. She was educated at the Chelsea School of Art (1978–82), and at the Royal College of Art (1982–5). Her work is mainly comprised of sculptures and drawings. She was artist-in-residence at the Manchester School of Art where she worked on site for *Out of Clay*, 1988, at the Brentwood High School and Yorkshire Sculpture Park (1988–9). She was commissioned to produce the *Monument to the Brown Dog*, which is situated in Battersea Park. Her work has been showcased all over the world, and she lives and works in London.

David Hockney
Peter Goulds Standing, 2005
Oil on canvas
1212.9 x 908.1mm (47¾ x 35¾")
© David Hockney. Photograph: Richard Schmidt

David Hockney was born in Bradford in 1937. He studied at the Bradford School of Art from 1953 to 1957. Between 1959 and 1962 he studied at the Royal College of Art where R.B. Kitaj, Allen Jones and Derek Boshier were among his classmates. Hockney graduated with a gold medal and held his sell-out one-man show at the Kasmin Gallery, London in 1963. Hockney has worked across all media: drawing, painting, printmaking and photography. He has been

commissioned to design sets for theatrical displays and the monograph *Hockney Paints the Stage* was the first comprehensive examination of the artist's work for the theatre. Inspired by Ingrès, in 1999 he began hundreds of portrait drawings using camera lucida. Extensive research into the Old Masters' use of the lens was published as *Secret Knowledge* in 2001. He divides his time between California and London.

Takashi Homma
From the series 'Children of Tokyo', 2000–01
C-print
© Takashi Homma

Takashi Homma was born in Tokyo in 1962. He studied at the Department of Photography, at the Nihon University in Tokyo, from 1981 to 1984. He worked for the Light Publicity Company in Tokyo for six years (1985–91), before moving to London for a year (1991–2). Homma photographs Tokyo suburbia, showing neat houses and empty streets, that are hard and hopeless in tone. Homma portrays – with a certain distance – the dark side of the economic success that leaves little room for the realization of individual dreams in cold and sterile suburbs. He lives and works in Tokyo.

Craigie Horsfield
Albert Martín, Avigunda de Puig
de Jorba, Vallbona, Barcelona,
December 1995
Black-and-white photograph
1360 x 1200mm (53½ x 47¼")
Courtesy Monica de Cardenas
Gallery, Milan

Craigie Horsfield was born in
Cambridge, England, and now
lives and works in London and
New York. From early on in his
career Horsfield has integrated
his concern with relation into his
work, where art is seen as one
element of arts thinking, amongst
other ideas conventionally given
over to politics, philosophy and
ethics. At the core of Horsfield's
work concerning relation are his
collaborative social projects.
His photographs make up a
significant part of many of these
collaborations, which have also
included film, theatre, installation,
performance, dance, video,
sound, music, live mixing, urban
and architectural proposals and
the initiation of a festival. Recently
his work has been featured in
Documenta X and XI, Kassel.
His work can be seen in various
collections throughout Europe
and the USA.

Zhang Huan
Family Tree, 2000
C-print on Fuji archival paper
1270 x 1016mm (50 x 40")
each (9 images)
Courtesy Zhang Huan

Chinese artist Zhang Huan was
born in An Yang City, He Nan
Province in China, in 1965.
He studied for his BA at He Nan
University, Kai Feng, graduating
in 1988, and he received an
MA from the Central Academy
of Arts, Beijing, in 1993. He has

exhibited worldwide including
Zhang Huan, The Power Plant
Contemporary Art Gallery, Toronto,
2001; *Zhang Huan*, Museo des
Peregrinacions, Santiago de
Compostela, Spain, 2001; *Zhang
Huan*, Kunstverein, Hamburg,
Germany, 2002; *Zhang Huan*,
Nikolaj Copenhagen Contemporary
Art Center, Copenhagen, 2003;
*Regeneration, Contemporary
Chinese Art from China and the
US*, Samek Art Gallery, Pennsylvania,
2004; *Witness*, at the Museum
of Contemporary Art, Sydney,
2004, at the Bochum Museum,
Germany, 2003 and the Tri Postal,
Lille, 2004. He lives and works
in New York and Shanghai.

Gary Hume
Green Nicola, 2003
Gloss paint on aluminium
1800 x 1390mm
(70 9/10 x 54 7/10")
© Gary Hume, courtesy Jay
Jopling/White Cube (London)

Born in Kent in 1962, Gary Hume
became a star of the yBa (young
British artist) movement in the
1990s, virtually overnight with
his 'Doors' series. The series
comprises some fifty works and
the format and formal structure of
these largely several-part paintings
assembled in a row are based on
real doors to be found in public
institutions, such as hospitals and
schools. With these rows of door
images and their sparse depiction,
Hume makes reference to the
heroes of the 'colour-field', 'hard-
edge' and 'shaped-canvas'
movements of the 1960s and
1970s in America. He finds and
invents new images of everyday
images, whether they be icons
of pop or the fashion world; his
work *Michael* (Michael Jackson,
2001) is an example of this.

Lucy Jones
Asleep, Seeing, or Dead, 2000
Oil on canvas
2185 x 1570mm (86 ⅛ x 61 ⅞")
Courtesy Angela Flowers
Gallery, London

Jones was born in London in 1955.
She studied at the Byam Shaw
School of Drawing and Painting,
1974–6, and at the Camberwell
School of Art, graduating with
first-class honours in 1979. She
studied for her MA at the Royal
College of Art until 1982, and then
at The British School of Rome,
1982–4. She has been a tutor at
the Chelsea School of Art and the
Slade School of Art and has won
several prizes for her work including
a John Moores Exhibition prize
in 1995 and the Graham Young
Print Prize at the Royal Academy's
Summer Exhibition in 2002.

Alex Katz
Ada, 2004
Oil on canvas
2438 x 851mm (96 x 33½")
Courtesy PaceWildenstein,
New York. Photograph:
Ellen Labenski

Alex Katz was born in 1927 in
New York City. He studied at the
Cooper Union Art School in
New York, and the Skowhegan
School of Painting and Sculpture
in Maine, between 1946 and
1950. His first solo exhibition took
place at the Roko Gallery in New
York in 1954. The first retrospective
of his work was held at the Whitney
Museum of American Art, New
York in 1986, and took a tour
to Miami the same year. Although
Katz's art grew out of the
New York School of abstract
expressionism, which he both
acknowledged and rejected,
he is better known for his large-

scale, or 'billboard' paintings, which
convey their mood and atmosphere
primarily through colour and the
broad arrangement of shapes on
a flat plane.

Peter Kennard
Face 9, 2002
Oil and silver-gelatin on canvas
558 x 457mm (22 x 18")
© Peter Kennard, courtesy
Gimpel Fils, London

Peter Kennard was born in London
in 1949. He studied at the Byam
Shaw School of Art from 1965
to 1967, and at the Slade School
of Fine Art from 1967 to 1970.
He graduated from the Royal
College of Art with an MA in Fine
Art in 1979. His selected shows
include: *Photomontages for Peace*,
Palais des Nations, Geneva, 1989;
Stop Painting and Photomontages,
1973–91, Kent Gallery, New York,
1992; *Break Up – Eastern Europe*,
Laing Gallery, Newcastle, 1992;
Our Financial Times, Gimpel Fils,
London (with Ken Livingstone MP,
1995), and *Decoration*, Gimpel
Fils, London, 2004.

Hew Locke
Jungle Queen I, 2003
Wood and cardboard base,
glue, mixed media (pom-poms,
feather trim, beads, toys etc.)
2750 x 1600 x 400mm
(108 ⅜ x 63 x 15¾")
Courtesy Cherrybrisk
Collection, London

Hew Locke was educated at the
Falmouth School of Art, graduating
with a BA in Fine Art in 1988,
and from the Royal College of Art
with an MA in Sculpture in 1994.
His work is included in many
collections, including The Saatchi
Gallery, London, the collection
of Eileen Harris Norton and Peter

Norton, Santa Monica and the V&A Drawing Collection, London. He won the East International Award, and the Paul Hamlyn Award in 2000. *Hew Locke*, the monograph was published in 2005 by The New Art Gallery, Walsall, and he will be exhibiting in British Art Show 6 (2005–6).

**David Mach
Lord Chief Justice,
Lord Woolf, 2003
Nickel-plated metal coat
hangers
2210 x 1524mm (87 x 60")
© David Mach**

Born in 1956, David Mach began making sculptures from coat hangers in 1992. Mach has exhibited internationally, was nominated for the Turner Prize in 1988, and elected a Royal Academician in 1998. His collage portrait of the entrepreneur Sir Richard Branson was commissioned by the National Portrait Gallery and is constructed from a postcard of a Dame Laura Knight self-portrait, also in the collection.

**Melanie Manchot
Emma and Charlie, from the
'Fontainebleau' series, 2001
C-print
1000 x 1250mm
(39 ³/₈ x 49 ¹/₄")
Courtesy of Melanie Manchot
and Fred Gallery, London**

Melanie Manchot was born in Germany in 1966. She was educated at New York University, 1988–9; at City University, London (MA in Arts and Education), 1989–90; and the Royal College of Art, London (MFA in Photography), 1990–92. Her work is part of many private and public collections internationally.

Awards and fellowships include the 1997 Arts for Everyone Award, British Council Awards in 1999 and 2005, and a MacDowell Fellowship (USA) in 2000. A selection of her solo shows include *Love is a stranger*, Cornerhouse, Manchester, 2002; Portland Institute for Contemporary Art, Portland, Oregon, 2002; *Moscow Girls*, Rhodes + Mann Gallery, London, 2004; and *Stories from Russia*, The Photographers' Gallery, London, 2005. Her monograph *Love is a stranger*, was published by Prestel in 2001.

**Yasumasa Morimura
An Inner Dialogue with
Frida Kahlo, 'Hand-shaped
earring', 2001
C-print
1200 x 960mm (47 ¹/₄ x 37 ⁷/₈")
Courtesy of Yoshiko Isshiki
Office**

Osaka-based Morimura is one of the most internationally renowned Japanese contemporary artists. Underlying his work is a lucid understanding of the power of well-known images. He uses his own body as a medium for the disruption of Western pictorial convention to produce a tribute to, and ironic critical view of, Western painting. Morimura burst onto the international art scene with his 'Art History' series, computer-aided reconstructions of great Western paintings that featured the artist's big-nosed face replacing the faces of the works' original subjects. Rather than reject images, Morimura thinks it may be more profitable to occupy them. His more recent work has featured the artist made-up as Hollywood starlets, and has won him solo shows at the Museum of Contemporary Art, Chicago,

the Yokohama Museum of Art, and ensured his inclusion in major group shows at scores of important galleries and museums around the world.

**Zwelethu Mthethwa
Untitled, from the
'Sugar Cane' series, 2003
C-print
1499 x 1943mm (59 x 76 ¹/₂")
Courtesy Jack Shainman
Gallery, New York**

Zwelethu Mthethwa was born in 1960 in Durban, Kwazulu Natal, South Africa. He received an advanced diploma in Fine Arts from the Michaelis School of Fine Art, UCT, in 1985; and an MFA in Imaging Art, Rochester Institute for Technology, USA, 1989. He was appointed Lecturer of Photography and Drawing at the Michaelis School (1994–8), and Senior Lecturer in 1998. As well as acting as a panellist for the National Arts Council in South Africa, Mthethwa was elected on to the Association for Visual Arts Executive Committee in 1999, and was an adjudicator for several competitions. His work has been showcased all over the world and his solo shows have included *Lines of Negotiation*, Jack Shainman Gallery, New York, 2003 and *Harvesting Workers*, Davis Museum, Wellesley College, MA, in 2004.

**Vik Muniz
Jorge, from 'Pictures of
Magazines', 2003
C-print
Two sizes: 2540 x 1829mm
(100 x 72in)
1270 x 1016mm (50 x 40")
Edition of 6 + 4 AP
Courtesy Galeria Fortes Vilaça,
São Paulo**

Vik Muniz was born in 1961, in São Paulo, Brazil. He currently lives and works in New York City and Rio de Janeiro. His solo exhibitions include: *The Things themselves: Pictures of Dusk by Vik Muniz*, Whitney Museum of American Arts, New York, 2001; Centro Galego de Arte Contemporanea-CGAC; Santiago de Compostela, Spain, 2003–4; *Macro-*, Museo D'Arte Contemporanea Roma, 2004; Paço Imperial, Rome, 2003; BrazilMonadic *Works and Drawings*, Galeria Fortes Vilaça, São Paulo, 2003; and Indianapolis Museum of Contemporary Art, Indianapolis, 2003. His most recent show was held at the National Academy of Sciences, Washington DC, entitled *Prisons after Piranesi*. A retrospective of Muniz's work will open at the Miami Art Museum in 2006 and will travel in the USA. *Reflex: A Vik Muniz Primer*, a mid-career survey examining his series was published by Aperture in 2005.

Tim Noble and Sue Webster
He/She, 2004
Welded metal, light projector
He: 1850 x 960 x 1480mm
(72³/₄ x 37³/₄ x 58¹/₄")
She: 1140 x 1000 x 1860mm
(44 ⁷/₈ x 39 ³/₈ x 73¹/₄")
Courtesy Stuart Shave/Modern
Art, London

Tim Noble was born in Stroud, England, in 1966 and did an art foundation course at Cheltenham Art College (1985–6). He received a BA in Fine Art from Nottingham Trent University in 1989; and an MA in Sculpture from the Royal College of Art, London, in 1994. During his time in Nottingham he met Sue Webster, who he has worked with since 1994. Webster was born in Leicester in 1967, completed her art foundation course at Leicester Polytechnic and then received a BA in Fine Art from Nottingham Trent University in 1989. From 1989 to 1992, Noble and Webster took up residency at Dean Clough, Halifax, West Yorkshire. Their recent solo exhibitions have included PS1/MoMA, New York, 2003 and *Modern Art is Dead*, Modern Art, London, 2004.

Catherine Opie
Self-Portrait/Nursing, 2004
C-print
1018 x 813 mm
(40 x 32")
Courtesy Regen Projects,
Los Angeles

Catherine Opie was born in Sandusky, Ohio in 1961. She received her MFA from CalArts in 1988. In 2000, Opie was appointed Professor of Fine Art at Yale University, and in 2001, she accepted the position of Professor of Photography at UCLA. Opie has exhibited extensively both nationally and internationally. Her work has appeared in group exhibitions from Paris to Australia to New Orleans, including the 1995 Whitney Museum Biennial in New York and *In a Different Light* at the University Art Museum in Berkeley in 1995. Recent solo museum exhibitions have been organized by The Saint Louis Art Museum, The Photographers' Gallery in London, the Museum of Contemporary Art in Chicago, and the Museum of Contemporary Art in Los Angeles. She lives and works in Los Angeles.

Julian Opie
Alex, bassist; Damon, singer;
Dave, drummer; Graham,
guitarist, 2000
C-type colour prints on
paper laid on panel
868 x 758mm (34¹/₈ x 29⁷/₈")
© Julian Opie

Julian Opie was born in London in 1958. He studied at Goldsmith College of Art between 1979 and 1982. Since his first one person show in 1983, Opie has exhibited widely in Europe and the USA. Opie's early sculpture, which thrust him into the limelight in the mid-1980s were centred around an interaction between painting and sculpture and characterized by a loose style and playful inquisitiveness. Recent solo shows include; *Bijou Gets Undressed,* in Düsseldorf, 2003, and he has curated installations for Selfridges, Manchester, 2003, and the Public Art Fund, City Hall Park, New York, 2005. Opie lives and works in London.

Celia Paul
My Mother in a Saint's
Dress, 2003
Oil on canvas
916 x 916mm (36 x 36")
© Celia Paul, courtesy
Marlborough Graphics, London

Celia Paul was born in 1959 in Trivandrum, India and attended the Slade School of Art, London from 1976 to 1981. She has exhibited widely and has works in many public collections including the British Museum, the V&A and the Metropolitan Museum, New York. Lucian Freud was of great influence to Paul during her student years and she appeared in many of his paintings including *Painter and Model and Girl in a Striped Night-shirt*. As well as several solo shows at Marlborough Fine Art, London, Paul has exhibited at the annual *Corner* exhibition in Charlottenborg, Copenhagen, for the last three years. Her exhibition *Stillness* was on view at Abbot Hall, Kendal, Cumbria in 2004, and a retrospective exhibition of paintings and prints was held at the Graves Art Gallery, Sheffield, 2005.

Stuart Pearson Wright
J. K. Rowling, 2005
Mixed media
972 x 720mm (38¹/₄ x 28³/₈")
© National Portrait Gallery,
London (NPG 6723)

Stuart Pearson Wright was born in Northampton in 1975. He studied at the Slade School of Art and University College London, 1995–9. He has depicted the following noted persons in his portraits: Mike Leigh, Richard E. Grant, Charles Saumarez Smith, Michael Palin and Terry Jones.

He has won several major awards including the BP Travel Award in 1999 and the overall award in 2001. His selected solo shows were held at the National Portrait Gallery, as a result of the BP Travel Award, in 1999 and at the Eastbourne Arts Centre in 1995.

Weng Peijun
Academic Degree (from
the series 'Great Family
Aspirations'), 2000
C-print
Courtesy of Hanart TZ
Gallery, Hong Kong

Weng Peijun was born in Hainan, China in 1961. He moved to Guangzhou to study at the Academy of Fine Arts. He first began to show an interest in drawing when he was six, and when he was fourteen his father made sure that drawing was more than just a passion, by hiring him a drawing teacher and buying him artist's monographs. His first artist experiments only date back to 1997. He experimented with different styles, one day he was an Abstract Expressionist, the next he concentrated on geometric abstraction. In 2000, inspiration struck with his series 'Great Family Aspirations', based on propaganda posters from the Cultural Revolution, depicting thought-provoking scenes of families after 1976, and the institution of the single child policy. His work has been exhibited worldwide.

Evan Penny
Gerry, 2003
Silicone, pigment, hair,
fabric, aluminium
2489.2 x 2336.8 x 1574.8mm
(98 x 92 x 62")
Courtesy Sperone
Westwater, New York

Evan Penny was born in 1953 in South Africa. A Canadian citizen, Penny currently lives and works in Toronto, Canada. He received a postgraduate degree in Sculpture from the Alberta College of Art in 1978 and has been making sculpture of the human form for almost three decades, focusing recently on the terrain between the 'real' and the 'replica'. Since his first solo exhibition in 1981, Penny has had numerous exhibitions and his work has been shown extensively throughout Canada and abroad. He has held teaching positions at the Alberta College of Art, the School of the Art Institute of Chicago, the Ontario College of Art, Toronto, and the Toronto School of Art. A major retrospective of his work toured Canada throughout 2004 and 2005. His work was included in an exhibition of contemporary sculpture, *Figure it Out*, 2005, held at the Hudson Valley Center for Contemporary Art. He also had a solo exhibition at Sperone Westwater, New York in the same year.

Grayson Perry
St Claire (Thirty Seven Wanks
Across Northern Spain), 2003
Glazed ceramic
840 x 550mm (33⅛ x 21⅝")
Courtesy of Grayson Perry and
Victoria Miro Gallery, London

Grayson Perry was born in Essex in 1960. It is impossible to discuss Grayson Perry without also mentioning Claire. Claire is Perry's transvestite alter ego, a part of him who established herself as an independent personality at puberty, but who now returns with increasing frequency to feature in his work. 'Claire is an Essex housewife up to town to do some shopping,' Perry explains, 'a cross between Katie Boyle and Camilla Parker Bowles.' The description reveals something of both Perry's wicked sense of humour, and his interest in the social composition of contemporary Britain. Perry studied Fine Art at Portsmouth Polytechnic, but it was an evening class in pottery that led most directly to the particularities of his current practice. Winner of the Turner Prize in 2003, his selected solo exhibitions have been held at the Anthony d'Offay Gallery, London, 1996–7; Laurent Delaye Gallery, London, 2000; Barbican Art Gallery, London, 2002; Victoria Miro Gallery, London, 2004; and Galleria Il Capricorno, Venice, 2005.

Elizabeth Peyton
Luing (Tony), 2001
Oil on MDF
279.4 x 355.6mm (11 x 14")
© Elizabeth Peyton, courtesy
of Sadie Coles HQ, London and
Gavin Brown's Enterprise,
New York

Born in 1965 in Danbury, Connecticut, Elizabeth Peyton paints and draws portraits of people who are in some way close to her. The crucial factor in her portrayal of the chosen subject is the intensity of the encounter with that companion or worshipped idol, and in Peyton's paintings and drawings the distinction between friends and stars ultimately becomes blurred. Peyton's first major museum exhibition was at the Kunstmuseum Wolfsburg, in 1998, in a solo show organized in co-operation with the Museum für Gegenwartskunst in Basel. A complete monograph on Peyton was published by Rizzoli in 2005. She lives and works in New York.

Tom Phillips
Sir John Sulston, 2004
Oil on canvas
510 x 510mm
(20⅛ x 20⅛")
© Tom Phillips

Tom Phillips was born in 1937 in London where he still lives and works. As an internationally established artist and prominent Royal Academician he is represented in museum collections worldwide. He is best known for his book A *Humument* and his work on Dante's *Inferno* which he translated and illustrated (as co-director of the television version he won the Italia Prize).

Major retrospectives of his paintings have been held on both sides of the Atlantic including National Portrait Gallery, Yale Centre, Royal Academy, Musée d'Art Moderne, Paris, and Dulwich Picture Gallery. His theatre projects include designing *The Winter's Tale*, for the opening season of the Shakespeare's Globe Theatre, and translating *Otello* for the ENO, in 1998. He is a trustee of the National Portrait Gallery and the British Museum.

Marc Quinn
Lucas, 2001
Human placenta and umbilical
cord, stainless steel, perspex,
refrigeration equipment
2045 x 640 x 640mm
(80½ x 25³/₁₆ x 25³/₁₆")
© Marc Quinn, courtesy Jay
Jopling/White Cube (London).
Photograph: Roger Sinek

Born in London in 1964, Quinn studied at Cambridge University before returning to London to establish his career as an artist. Although Quinn is known as a sculptor, he has also produced accomplished prints and photographs. His use of non-traditional materials, ranging from blood to silicone to human excrement, speaks of his interest in understanding the profundities of the corporeal body and the abundance of nature, in their beauty and their messy reality. Quinn's solo show at the South London Gallery in 1998 marked a new and sustained post-*Sensation* moment in London art of the 1990s.

Alessandro Raho
Dame Judi Dench, 2004
Oil on canvas
2521 x 1759mm (99¼ x 69¼")
© National Portrait Gallery,
London (NPG 6671)

Alessandro Raho's paintings and photographs deal with narrative, nostalgia and desire, using subject matter that ranges from personal friends to landscapes. He employs a variety of intricate processes to make his paintings luxuriously photographic and his photographs deceptively painterly. Raho has exhibited his work in such venues as London's Institute of Contemporary Arts and the Walker Art Gallery, Minneapolis, USA.

Victoria Russell
Fiona Shaw, 2002
Oil on canvas
1828 x 1220mm (72 x 48")
© National Portrait Gallery,
London (NPG 6609)

Russell was born in 1962 and studied at the Royal Academy Schools, London and Central St Martin's College of Art and Design. She has held many solo exhibitions, participated in numerous Group Exhibitions and received awards and portrait commissions. Russell has been painting theatre audiences for several years, the viewer becoming the subject of attention of the figures in the painting thus shifting the power dynamic between the viewed and the viewer. Her work incorporates references to both painting and to cinema. This brings traditional painting into a contemporary context allowing Russell to recast representations of women.

Jenny Saville
Reverse, 2002–3
Oil on canvas
2133 x 2439mm (84 x 96")
Courtesy Gagosian Gallery,
New York. Photograph: Robert McKeever

Jenny Saville was born in Cambridge in 1970. In 1990, midway through her BA course at the Glasgow School of Art, she exhibited in *Contemporary '90* at the Royal College of Art. In 1992 she completed her degree as well as showing in Edinburgh and London. Following the success of her show in the Saatchi Gallery in 1994, Saville went on to take part in the exhibition *American Passion*, which toured from the McLellan Gallery, Glasgow, to the Royal College of Art and the Yale Center for British Art in New Haven, Connecticut. From then on she was invited to take part in group shows and in 1999 her first solo exhibition was met with critical success. Some of her more recent exhibitions include: *Migrants*, Gagosian Gallery, New York, 2003; *Summer Exhibition*, Royal Academy of Arts, London, 2004; *The Figure In and Out of Space*, Gagosian Gallery, New York, 2005 and *Jenny Saville*, Museo d'Arte Contemporanea Roma, Rome, 2005. She lives and works in Italy.

Christoph Schellberg
MC Schafter, 2002
Acrylic on canvas
1950 x 1500mm
(79 x 59") each
Courtesy Hans and Gro Luehn

Christopher Schellberg was born in Düsseldorf, Germany in 1973. He was educated at the Academy of Fine Arts, Hamburg, Germany, between 1995 and 1997; and then at the Academy of Arts, Düsseldorf, Germany between 1997 and 2001. He lives in Cologne and works in Düsseldorf. His first solo show took place at the Ville de Bank, Enschede, the Netherlands, and a selection of following solo shows include: *Fleurs du Mal*, Schickeria Bar, Berlin, 2004; *Pixels*, Stallan Holm Gallery, New York, 2004; and *Each Day is Valentine's Day*, Jablonka Luhn, Cologne, 2005.

Tai-Shan Schierenberg
Seamus Heaney, 2004
Oil on canvas
967 x 915mm (38 x 36")
Courtesy Angela Flowers
Gallery, London

Tai-Shan Schierenberg was born in England in 1962, but grew up in Malaysia, London and Germany. He studied at St Martin's School of Art, London from 1981 to 1985 and the Slade, London, from 1985 to 1987. He was the co-winner of the BP Portrait Award at the National Portrait Gallery, London, in 1989, for which he recieved a commission to paint Sir John Mortimer. He was the first prize winner at the Royal Overseas League exhibition, for *A View of the New*, in 1990. Through his gallery, Angela Flowers, he has exhibited extensively in Europe and the USA.

Gary Schneider
Shirley, 2001
C-print
1524 x 1219mm (60 x 48")
© Gary Schneider

Gary Schneider, born in South Africa in 1954, has a BFA from the University of Cape Town and an MFA from the Pratt Institute in New York. He worked in the theatre of Richard Foreman and Robert Wilson in the 1970s, also making films throughout the early 1980s. Schneider began exhibiting photographs in 1991 at PPOW gallery in New York. *His Genetic Self-Portrait* installation, completed in 1998 was exhibited at mass MoCA and the International Center of Photography, USA. It has also been exhibited internationally and received an Eisenstadt award in 2000. In 2004, a survey, *Gary Schneider: Portraits*, was mounted at the Sackler Museum, Boston and received an NEA grant. The catalogue was published by Yale University Press and HUAM. In 2005 he received the Lou Stoumen Award and Aperture exhibited and published his *Nudes*. Some collections which include his work are The Whitney Museum, The Guggenheim Museum and The Metropolitan Museum, New York; The National Gallery of Canada; The Musée de l'Elysée, Lausanne; The MFA, Boston and The Art Institute of Chicago.

Andres Serrano
Boy Scout John Schneider,
Troop 422, 2002
C-print
1524 x 1257mm (60 x 49½")
© Andres Serrano, courtesy
Gimpel Fils, London

Andres Serrano was born in
New York in 1950. He studied
at the Brooklyn Museum Art
School, New York between 1967
and 1969. He started to exhibit
his photographic works in the
mid-1990s, and selected solo
shows include: *A History of Andres
Serrano: A History of Sex*,
Paula Cooper Gallery, New York,
1997; *Andres Serrano*, PROA,
Buenos Aires, Argentina, which
travelled to the National Gallery
of Victoria, Melbourne, Australia,
in 1997; *America*, Gimpel Fils,
London, 2002; and *America*,
Paula Cooper Gallery, New York,
2003–4. He won the Gold and
Silver Award at the Art Directors
Club 79th Annual Awards, 2000.

Shirana Shahbazi
Andro-01-2003
C-print on aluminium
Variable dimensions
Courtesy Bob van Orsouw
Gallery, Zurich

Shirana Shahbazi was born in
Tehran, Iran, in 1974, and moved
to Germany in 1985. She studied
Photography and Design at the
Fachhochschule Dortmund
(1995–7), and Photography at the
Hochschule für Gestaltung und
Kunst, Zurich (1977–2000). In
2002 her first solo exhibition took
place at the Bob van Orsouw
Gallery, Zurich. Solo exhibits in
New York (Salon 94, Trans Area,
the Wrong Gallery), as well as
participation in important group
exhibits including the 2002 Venice

Biennale and the 2005 Prague
Biennial add to the international
reception of her many-faceted
work. In 2002 Shahbazi was
awarded the highly esteemed
Citigroup Private Bank Photography
Prize, in London, for her photo-
series 'Goftare Nik/ Good Words'.
She lives and works in Zurich.

Malick Sidibé
Vues de dos, 2001
Gelatin silver print, painted
glass frame
215.9 x 152.4mm (8½ x 6")
Courtesy of Jack Shainman
Gallery, New York

Born in 1935, in the small village
of Soloba, Sudan (now Mali),
Sidibé stood out because of
his talent for drawing. His tutors
encouraged him to enlist in
the School of Sudanese Arts
in Bamako. He graduated in
Jewellery and Design but started
his career in a totally different
field – the decoration of the
Photo Service boutique, where
he became the pupil of its owner.
Three years later he opened
his own studio – Studio Malick,
where he still works. In the 1960s
and 1970s he focused solely
on photographing local youth and
their wanderings. If his images
emanate so much power, it is
because, beyond the convivial
and careless atmosphere, he also
illustrates the difficulty of having
to adapt to life in the city. The
confrontation with unemployment,
alcohol and the irresistible desire
to be like the young whites make
for a powerful image.

The Singh Twins:
Amrit and Rabindra
From Zero to Hero, 2002
Poster, gouache, gold dust on
mountboard
380 x 520mm (15 x 20½")
© The Singh Twins:
Amrit and Rabindra

London-born twin sisters Amrit
and Rabindra K. D. Kaur Singh
are contemporary British artists
of international standing,
whose award-winning paintings
have been acknowledged as
constituting a unique genre in
British art and for initiating
a new movement in the revival
of the Indian miniature tradition
within modern art practices.
An Arts Council film about their
work received The Best Film
on Art award at the 2001 Asolo
International Film Festival, and
in the same year they were short
listed for the Asian Women of
Achievement Award. In 2002,
they were appointed official artists
in residence for the Manchester
Commonwealth games. Their
work features in numerous
publications including *The Oxford
History of Art*, and they have been
invited to speak at galleries and
universities worldwide. Significant
interest from academics and
students has resulted in their
work being incorporated into the
Open University syllabus.

Beat Streuli
From the series
'New York', 2001
C-print
1510 x 2010mm (59½ x 79¼")
© Beat Streuli

An internationally acclaimed
photographer, Beat Streuli was
born in Altdorf, Switzerland in
1957, and now lives and works
in Zurich, Brussels and
Düsseldorf. He studied at the
Kunstgewerberschule in Zurich
and Basel (1977–81), and he
took seminars at the Hochschule
der Kunste, Berlin (1981–3). He
has lived in Paris, Rome, London
and New York, and received
the Swiss Arts Council Grant in
1985, 1986 and 1988. He has
had numerous group and solo
exhibitions worldwide. Streuli has
been drawn back to the city of New
York again and again. Fascinated
by the contrasts between the
shadows of the skyscrapers
and the glaring sunlight, he has
captured unique and evocative
images of people in this hectic
modern metropolis and many
other cities.

Thomas Struth
The Richter Family II,
Cologne, 2002
C-print plexi-mounted
1020 x 1614mm
(40³/₁₆ x 63⁹/₁₆")
© Thomas Struth

Struth studied at the Düsseldorf
Academy, where he was taught
by Gerhard Richter. During the
1970s, he began to take
photographs that explore the
character of urban spaces, and
what it can reveal about the history
and identity of communities.
Beginning with the streets of
Düsseldorf, he gradually expanded

151

his project to include other cities in Western Europe, the United States, and Asia. In these photographs, buildings and cars become as evocative as human faces. Accustomed to hurrying through the city with an almost unseeing eye, we are encouraged, in the artist's words 'to give pause, to move to investigative viewing'. Struth also makes portraits of friends and acquaintances, usually in intimate gatherings, as if contrasting the public environment of architecture with the private space of the family. These photographs are explorations of social dynamics, showing how people within a tightly-knit group arrange themselves in front of the camera.

Sam Taylor-Wood
 **Ed Harris, from the series
'Crying Men', 2002**
C-print mounted on aluminium
862 x 1117mm
(33¹³/₁₆ x 43¹³/₁₆")
**© Sam Taylor-Wood,
courtesy Jay Jopling/White
Cube (London)**

Sam Taylor-Wood graduated from Goldsmiths College in 1990. Her work in photography and film is distinguished by an ironic and subversive use of the media, which centres on the creation of enigmatic situations replete with a latent but explosive energy. In films like *Noli Me Tangere* (1998), and photographs such as *Wrecked* (1996) she explores the boundaries between the sacred and profane, fusing religious imagery informed by the Renaissance and baroque periods with the secular, urban and contemporary landscape which she inhabits. Since her solo show at White Cube in 1995,

Taylor-Wood has had numerous shows including Fundico La Caixa, Barcelona, Hirshhorn Museum, Washington DC, and Matthew Marks Gallery in New York. In 1997 she received the Illy Café Prize for the Most Promising New Artist at the Venice Biennale and was nominated for the Turner Prize in 1998. The Hayward Gallery hosted a major survey of Taylor-Woods's work in 2002.

Juergen Teller
Yves Saint Laurent, 2000
C-print
254 x 304.8mm
(10 x 12")
© Juergen Teller

Juergen Teller was born in 1964 in Erlangen, Germany and after a short spell working as an apprentice bow maker, he began his career as a photographer. He studied at the Bayerische Staatslehranstalt für Photographie in Munich between 1984 and 1986, and then moved to London in September 1986. His ad campaigns have included work for Marc Jacobs, Helmut Lang, Yves Saint Laurent and Calvin Klein. He has photographed amongst others, Charlotte Rampling, Pele, Barbara Cartland, Kate Moss, William Eggleston, Kurt Cobain, Björk, Elton John, O.J. Simpson and Arnold Schwarzenegger. Recent exhibitions of his work include: *Louis XV*, Contemporary Fine Arts, Berlin, 2005; *Fashioning Fiction*, MoMA, New York, 2004; *Ich bin vierzig*, Kunsthalle Wien, 2004, and an exhibition at The Cartier Foundation, Paris, 2006.

Mario Testino
**The Prince of Wales with sons
Prince William and
Prince Harry, 2004**
© Mario Testino

Mario Testino was born in Lima, Peru. He studied Economics, Law and International Relations before moving to London to begin his formal training in photography. Mario travels extensively shooting for American, British, French and Italian *Vogue*, *L'Uomo Vogue* and *Vanity Fair*. He has worked with many high-profile celebrities including the British royals, and has contributed to the images of leading fashion houses. *Mario Testino: Portraits* opened at the National Portrait Gallery in London, February 2002 and the exhibition has travelled around the world stopping in Milan, Amsterdam, Edinburgh and Tokyo. As well as many other international solo exhibitions, Testino has been involved with several book projects. Recently, a collaboration with Marie Stopes International, Interact Worldwide and the United Nations Population Fund (UNFPA) called *Women to Women: Positively Speaking* was launched to raise awareness of women living with HIV/AIDS.

Andrew Tift
Alexander and Eun Ju, 2004
Acrylic on canvas
1127 x 973mm (44¼ x 38¼")
© Andrew Tift

Andrew Tift graduated with a first-class honours degree and a Master of Arts degree from the University of Central England. In 1995 he had a portrait-based solo exhibition at the National Portrait Gallery in London following a visit to Japan, which was sponsored

by BP. He has exhibited in the BP Portrait Award at the National Portrait Gallery nine times and has been short listed for the prize on three different occasions. His painting of the Rt Hon. Tony Benn for the Palace of Westminster collection won third prize at the 1999 BP Portrait Award. Tift has won many other awards including The Japan Festival Award, The European Painting Award at the Frissiras Museum in Athens and the Emerson Group Award at the Manchester Academy of Fine Arts. In 1998 he was commissioned to paint the portraits of Neil and Glenys Kinnock for the collection at the National Portrait Gallery, London, which was unveiled in 2002.

Wolfgang Tillmans
Peter Saville, 2002
C-print
610 x 508mm (24 x 20")
© Wolfgang Tillmans

Wolfgang Tillmans was born in Remscheid, Germany in 1968 and studied at Bournemouth & Poole College of Art and Design. He is widely regarded as one of the most influential artists of his generation. His work, whilst appearing to capture the immediacy of the moment and character of the subject, also examines the dynamics of photographic representation. From the outset he ignored the traditional separation of art exhibited in a gallery from images and ideas conveyed through other forms of publication, giving equal weight to both. His expansive floor to ceiling installations feature images of subcultures and political movements, as well as portraits, landscapes, still-lifes and abstract imagery varying in

scale from postcard to wall-sized prints. His work has been shown at the Museum of Modern Art, New York in 1996 and at Tate Britain, London, in a major retrospective in 2003. He was awarded the Turner Prize in 2000.

Daphne Todd
Me in a magnifying mirror, 2001
Oil on panel
412.8 x 406.4mm (16¼ x 16")
© Daphne Todd, by kind permission of Messums Gallery

Daphne Todd studied at the Slade School of Fine Art, as both an undergraduate and postgraduate (1964–71), under the direction of Sir William Coldstream. While she was there she was awarded the Tonks Drawing Prize; the intercollegiate David Murray Award for landscape painting and the British Institute Award for figurative painting. She taught part time at the Byam Shaw and at the Heatherley School of Art in the 1970s, and then spent two years in Spain painting landscapes. She returned to become Director of Studies of Heatherleys (1980–86). She exhibited widely in group shows during the period including the Royal Academy's *Summer Exhibition*, but ceased to submit after objecting publicly to their *Sensation* exhibition. Major prizes include first prize for the Hunting National Art Prize in 1984, and the Ondaatje Prize for Portraiture and the Gold Medal of the Royal Society of Portrait Painters in 2001.

Francisco Toledo
Self-Portrait XXXVIII, 2000
Mixed colour intaglio
280 x 220mm (11¼ x 8⁵⁄₈")
© Francisco Toledo

Francisco Toledo was born in Oaxaca, Mexico in 1940. He studied at the Escuela de Bellas Artes de Oaxaca and the Centro Superior de Artes Aplicadas del Instituto Nacional de Bellas Artes, Mexico, where he studied graphic arts. In 1960 he moved to Paris from where he travelled throughout Europe. In 1965 he returned to Mexico and started to promote and protect the arts and crafts in his native state of Oaxaca; he designed tapestries with the craftsmen of Teotitlan del Valle and in 1988 he created the Instituto de Artes Graficas de Oaxaca. Toledo's outstanding creativity has been expressed in pottery, sculpture, weaving, graphic arts and painting. He has had exhibitions in Argentina, Brazil, Colombia, Ecuador, Spain, Belgium and the USA. Toledo is a patron of the arts and crafts of Oaxaca.

Luc Tuymans
Portrait, 2000
Oil on canvas
670 x 390mm (26³⁄₈ x 15³⁄₈")
Courtesy Zeno X Gallery, Antwerp

Tuymans was born in Mortsel, Belgium in 1958. He has been recognized in Europe for creating a powerful body of work that reaffirms the importance of painting in a climate that continually questions the legitimacy of the medium. Tuymans feels that painting must continually confront the power and fragmentation of the media. The human condition

on the heels of two World Wars and the current proliferation of media images of global bloodshed and disaster have pushed humankind to the point of numbness. For Tuymans this imaging trend represents 'absolute horror and absolute indifference at the same time; it is a perversity that creates itself entirely in images. In my view, the perversity of these images is the right idea to start from'. Solo exhibitions include: The Renaissance Society, Chicago, 1995; Kunstmuseum St Gallen, 2003; Helsinki Kunsthalle, Finland, 2003; Pinakothek der Moderne, München, 2004; Museo Tamayo, Mexico City, 2004; K21 Düsseldorf and Tate Modern, London, 2004. He lives and works in Antwerp.

Bettina von Zwehl
#5 from the series 'Alina', 2004
C-print
598 x 464mm (23½ x 18¼")
© Bettina von Zwehl

Bettina von Zwehl was born in Munich, Germany in 1971 and studied in London, firstly at the London College of Printing (BA Photography) 1997, and then at the Royal College of Art, London (MA Fine Art Photography) 1999. Solo exhibitions include *An Anatomy of Control 2000*, Lombard-Freid Fine Arts, New York, 2000; Victoria Miro Gallery, The Project Space, London, 2002; and The Photographers' Gallery, London, 2004. A monograph of von Zwehl's work will be published by Steidl and Photoworks in 2006.

Gillian Wearing
Self-Portrait at Three years old, 2004
Digital C-print
1820 x 1220mm (71³⁄₄ x 48¹⁄₈")
Courtesy Maureen Paley, London

London-based artist Gillian Wearing is known for her clever and acutely poignant photography and video work, exploring the complexity of human relationships. Gillian Wearing was born in Birmingham, England, in 1963. Winner of the prestigious Turner Prize in 1997, Wearing has participated in major exhibitions showcasing young British art, such as *Brilliant! New Art from London*, the Walker Art Center, Minneapolis, 1995, and *Sensation*, the Royal Academy, London, 1997. Wearing was honoured with a mid-career retrospective at the Serpentine Gallery, London, in 2000.

Antony Williams
Robert, Anne, and Henry Tann, 2004
Egg tempera
1168.4 x 1708.15mm (46 x 67¼")
© Antony Williams, courtesy Petley Fine Art, London

Antony Williams is a member of the Royal Society of Portrait Painters, and his solo exhibitions include: Albernate Gallery, London, 1997; Sala Pares, Barcelona, 1999; Messum Gallery, London, 2000; Galleria Leandro Navarro, Madrid, 2001; Petley Fine Art, Monaco, 2003; Petley Fine Art, London, 2004. He has won the Ondaatje Award, 1995, the Carroll Foundation Award, 1991 and 1995, and the Discerning Eye Award for Still Life, 1998.

Catherine Yass
Star: Karisma Kapoor, 2000
Ilfochrome transparency,
lightbox
880 x 1310 x 12.5mm
(34⁵/₈ x 51⁵/₈ x ¹/₂")
Courtesy Alison Jacques
Gallery, London

Catherine Yass, who was born
in London, graduated from the
Slade School of Art in 1986, and
completed an MA at Goldsmiths
College in 1990. She has
exhibited both nationally and
internationally, since the early
1990s, and was commissioned to
create a new video work for the
opening of Walsall's New Gallery
in 2000, presenting a unique
portrait of the area. A solo exhibition
followed at London's Jerwood
Gallery in 2001, and she
represented the UK at the 10th
Indian Triennial, with the series of
portraits of Bollywood stars and
cinemas. Yass was nominated
for the Turner Prize at Tate Britain.
Since then, she has collaborated
with Merce Cunningham on
his world tour of *Split Sides*,
which premiered at the Brooklyn
Academy, New York, 2003. Solo
shows include the Herzliya
Museum of Contemporary Art and
FOAM Fotografiemuseum,
Amsterdam, as well as projects
and exhibitions at *Art Unlimited*
at Art/36/Basel, Henry Art Gallery,
Seattle and *Expo Tokyo*, Japan
(all 2005). Yass is represented
in many public collections including
The British Council, Tate Britain
and the Jewish Museum,
New York.

Jonathan Yeo
Rupert Murdoch, 2004
Oil on canvas
1274 x 766mm (50¹/₄ x 30¹/₈")
© Jonathan Yeo

Yeo did not go to art college but
instead taught himself to paint
in his early twenties while being
treated for cancer. His first portrait
commission was in 1993 to paint
Archbishop Trevor Huddleston,
founder of the Anti-Apartheid
movement. In the late 1990s and
early noughties, he undertook
a number of high profile portrait
commissions and other figurative
works both in the UK and
internationally. In 2001 he was
commissioned to paint Tony Blair,
Charles Kennedy and William
Hague during the election campaign.
The triptych – cheekily titled
Proportional Representation –
caused some controversy when
it was unveiled as the portraits
were on vastly different sized
canvases, proportionate to each
party's share of the votes.

Pinar Yolaçan
Untitled, 2003
C-print
1016 x 822.3mm (40 x 32²/₈")
Courtesy Rivington Arms
Gallery, New York

Pinar Yolaçan was born in Ankara,
Turkey in 1981. She attended
London's Central Saint Martins
College of Art and Design and
Chelsea School of Art and Design,
and received her Bachelor of
Fine Arts at Cooper Union in New
York City. She had her first solo
show, *Perishables*, in New York at
Rivington Arms Gallery in 2004.
She lives and works in Brooklyn,
New York.

Page 4
Jim Campbell
Portrait of a Portrait of Claude
Shannon, 2000–01
Custom electronics, LEDs,
treated plexiglass
305 x 381 x 76.2mm
(12 x 15 x 3")
Courtesy of Jim Campbell and
Hosfelt Gallery, San Francisco

Page 6
Braco Dimitrijevic
The Casual Passer-By I Met at
3.41pm, New York, 1988
Photographic paper mounted
on canvas
5 x 4m (16ft 4⁸/₁₀ x 13ft 1⁵/₁₀")
Private Collection, New York

Page 6
Robert Crumb
Jacket cover, taken from
The R. Crumb Handbook
MQ Publications, London

Page 8
Cindy Sherman
Untitled Film Still #54, 1980
Gelatin silver print
173 x 240mm
(6¹³/₁₆ x 9⁷/₁₆")
© 2005, Digital image,
The Museum of Modern Art,
New York/Scala, Florence

Page 9
Sam Taylor-Wood
David Beckham, 2003–4
Digital film displayed
on plasma screen
© Sam Taylor-Wood,
commissioned by the National
Portrait Gallery through the
Fund for New Commissions
(NPG 6661)

Page 10
Susan Hiller
Midnight Waterloo, 1987
C-print
762 x 520mm (30 x 20½")
Courtesy Susan Hiller and
Timothy Taylor Gallery, London

Page 10
Paula Rego
Germaine Greer, 1995
Pastel on paper laid on
aluminium
1200 x 1111mm
(47¼ x 43¾")
© National Portrait Gallery,
London (NPG 6351)

Page 12
Marlene Dumas
Helena nr.3, 2001
Oil on canvas
2000 x 1200mm (78¾ x 47¼")
Courtesy Zeno X Gallery,
Antwerp

Page 12
Ishbel Myerscough
Dame Helen Mirren, 1997
Oil on board
351 x 348mm (13¾ x 13⁵/₈")
© National Portrait Gallery,
London (NPG 6415)

Page 14
Martin Parr
From A to B
© Martin Parr/Magnum Photos

I. Blazwick, C. Christov-Bakargiev, et al., *Faces in the Crowd – Picturing Modern Life from Manet to Today* (exh. cat., Whitechapel Gallery, London, 2004)

BP Portrait Award
- 1990–2001, Essay by Martin Gayford
- 2002, Essay by William Packer
- 2003, Essay by A.S. Byatt
- 2004, Essay by Blake Morrison
- 2005, Essay by Philip Hensher (National Portrait Gallery, London)

R. Brilliant, *Portraiture (Essays in Art and Culture)*, (Reaktion Books, London, 2004)

British Contemporary (exh. cat., Arario Gallery, Korea, 2003)

M. Collings, 'How Contemporary Art is Redeemed from Shallowness', *Modern Painters*, April 2005, pp.90–93

J. Coingard, 'La fin du Portrait Officiel?', *Conaissance des Arts*, no. 594, May 2002, pp.74–81

C. Cotton, *The Photograph as Contemporary Art* (Thames and Hudson, London, 2004)

C. Darwent, 'Absence minded', *Art Review*, LVI, April 2005, pp.54–9

W.A. Ewing, J.C. Blaser and N. Herschdorfer, *About Face: Photography and the Death of the Portrait* (exh. cat., Hayward Gallery, London, 2004)

M. Falconer, 'Surviving and thriving as a portrait painter', *Artists and Illustrators Magazine*, July 2002, pp.17–19

D. Gaston, 'The Face of Contemporary Portraiture', *Art-New-England*, XXIV, no. 6, October/November 2003, pp.16–17

T. Gett, 'About faces', *British Journal of Photography*, CL, September 2003, pp.18–19

R.Gibson, *The Portrait Now* (National Portrait Gallery, London, 1993)

U. Grosenick, *Women Artists in the 20th and 21st Century*, (Taschen, London, 2001)

U. Grosenick and B. Riemschneider (eds.), *Art Now* (Taschen, London, 2005)

P. Holmes, 'R A Modern', *Art-Review*, LIII, September 2002

C. Homburg, *German Art Now* (Merrell Publishers Limited in association with the Saint Louis Art Museum, 2003)

A.F. Honigman, 'Where do I belong', *Art Review*, LVI, April 2005, pp.78–80

L. Hoptman, *Drawing Now: Eight propositions* (Museum of Modern Art, New York, 2002)

B. Johnson (ed.), *Photography Speaks: 150 Photographers on their Art* (Aperture, New York, 2004)

C. Kino, 'Hired Hands', *Art and Auction,* XXIV, no. 2, February 2002, pp.102–11

B.A. Knight, 'Watch me! Webcams and the public exposure of private lives',

Art-Journal, LIX, no. 4, Winter 2000, pp.21–5

P. Lafuente, 'Portraiture stripped bare', *Art Review*, LVI, April 2005, pp.70–73

T. Lubbock, 'Eye Contact', *Art Review*, LVI, April 2005, pp.64–9

L. Nochlin, 'Picturing Modernity Then and Now', *Art in America*, no. 5, May 2005, p.124

E. Nora, *Face to Face: The Art of Portrait Photography* (Flammarion, Paris, 2004)

M. Nuridsany, *China Art Now* (Flammarion, Paris, 2004)

Phaidon Press editors, *Cream 3* (Phaidon, London, 2003)

C. Ross, 'The Insufficiency of the Performative: Video Art at the Turn of the Millennium', *Art Journal*, LX, no. 1, Spring 2001, pp.28–33

J. Saltz, 'The Richter Resolution', *Modern Painters*, April 2005, pp.28–9

M. Sanders, K. Tsuzuki and F. Sawa (eds.), *Reflex: Contemporary Japanese Self-Portraiture* (Trolley, London, 2002)

B. Schwabsky (introduction), *Vitamin P* (Phaidon, London, 2004)

B. Schwabsky and A. Gingeras, *The Triumph of Painting*, (exh. cat., Jonathan Cape for the The Saatchi Gallery, London, 2005)

Schweppes Photographic Portrait Prize (National Portrait Gallery, London, 2003, 2004, 2005)

D. Singer, S.M. Momin and C. Isles, *Whitney Biennial 2004* (exh. cat., Whitney Museum of American Art, New York, 2004)

M. Sladen, *the americans. new art* (Barbican, London, 2001)

S. Sollins, *Art 21.2: Art in the Twenty-first Century 2* (Harry N. Abrams, New York, 2003)

B. Steiner and J. Yan, *Autobiography* (Thames and Hudson, London, 2004)

I. Stevens, 'New faces', *Art Review*, II, no. 9, December 2004–January 2005, p.21

T. Warr and A. Jones, *The Artist's Body* (Phaidon, London, 2000)

J. Watkins and M. Kataoka, *Facts of Life: Contemporary Japanese Art* (exh. cat., Hayward Gallery, London, 2003)

L. Weintraub, *Making Contemporary Art: How Today's Artists Think and Work* (Thames and Hudson, London, 2003)

S. West, *Portraiture* (Oxford History of Art), (Oxford University Press, Oxford, 2004)

V. Williams, 'Breaking the rules', *Art Review*, April 2005, pp.51–4